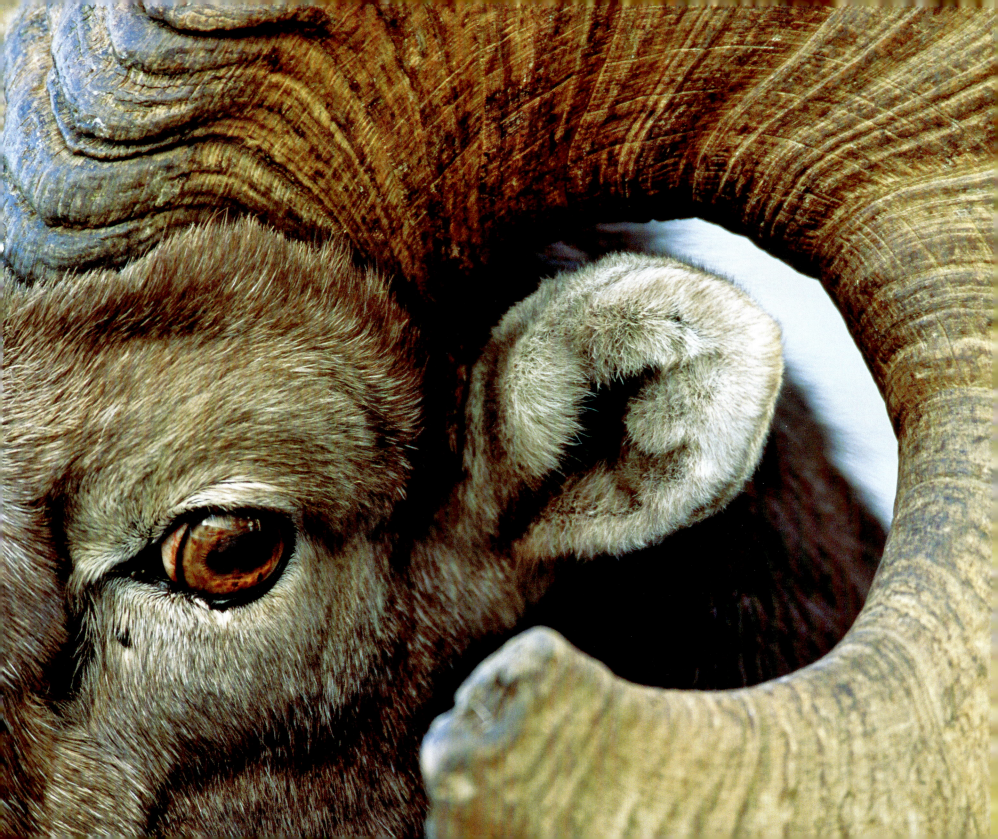

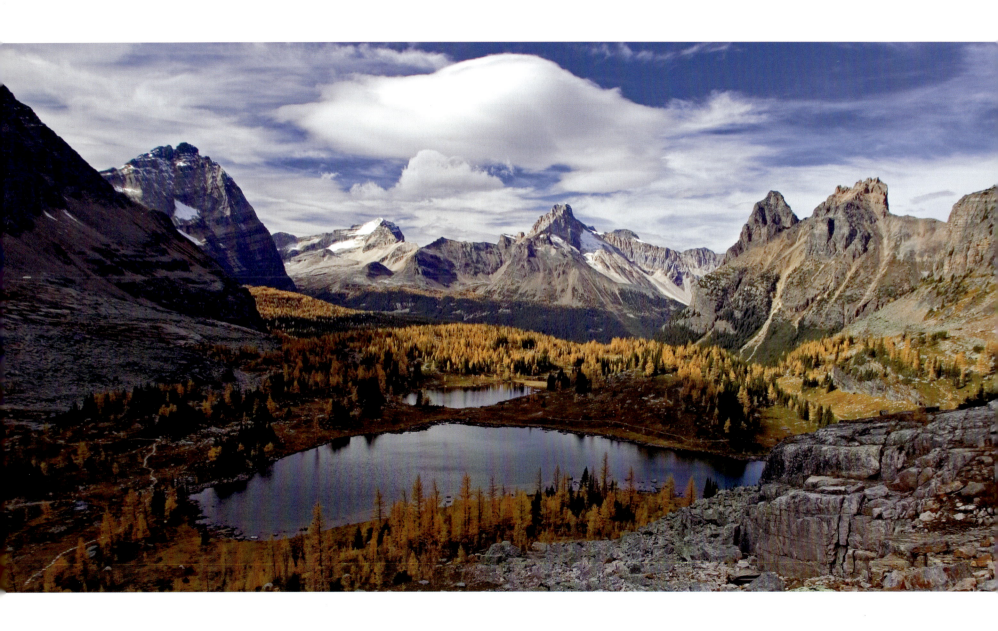

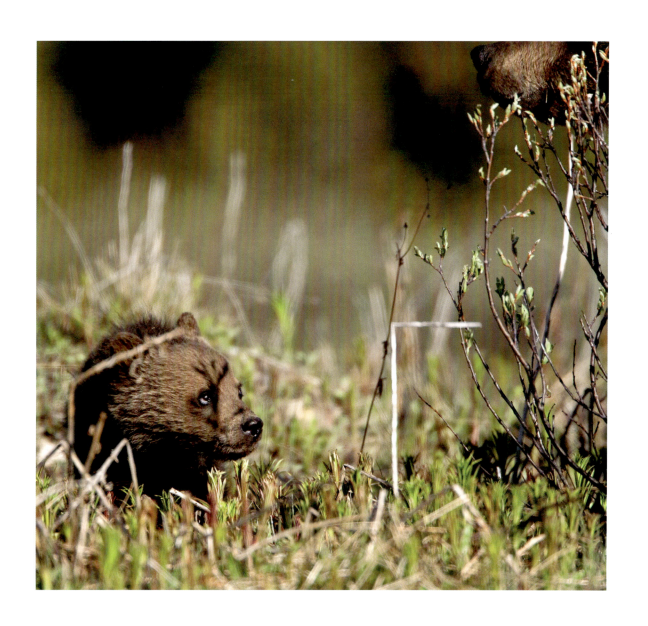

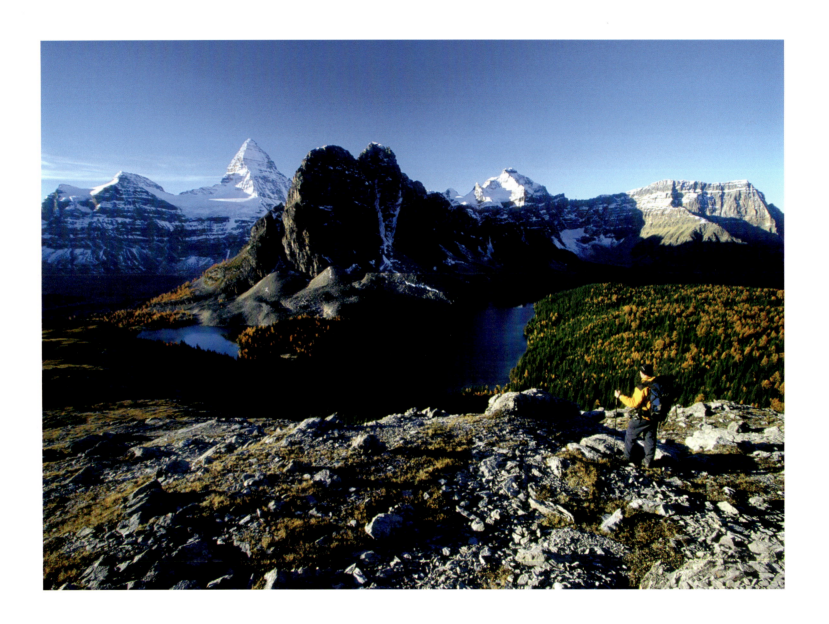

THE WILL *of* THE LAND

PHOTOGRAPHS & TEXT BY PETER A. DETTLING

RMB
Victoria Vancouver Calgary

Copyright © 2010 Peter A. Dettling

All rights reserved. No part of this publication may be reproduced, stored in a retrieval system, or transmitted in any form or by any means—electronic, mechanical, audio recording, or otherwise—without the written permission of the publisher or a photocopying licence from Access Copyright, Toronto, Canada.

Rocky Mountain Books
www.rmbooks.com

Library and Archives Canada Cataloguing in Publication

Dettling, Peter A. (Peter Albert)
The will of the land / photographs & text by Peter Dettling.

Includes bibliographical references.
ISBN 978-1-926855-00-4

1. Rocky Mountains, Canadian (B.C. and Alta.)—Pictorial works. 2. Natural history—Rocky Mountains, Canadian (B.C. and Alta.)—Pictorial works. 3. National parks and reserves—Rocky Mountains, Canadian (B.C. and Alta.)—Pictorial works. I. Title.

FC219.D48 2010 917.110022'2 C2010-902810-4

Printed in Canada

Rocky Mountain Books acknowledges the financial support for its publishing program from the Government of Canada through the Canada Book Fund (CBF), Canada Council for the Arts, and the province of British Columbia through the British Columbia Arts Council and the Book Publishing Tax Credit.

This book was produced using FSC-certified, acid-free paper, processed chlorine free and printed with vegetable-based inks.

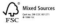

To Nanuk and his family and to the Brave One and his kin.

During my years of observation of the Bow Valley wolves, Lakota was the wolf I grew to know the best. I named him Lakota after the Sioux word for "friends" or "those who are united." Lakota offered me his trust. If I ever see him again, I may have a hard time looking straight into his eyes, given what happened to his family because of my kind. Yet I also hope that maybe he could forgive me because I took the time to observe, listen and learn from his kin, which ultimately convinced me to write this book.

Maybe, only maybe, this book will help to ignite some much-needed change in the way we treat not only wolves or bears but also our national parks and the natural world in general.

CONTENTS

Foreword 11
Acknowledgements 15

Introduction

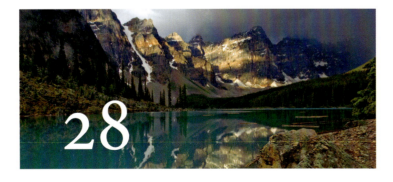

Garden of Eden

First Blood 22
Big Medicine 29
Bears in Love – Part I 35

Paradise Lost

Nanuk 48
Alone with the Bows 55
Deadly Tracks 63
Joining the Hunt 69
Sharing the Road 77
The Battle for Nanuk's Hill 86
Bears in Love – Part II 99
Playing God in the Canadian Rocky Mountain National Parks 107
The End of the Bows 123
Last Stand 129

Regaining Paradise

The Great Deception 143
Quo Vadis? 157

Epilogue: The Will of the Land

Map 180
Grizzly Family Tree 182
Bow Valley Wolf Family 183
References and Related Reading 186

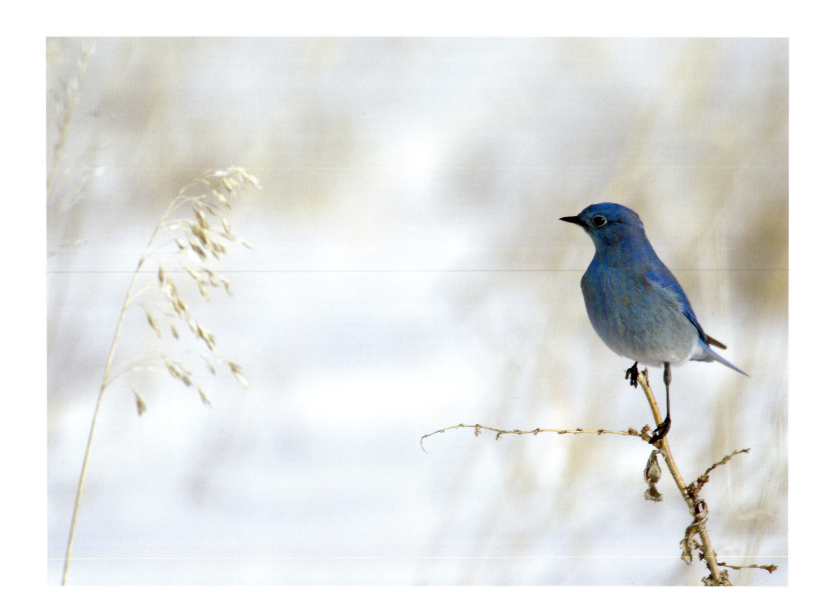

FOREWORD

In this captivating but disturbing book, Peter shares an emotional journey that begins with the joy and wonderment of nature unfettered, descends through disenchantment and concludes with a subdued note of cautious hope. Throughout the book, stunning photographs and provocative narrative shine a bright light on an often obscured Canadian travesty – the exploitation of national parks for profit. Exposed for all to see is the ecological impoverishment of Canada's oldest and most iconic park, brought about by 130 years of commercial growth and development.

The Will of the Land is an intimate and compassionate portrayal of beleaguered wildlife trying to survive in the commercialized Bow River Valley of Banff National Park. The immediacy of Peter's images is so moving that you are mentally transported to the park. Poignant narrative makes it easy to understand why the valley's beauty, splendour and magnificent ecological diversity have captivated and sustained people for millennia, unfailingly offering spiritual and physical sustenance. Unencumbered by a built environment, the Bow Valley dependably formed the basis of survival for countless cultures, plants and animals. In the minds of most Canadians, Banff remains the pristine crown jewel of national parks, a place where wild animals can live unimpeded by humanity's relentless obsession with growth and environmental destruction.

Mountain Bluebird

Peter, however, skillfully exposes this widely held perception as contrived myth. Using inspiring images, he conjures the unrealized promise of what Banff alleges to be. His narrative reveals the uncomfortable truth that a fundamental conflict exists between unbridled commerce and healthy environments. We are left to conclude that there is no national park more beautiful yet over-exploited, abused and despoiled than Banff. The take-home messages are clear and sombre. Specifically, all is not well and something must be done to halt this tragedy.

By law, national parks are protected for public understanding, appreciation and enjoyment while being maintained in an unimpaired state for our children. To that end, Parks Canada is mandated first to protect ecological integrity and secondarily to allow the public to explore, learn about and enjoy Canada's natural spaces. In other words, Canada's national parks are for people, but not at the disadvantage of other species. Indisputably, however, the primary goal of protection has failed in Banff. The impoverished condition of the park environment provides convincing evidence that the business interests of humans have been represented disproportionately, at the expense of wildlife. In essence, society has willingly sacrificed the ecological integrity of the park for the pursuit of monetary profit.

Peter's concerns are not new, nor are the problems that precipitated them. Failure to reconcile ecology and commerce has been a hallmark of Parks Canada's policy for decades. For many, the exploitation of Banff measured the success of an enterprising economy. Although

Parks Canada has clear and comprehensive legislation and policies, including the National Parks Act, Banff suffers from their inconsistent application. Some of the explanation lies in the evolution of Banff National Park, some in ad hoc decision-making and some in weak political will in the face of a range of interest-based lobbying.

From its inception and through a succession of complicit governments, Banff National Park has been modified by an economy that has largely ignored the environment or, worse, viewed the environment as an obstacle to overcome. The unrelenting wear and tear of commercial progress has left the once exquisite ecological tapestry of Banff threadbare and tattered. Highways, railways, two townsites, dams, reservoirs, ski hills, golf courses, hotels and high-tension power lines have despoiled the landscape and diminished the lives of wild inhabitants that constitute and define Banff. Erosion of the park environment is widespread, inescapable and persistent, with the ecological penalties seemingly growing irreversible and unsolvable. The disquieting reality is that the needs of wolves and bears living in the Bow Valley have always been, and continue to be, secondary to the increasingly demanding commercial and recreational requirements of people.

As unsettling as it is to contemplate, the wolves and bears of the Bow Valley live in an environment dominated by humans, an "ecologically impoverished wilderness" that is the product of a thriving tourism industry and prosperous commercial enterprises, all of which are dependent on transportation. Consequently, the animals must contend with multiple threats to their livelihood, including railways, highways and urban developments (towns). The survival of individual animals is tenuous, while families and packs are ephemeral. Wolves and bears die in the park at only slightly lower rates than in unprotected areas outside the park where they are hunted and trapped.

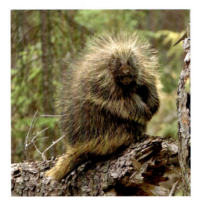

Fundamentally, the exploitation of Banff National Park for the primary benefit of people reflects a sad lack of empathy for nature. From the perspective of the wolves, bears and other animals that Peter speaks for, the cost of this human hegemony is often measured in loss of life and prolonged suffering. When we appropriate or impoverish park habitat for our elite purposes, we are depriving wild animals of their life-sustaining requisites of food, water and shelter. Ultimately, this causes suffering of individuals through displacement, stress, starvation and reduced security.

These vexing ethical problems are further compounded because decision-makers, and the public, fail to recognize the difference between the existence of a species and the long-term persistence of ecological systems upon which the species depends – a relationship that also applies to humans. Simply, intact ecological systems are characterized not only by the species (components) that inhabit them, but also by ecological functions and processes that link species with their environment (e.g., migration, predator/prey relationships). Although species may continue to exist long after natural ecological relationships have been altered or destroyed, such impoverished systems are not sustainable and do not typify healthy environments.

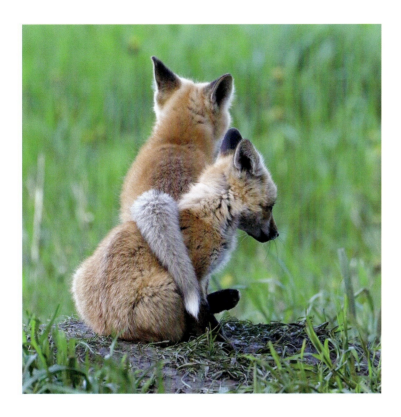

Red Fox pups wait for the return of one of their parents at dawn.
OPPOSITE: A somewhat surprised looking porcupine stares at the author in a remote corner of Jasper National Park.

Of course, in a world dominated by people, environmental devastation has become a normal state of affairs, which is exactly the point of Peter's book. Banff is a national park where unimpaired nature supposedly has primacy, an exceptional counterpoint to humanity's ongoing subjugation of the world we inhabit. At a minimum, the expectation that the park should provide a safe and secure haven for wolves, bears and, by extension, other wild animals is more than reasonable. For Peter, protecting and restoring Banff is a matter of principle and law, unmistakably distinguished from matters of price.

Clearly, a substantial price has already been paid for human progress. Our unchecked exploitation of the park environment has mortgaged the future while accruing a massive ecological debt. Yet, Peter argues convincingly that Banff remains full of unrealized potential and promise. He contends that we can secure a healthy future and good quality of life for park wildlife by focusing on environmental restoration rather than destructive growth. Doing so, however, will take the commitment of a public willing to do what is necessary and not just what is politically expedient.

Perhaps Peter's impassioned call will wake up Canadians from their current stupor. To that end, this book aims to motivate those of us who are already sympathetic to the plight of bears and wolves. At the same time, its intent is to inform the politicians and policy-makers, whose decisions ultimately determine the fate of wolves and bears, that slowly killing these animals by depriving them of their life requisites is a moral issue. Above all, this book is for the wolves and bears that depend on the Bow Valley for their livelihood but are unable to represent themselves. As their emissary, Peter encourages each of us to become lobbyists for all of the park animals that are suffering the abuses of ongoing environmental degradation. In doing so, I think he rightly assumes that compassion for an idea is hard to generate, but compassion for a wolf or bear is much less so.

—Paul Paquet

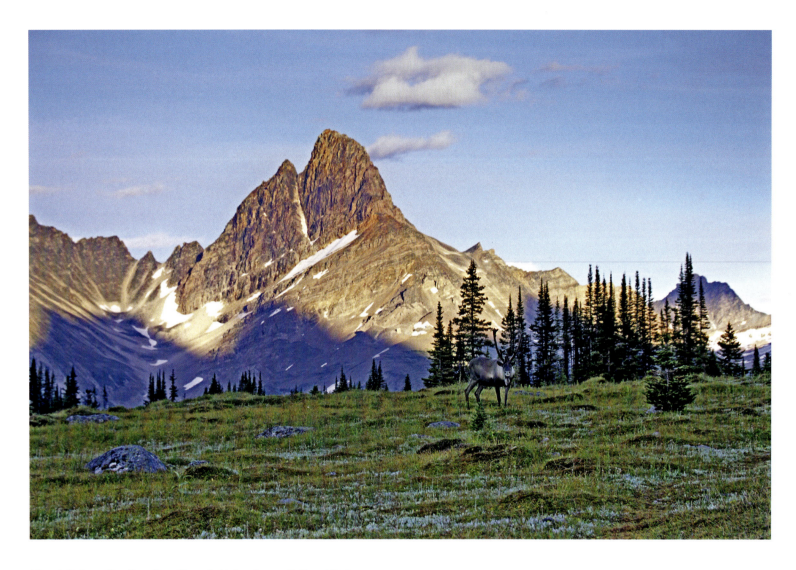

Mountain (woodland) caribou, Tonquin Valley, Jasper National Park

ACKNOWLEDGEMENTS

This project started a long time ago, so it is hard to know where to start to give my sincerest gratitude to all the people who have supported my work over the years. Consequently, aside from the first two, I thank the following "Lakotas" in chronological order:

Jeff Gailus, gifted writer and environmentalist, who took my raw material and turned it into a coherent, eloquent and elegant essay.

Don Gorman, publisher at Rocky Mountain Books, who supported me fully from day one, which has enabled me to write and publish a book about a subject that is too often ignored.

The foundation of this book was laid when I visited the Canadian Rocky Mountains with my father, Albert, and my sister Lea back in 1993. For their continuing support and love, as well as the support of my oldest sister, Corina, and especially my mother, Ursulina, I am eternally grateful. They have always encouraged me to follow my heart and become an artist, even if it meant leaving home and country in order to set up camp halfway around the world.

Tom Ulrich, who introduced me to the world of professional nature photography and the Rocky Mountains, you ignited a passion that is still with me today.

Volker Schelhas, who led me on my first encounters with wild-living wolves in Jasper National Park.

Hälle and Linda Flygare, for their friendship, support and continuous counselling.

Günther and Karin Bloch, true friends of all canines, for opening the door to the magical world of free-roaming wolves.

Georg Sutter, dedicated friend of all the wild animals, whose knowledge of the natural world continues to inspire me.

John E. Marriott, colleague and devoted ambassador of respectful nature photography, for leading me in the right direction to grizzly bear 1729 (Casanova) in the spring of 2008.

I would also like to thank Sadie Parr, Laura Lynes, Robert Berdan, Mike Gibeau and Paul Paquet for reading some or all of the many versions of this manuscript and sharing with me their advice, knowledge and expertise. This book would not have become what it is without their knowledge and inspiration.

A big thank you to all the people at Rocky Mountain Books – especially Chyla Cardinal (design), Neil Wedin (marketing) and Shauna Rusnak (final edit) – for helping me to give the suffering wilderness found in our Rocky Mountain national parks a voice in the form of this book.

My sincerest gratitude also to the many unnamed individuals behind the scenes who contributed to this book in many ways, and my sincerest apologies for any omissions or oversights.

Finally, yet importantly, I would like to thank the land itself: the Rocky Mountains and all the wild ones who share this region with us. In particular, thanks to the Brave One, Casanova, Jolie and her cubs, and Nanuk, Delinda and all of their family members. Thank you for allowing me to observe, document and be awed. You taught me volumes, not only about the natural world, but also about my kin and myself.

INTRODUCTION

The battle to establish parks may be won, but the battle to keep them inviolate is never won.

—James Bernard Harkin (1875-1955), first commissioner of Canada's Dominion Parks Branch

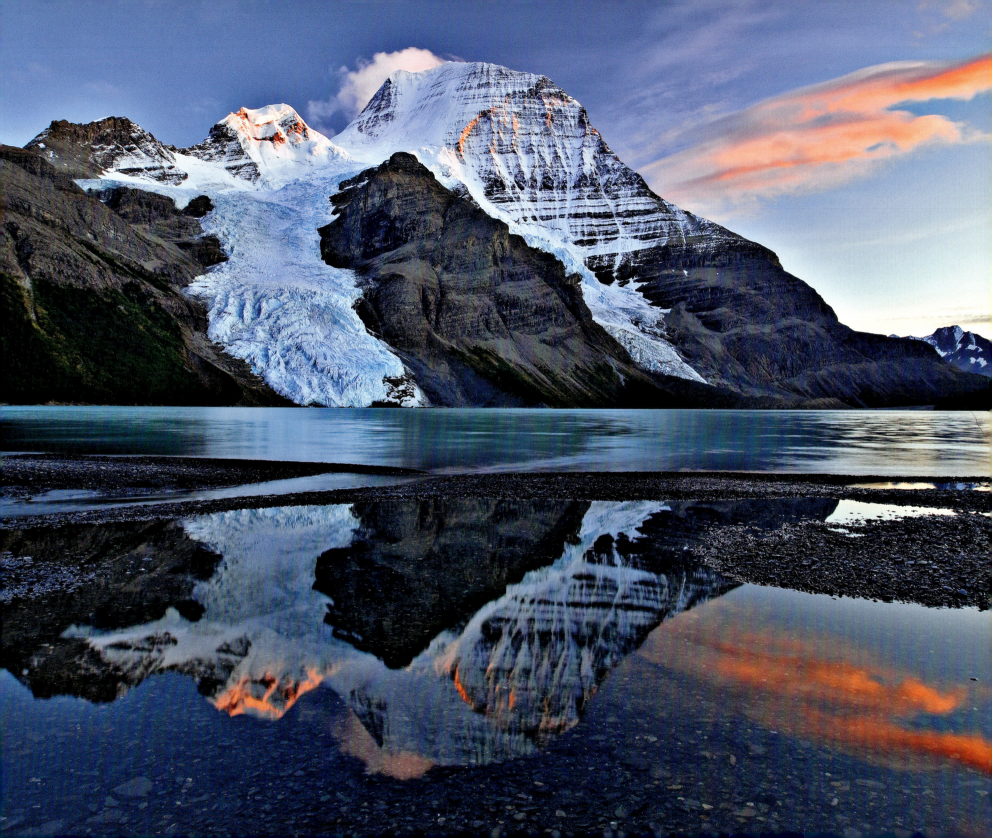

One of my fondest memories of my first trip to the Canadian Rockies, in 1993, is paddling on the majestic Moraine Lake with my father and sister. Moraine Lake, its image immortalized on the 1970 and 1978 issues of the Canadian $20 bills, is one of the country's most recognized landmarks. On that warm August day, we paddled our canoes to the end of the lake while the sun was peaking over the ten magnificent peaks that hold the stunning turquoise waters. Pulling ashore for a break, I had no doubt that the forces of creation had been at their very best the day they created this part of North America. It was like stepping into the Garden of Eden.

The next day, we drove our rental car north along the Continental Divide, as many tourists do, toward Jasper. For hours and hours I saw nothing but vast forests decorated with free-flowing rivers and serene mountain lakes glimmering in the summer sun. In the town of Jasper, a few elk crossed the street in front of us, forcing us to stop our car and marvel at the fairy-tale nature of our experience. The next morning, we spotted a grizzly and a black bear. We stayed for another week, but we could have returned to Switzerland that very day with enough memories to nurture a lifetime. Countless tourists carry similar experiences in their hearts for the rest of their lives.

I returned to North America many times. Eventually, I did not want to live anywhere else but in the Canadian Rockies. In 2002, after a lengthy immigration process, I picked up my life in the Swiss Alps and moved it to a mountain range halfway around the world. After attending an intensive, year-long photography school on Vancouver Island, I finally moved to Canmore, Alberta. A growing tourist town in the Bow Valley, Canmore is just outside the eastern boundary of Banff National Park. I was thrilled. I wanted to learn and experience so many things, such as how to share the landscape with the mighty grizzly bear. I hoped to encounter a cougar on the trail, listen to the bugling of the elk in the fall and observe osprey diving into the crystal-clear water in pursuit of trout. I wanted to know the feeling of the soft-covered ground of old-growth forests and recognize the haunting echo of loons on serene lakes. Maybe I would even hear the howl of the most fascinating animal of all, the wolf. And so, I started to prowl the river valleys, alpine meadows and mountaintops in search of the natural wonders of the Rocky Mountains.

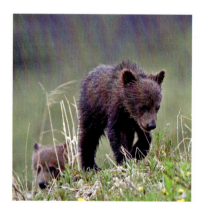

Four years later I found myself sitting in a local coffee shop, enjoying a latte and reading the local newspaper. A headline caught my eye: "Banff bison considered again." Ah, the proposal to bring bison back to Banff National Park is on the table once more. I spotted another intriguing headline on page 9: "Wolf killed on the Trans-Canada Highway." Page 12 bore more sobering news: "New elk reduction methods proposed." The last nine pages, as always, belonged to the realtors and land speculators who are doing their best to turn the Bow Valley, including parts of Banff National Park, into a suburban jungle. Suddenly my latte did not taste so good.

Such news is nothing new in the Bow Valley, I thought to myself, longing for those early days when I drove through this part of the world as an unknowing tourist. Unfortunately, after living in the Canadian Rockies for less than half a dozen years, I cannot help but

be overwhelmed with frustration, sadness and even anger at the fallen state of this Garden of Eden. As a nature photographer and author, I *could* ignore these issues. I *could* showcase only the high points, like the tourist agencies and marketers do, and portray the area as a place where time seems to have stood still. A place where wolves and bears still roam free through vast, untouched forests. A paradise on Earth.

Instead, I decided to write this book to provide a more complete and honest picture of what is going on in one of the world's most famous tourist destinations. I believe it is my duty as an artist to represent both the beauty and the truth of Canada's Rocky Mountain national parks. While the beauty is self-evident, the truth is that our human footprint (e.g., highways, golf courses, dragon boat races and legions of five-star hotels) ensnares this paradise and puts it in great peril. Some of my views and ideas are critical of how these parks are managed and many will be discounted as being too emotional, too subjective. Nevertheless, the stories of the animals in this book are painfully real. Without a single exception, I tell and show these stories as they happened. The images do not have a single leaf removed or added, nor any artificial lighting. This is, after all, a book intended to paint a truthful picture of what is happening in Canada's Rocky Mountain national parks. By doing so, I hope to give voice to those who cannot stand up and speak for themselves.

—Peter Dettling
Canmore, Alberta, 2010

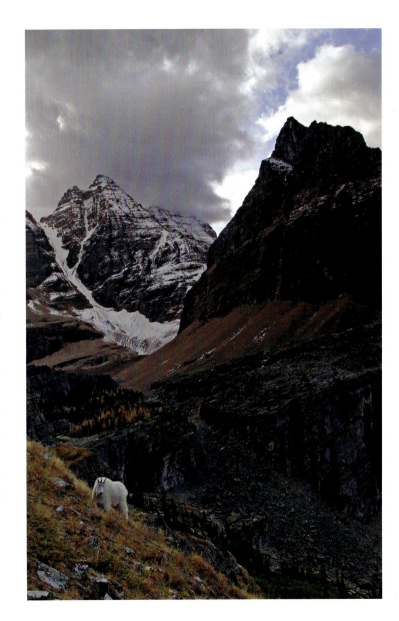

A mountain goat in its element in the high alpine environment of Yoho National Park.
OPPOSITE: Approximately 5½-month-old grizzly cubs take a walk in the rain.

GARDEN OF EDEN

Protected and preserved for all Canadians and for the world, each [national park] is a sanctuary in which nature is allowed to evolve in its own way, as it has done since the dawn of time.

Parks Canada, Introduction to the National Parks System Plan (1997)

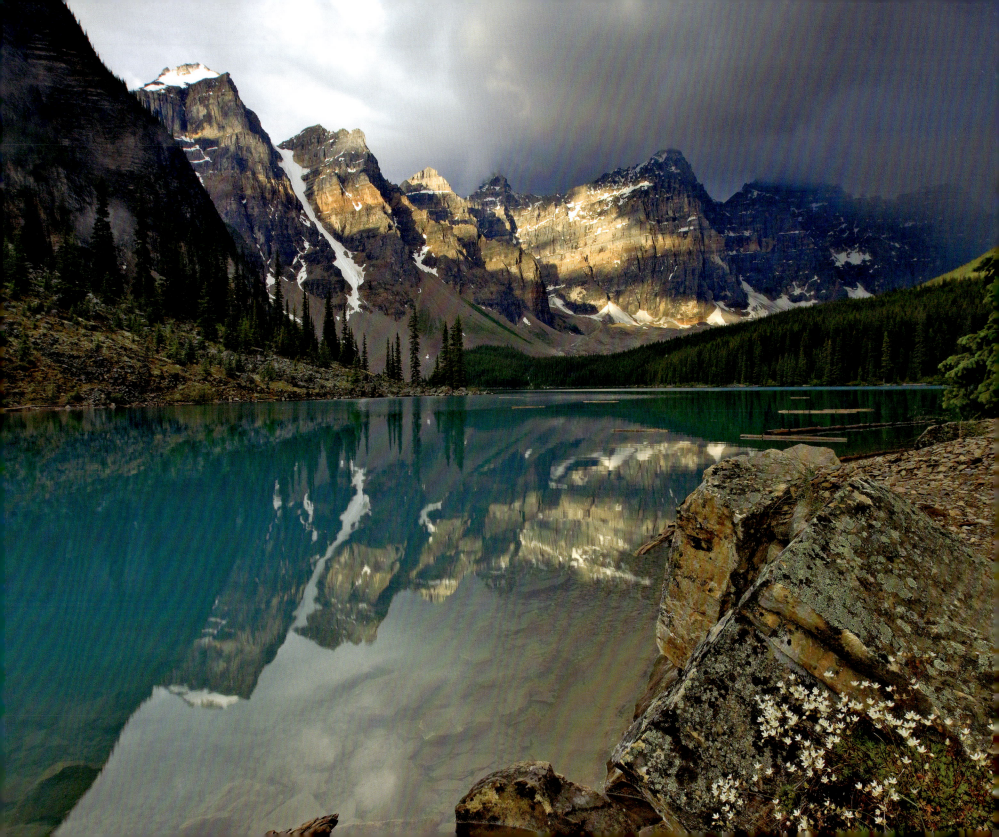

FIRST BLOOD

If one direction in art nowadays makes sense, then it is surely wildlife art. I suffer when I see the decline of the wild virgin areas. Wildlife art can affect the future of our planet. It may have only a small effect, but it is a contribution of our natural world – without which I could not live.

—Carl Brenders, naturalist and painter

I was a painter, not a photographer, when I first visited Canada. I had been painting watercolour landscapes and wildlife all of my adult life, but capturing them on film (and now digitally) was something I knew nothing about. Then a three-month study trip to Montana, in 1997, deeply changed the way I wanted to express myself as an artist, with photography slowly replacing painting as my new medium. After immigrating to Canada and graduating from photography school in 2003, I purchased a trunk-load of photography equipment and headed into the Rocky Mountains.

The Canadian Rocky Mountain National Parks World Heritage Site is the crown jewel of Canada's national parks system. At 22,990 square kilometres, the four national parks – Banff, Jasper, Kootenay and Yoho – and the provincial parks that abut them, cover an area nearly half the size of Switzerland. While both Switzerland and the Rocky Mountain World Heritage Site are dominated by mountains, glaciers and wide valleys, there is one big difference: where Switzerland is home to over 7.5 million people, this World Heritage Site contains only about 15 thousand residents. Here, nature, not people, dominates the landscape.

What makes these parks special, at least to my eye, is the combination of magnificent scenery complemented by the bountiful wildlife population. Except for bison, Canada's Rocky Mountain national parks still contain the full complement of plants and animals that existed here when the first European, Englishman Peter Fidler, entered the Canadian Rockies in 1792: elk and deer, mountain goats and bighorn sheep, bull trout and bald eagles, grizzly bears and grey wolves. Compared to this place, Switzerland is only a shell of what it once was.

My first self-assigned challenge was to capture wild-eyed bighorn sheep knocking heads in the bitter cold. Bighorns have always fascinated me. They remind me a bit of the ibex I grew up with in the Swiss Alps. The males' massive horns make them look regal and powerful, and they are swift and capable mountain climbers. Tom Ulrich, a professional nature photographer and friend from Montana, told me of a good place to photograph them during the rut. In November 2003 I followed Tom's directions and drove north to Jasper, just as I had with my father and sister ten years before.

The road to Jasper was frigid. Along the way, I stopped to photograph the freezing waters of Bow Lake. After setting up my tripod on the shoreline, I waited for the sun to peek over the Rockies. It must have been around −25°C when I captured the first rays of sunlight bathing Crowfoot Mountain in warm pink alpenglow. When I finally got back to my vehicle, I could hardly feel my fingertips, which burned as the blood began to return in the warmth of the car.

My daily routine in Jasper involved waking in the dark, grabbing a fresh cup of coffee and a butter croissant at a local bakery and then following the movements of a herd of bighorn sheep near the eastern boundary of the park. It was not at all what I expected. I often found the bighorns standing in the middle of Highway 16. They came to lick the salt from the road and, to the great amusement of the tourists, even directly off the sides of vehicles that had stopped nearby to watch.

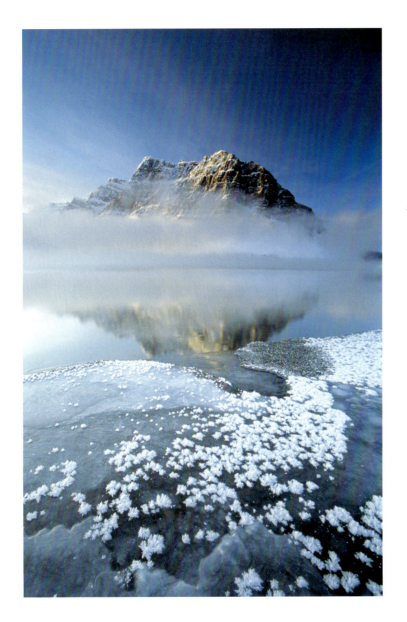

I soon tired of the artificial nature of this roadside drama and decided to hike a game trail that climbed above the highway. After all, I had come to photograph the dramatic collisions of combative males, not the tender licks of mineral-addicted roadside sheep. As I climbed, a large mountain lake appeared to my left. With much cracking, clicking and sighing, the cold temperatures and laws of physics turned fresh water into thick slabs of expanding ice. It sounded like whale song. During the intermittent silences, in the far distance, I finally heard a soft "tock," as if someone were hitting two blocks of wood together. Then silence. And then again, the soft "tock" of faraway head-butts. This, at last, was why I had come to Jasper.

I scanned the nearby slopes with my binoculars and there they were: the monarchs of the mountains. Thirty or so Rocky Mountain bighorns, including about a dozen males, were battling for the right to mate. I made my way over and stepped out of the forest onto the battleground, but there was no fighting anymore. Instead, the sheep all looked over suspiciously. Rather than getting closer, I decided to sit down and observe their ancient ritual. The sheep, in return, thanked me for my passive behaviour and started to spread out until they surrounded me. Their hooves scratched away the fresh fallen snow, their soft lips cropping the exposed vegetation. They breathed and sneezed and grunted.

As I watched and photographed in awe, the males became more active again. They tilted their heads to show off their horns for the watching females. Often, a big male would approach an opponent from the side or back and barrel into him with his chest, then deliver a series of jabs with one of his front legs. The colder it got, the more active the rams became.

The frigid waters of Bow Lake mark the start of one of the best-known rivers of Alberta, the Bow. The lake is usually frozen over from late November to early June.

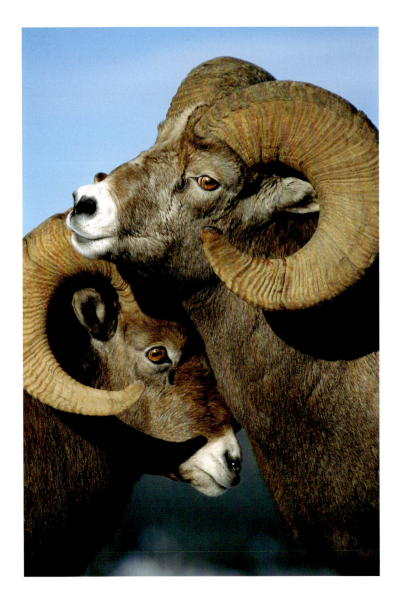

In Jasper National Park a young Rocky Mountain bighorn sheep tries to provoke a somewhat older ram during rut season. The bighorn is Alberta's provincial mammal, and Jasper is one of the best places to view the annual rut ritual. Two hundred years ago, these sheep were widespread throughout the western United States, Canada and northern Mexico. Some estimate their number to have been more than two million animals. By 1900, however, disease, hunting and competition from domestic sheep had wiped out much of the population. Wildlife management and conservation efforts helped some herds recover. While current bighorn populations in the mountain parks appear to be stable, disease, poaching and motor-vehicle accidents still pose significant threats.

The strangest sight was when two rams decided to take on a single, larger male. They sized each other up and then stepped back to get ready. The solitary ram rose on his hind legs and started his attack. The second-largest ram quickly took up the challenge and did the same, the two competitors crashing into each other like jousting knights. To my surprise, the smallest of the three, who had allied himself with the second-largest ram, then charged headfirst into his opponent from behind. They repeated this several times until they got tired of each other and ran back toward the females. I felt like David Attenborough, the famous British naturalist and broadcaster. It was my first of many dreams to come true in the Canadian Rockies.

Later, a single ram approached as I shivered in the cold. He came straight toward me with his head down and slightly tilted to the side, to make sure I recognized the immensity of his horns. I slowly picked up my camera and squeezed the shutter as he strolled passed, but it soon

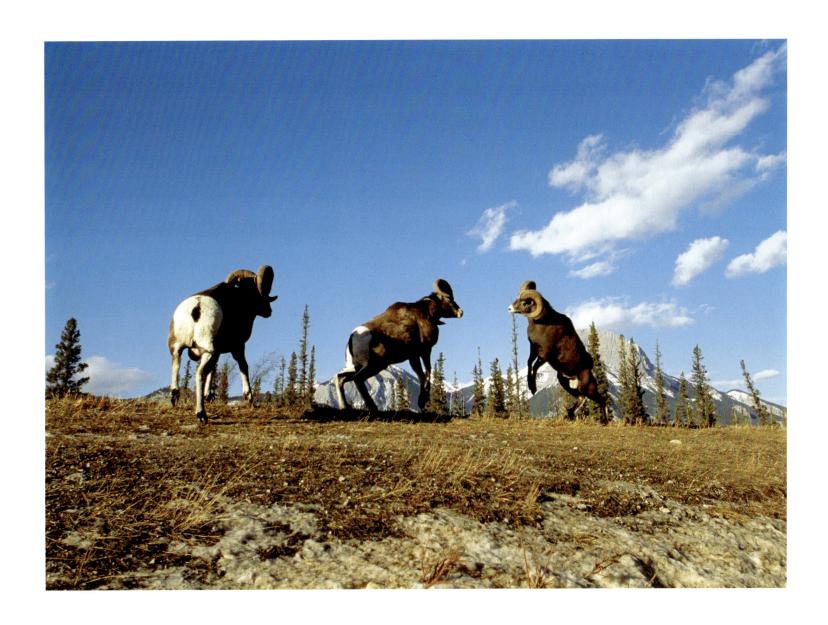

became clear he was not interested in me. There was a herd of females behind me, one of which he approached and sniffed. She urinated in response, taking a few steps away from the curious ram. He, in turn, raised his head toward the sky to perform what is called a "lip curl" or "flehmen response." By curling back his upper lip, the ram exposes an opening to the Jacobson's organ, which detects pheromones to inform the ram if the ewe is receptive to breeding.

The answer must have been yes, because he followed her as if she held the secret to immortality. By this time, four other rams had gotten wind of the situation and decided to join the party. The female spooked and tried to get away, but the rams followed. The chase was on. The bighorns ran up and down the steep cliffs with the ease and elegance of ballerinas. As the intensity of the dance increased, the female ran straight toward me, the four horny rams in hot pursuit! My escape blocked by the steep cliff behind me, I dove behind a tree and watched as the sheep dashed around me like white-water around a submerged rock, lusty and oblivious. I feared that they might slip and fall on the loose and icy rock, but I soon saw them reappear on the top of the next hill as the chase continued into the woods.

As the light faded, I decided to head back to Jasper for a good meal and a hot shower. Near town, I had to slow my car for four large rams crossing the highway. As if crossing a busy road was not dangerous enough, they decided to stop on the road to partake of the salt coating the asphalt. Afraid for their safety, I got out of my car to try to run them into the trees. "Go on, get out of here! Heyyyaaa!" I yelled as I chased them in circles in the middle of the road. I must have looked like I had lost my mind. It was hopeless. The road salt was too tempting for the wild sheep. Every time I scared them off, they just circled back and resumed their positions on the road. I had no choice but to leave them licking salt in the dark.

When I returned the next morning, a flock of ravens and two coyotes had replaced the quartet of stubborn rams. A large, dark pool of blood stained the road. I looked around for the source of the blood, but found nothing. Suspecting the worst, I drove to the warden station in Jasper to find out what had happened.

Apparently bloodstains do not lie. The warden told me that a large transport truck had killed all four rams in a single, brutal collision.

"Did he at least get a ticket?" I asked.

"No, probably not."

What a disaster. Four healthy bighorn rams destroyed in an instant, taking with them their strong genes and reproductive potential. This was not something I expected to happen in a national park meant to protect these animals. Indeed, my first Canadian Rockies dream did come true, but only to violently collide with a poignant reality.

A coyote investigates a bloodstain caused by a collision between a truck and a group of bighorn rams. In Jasper National Park alone, the Canadian National Railway killed more than 250 bighorns between 1981 and 1997. Highway vehicles killed 330 more during the same period. These incredibly high roadkill numbers are also a consequence of de-icing the highways with salt in the winter. Considering the status of these animals as "provincial mammal" and of these places as both national parks and a World Heritage Site, one would think governments would be willing to invest in the use of calcium magnesium acetate, a truly effective, if initially somewhat more costly, salt substitute. So far, this hasn't been the case and the bighorn sheep continue to die in large numbers.

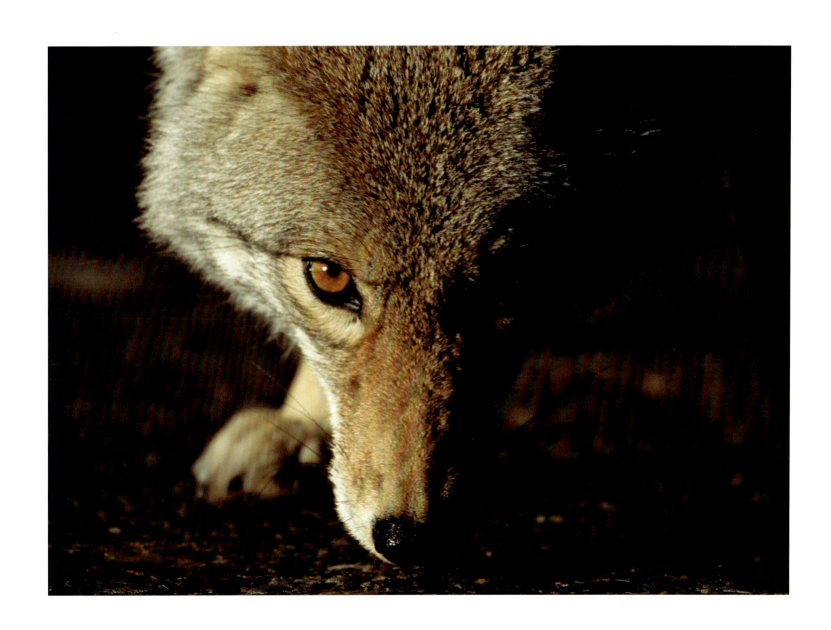

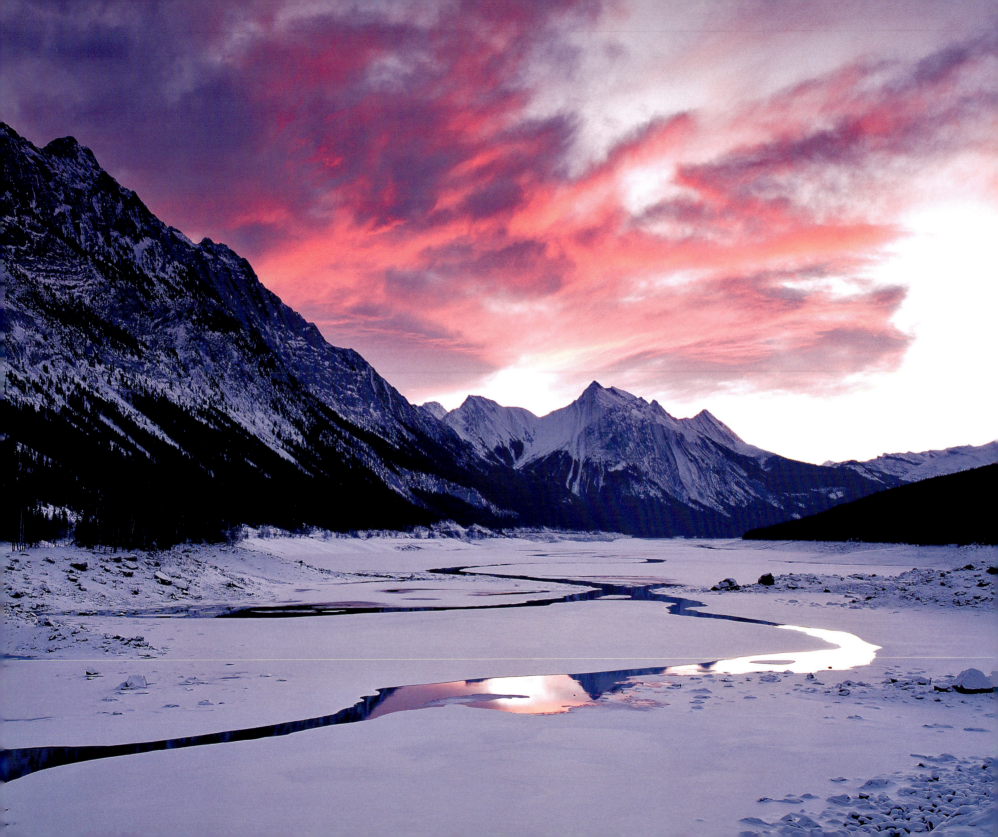

BIG MEDICINE

To look into the eyes of a wolf is to see your own soul – hope you like what you see.

—Aldo Leopold (1887-1948), conservationist, forester and philosopher

The death of the rams left me feeling very unsettled, so I decided to leave the busy highway behind and find some serenity. Volker Schelhas, who runs the Maligne Hostel and is a member of the Jasper Environmental Association, told me there had been a lot of wolf activity in the Maligne River valley southeast of the Jasper townsite. So, I decided to concentrate my efforts there.

The Maligne valley is one of the prime tourist destinations of Jasper National Park, especially the area near Maligne Lake's Spirit Island. Originally, a massive landslide off the surrounding Opal Hills created a natural dam and formed the lake. Few landmarks so perfectly epitomize the Canadian Rockies like the tiny Spirit Island, surrounded by high peaks, pristine forests and turquoise water.

On the way to Maligne Lake I passed Maligne Canyon, where 10,000 years of erosion have created a deep, narrow gorge. I then passed another famous tourist destination, Medicine Lake. Aboriginal people, who avoided the area out of fear of the valley's "big medicine," named Medicine Lake. In the Aboriginal lexicon, "medicine" is synonymous with "power," and (Big) Medicine Lake was named after an aquatic disappearing act that occurred every fall.

Medicine Lake at dawn in early winter. The strange annual water cycle (see text this page) gave this lake its name.

Each summer, the Maligne River carries large volumes of water down the valley away from Maligne Lake toward Maligne Canyon – the opposite direction from where I was heading. Before the river water reaches the canyon, it accumulates to form an eight-kilometre-long lake called Medicine Lake. There is no outlet stream from Medicine Lake, but the water does slowly drain into sinkholes and an underground cave system. Eventually it resurfaces 16 kilometres downstream in the Maligne Canyon. By autumn, when the water flow into Medicine Lake is reduced to a relative trickle, the lake essentially vanishes until the following spring. Before Western science could explain the phenomenon, the annual death and resurrection of a huge lake was Big Medicine indeed.

My heart ached for those sheep. I needed some big medicine of my own.

A thin layer of fresh, trackless snow covered Maligne Lake Road. I was obviously the first to brave the road this morning. I drove toward Medicine Lake, full of expectation and hoping for some magic moments with wolves. I decided to stop at the day-use area and have a look around, but there was nothing but trackless snow to see on a day like this. I drove up and down the road, searching for some clues of canine life in the new-fallen snow. Pulling into the same picnic area some time later, I found nothing once again. I drove up the road and back once more, stopping at the day-use area a third time. Still nothing. I drove on.

When the sun slid behind the mountains, I prepared to head back toward Jasper. I was almost ready to call it a day but decided to try one last time. As I approached the picnic site, I could not believe my eyes. A silver-grey wolf stood in the middle of the road. His back toward

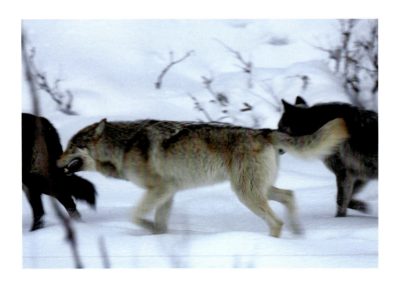

ABOVE: Wolves of the Maligne pack hurry back into the forest after a joyful family reunion. The two groups likely hadn't seen each other for a day or so while hunting for a meal.
RIGHT: Wolves are highly playful, social animals. According to Robert Busch, the social bonds within a wolf family are quite likely second only to those of humans and non-human primates.

me, he stared as still as a a statue. I drove slowly so I could stop on the icy pavement if I needed to, but the wolf did not even seem to notice me. Not even his ears turned to check on the car that came to a stop 20 metres behind him. A bit insulted at being ignored so completely, I turned the vehicle sideways so I could photograph the indifferent wolf without leaving the driver's seat. Just as I was about to snap the shutter, out of the corner of my eye, I saw another wolf running out of the forest to my left. It was a magnificent looking white wolf. He jumped gracefully onto the road and the two wolves ran side by side until they were out of sight. They were gone as silently and mysteriously as they had appeared.

I started the engine and crept around the corner. To my surprise (and joy!) I found not two, but ten wolves running toward each other on the road. Their excitement was palpable, with all of their tails wagging. Some fell to the ground, while others jumped around and licked each other like pups at the dog park. It was pure joy. I had never before (or since) witnessed such a cordial greeting between living creatures. When their party was over, they melted back into the woods. I waited and waited, hoping to hear maybe a howl or two, but the forest remained silent. They were gone.

I counted myself lucky. It was not so long ago when only the ghosts of wolves inhabited Canada's Rocky Mountain national parks, as wolves were exterminated from Banff National Park as early as the 1930s and then again by Parks Canada staff in the 1950s. For much of the 1950s, less than a dozen wolves roamed Jasper. Although the wolf eradication program ended in 1959, it took 25 years for wolves to permanently resettle some parts of the central Rocky Mountains. Yet, as I would learn, albeit unintentionally, the war on wolves in Banff and Jasper is not over. Not by a long shot.

The next morning, I returned to the picnic area to watch the sun peek over the horizon. As soon as I came to my favourite viewpoint, I spotted a few dark dots in the distance. Caribou? No, it was wolves crossing the delta at the east end of what, come summer, would be the lake. I drove as fast as I could to a nearby pullout, jumped out and grabbed my gear. As I ran down the trail, using bushes and trees as cover so the wolves would not see me and run away, I tried to mount

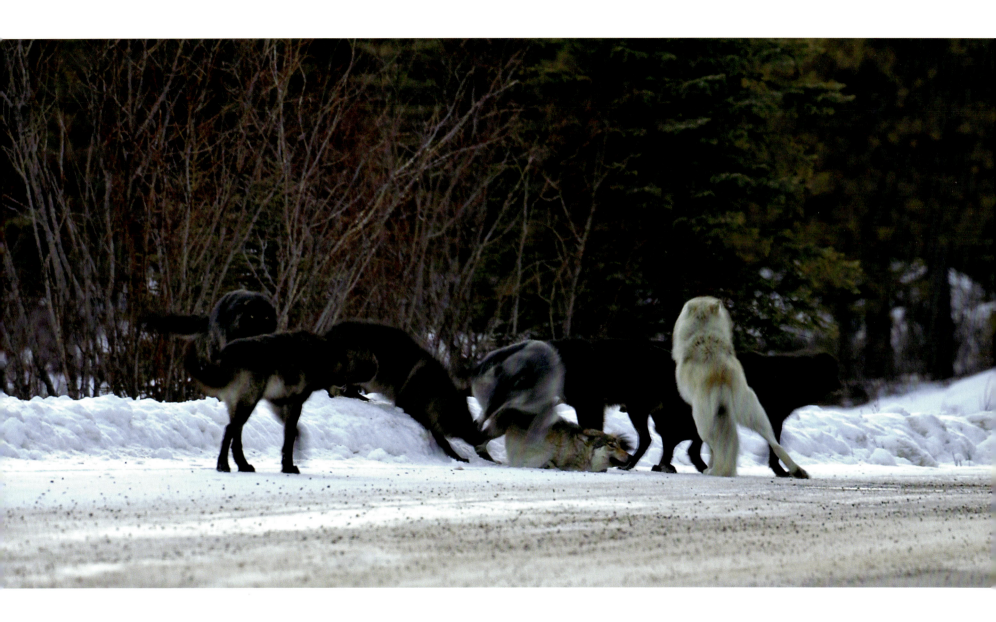

my longest telephoto lens on the tripod. When I finally attached the camera, I slowed and realized that I was the one being watched.

The large, white wolf hid in the trees like snowfall. I recognized this wolf from the previous day. Swinging around, I fell to my knees and tried to hide behind my tripod and huge telephoto lens. With my heart pounding hard in my chest, I felt extremely alert and alive. What the white wolf felt, I do not know. It froze stock still, for what seemed like eternity, before it turned to continue up the trail toward my parked car. One after another, the rest of the pack appeared from the forest like ghosts. Each wolf had the same reaction to me: stopping to stare and then moving on to follow the lead wolf's tracks up to the roadside pullout. Then, instead of fleeing like dogs on a driveway, they all settled into the snow around my Jeep.

Great, I thought to myself. Now I can't even go back to my car!

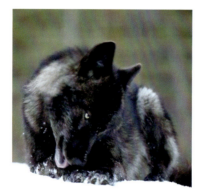

It was a strange situation. Ten wolves lay around my 4×4, totally ignoring me. I paused to admire the large carnivores and a sudden and unexpected rush of fear rose in my chest. The wolves were so relaxed, though. Some were even licking the snow between their toes. With their calm, my fear abated and confidence returned.

Time has no meaning in such situations. I do not know how long the wolves shared their medicine with me. Eventually the silver-grey one, which I later learned was the breeding female, rose to her feet and trotted off down the road. One by one, the wolves followed until they were all gone. Or so I thought.

When I walked in front of my Jeep to check out their tracks, I found one black wolf still lying there licking his paws. He was just as surprised to see me as I was to see him. As he turned to join the rest of his family, I got down on my knees to take one more picture before he disappeared. The black wolf stopped, turned around and very cautiously began to approach me in a crouched position. I knelt in place like a supplicant, one eye glued to the viewfinder, reminding myself that wolves have never attacked a human in the Rocky Mountain national parks.

He came closer and closer until my telephoto lens could no longer focus, which meant he was only four metres away. Peeking up over my camera, I started to feel uncomfortable for the second time that day. I had no idea what this curious canine might do next. Standing up slowly, I stretched my arm toward him while pointing my index finger toward the sky. "Watch it," I said in a calm, firm voice. The wolf whirled around and sprinted toward the rest of his clan.

Big Medicine, indeed.

According to Robert Busch's *The Wolf Almanac*, the grey wolf (*Canis lupus*) originally evolved in Eurasia around 1 million years ago and migrated into North America about 750,000 years ago via the Bering land bridge. Wolves were on the continent many hundreds of thousands of years before the first human appeared. Wolf/human relations disintegrated over time from admiration to pure hatred, and to this day, wolves continue to suffer greatly from a bad image based on misinformation, ignorance and arrogance from *Homo sapiens*, the "knowing man."

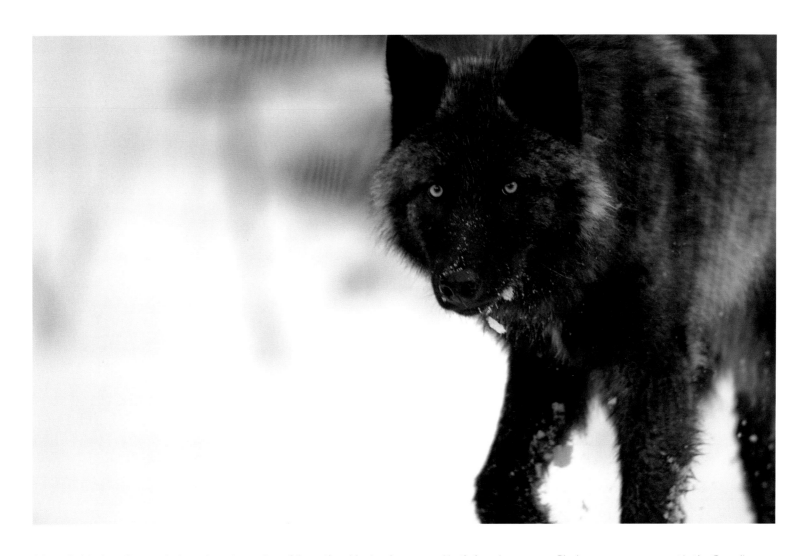

A juvenile black wolf moves in for a closer inspection of the author. Most wolves across North America are grey. Black ones are rare, except in the Canadian Rockies, where they are a common sight (and now south of the border as well since the reintroduction of Canadian wolves into Yellowstone and Idaho).

Roche Bonhomme, also known as Old Man Mountain, resembles the profile of a man's face wearing a feathered war bonnet.

BEARS IN LOVE – PART I

Animals have their comedy and their tragedy like us. They are full of similarity and mutual relationship. The humans mostly believe that there is an abyss between them and the animals. It is only a step in the wheel of life. For all of us are children of one whole. To recognize nature, one has to understand its creatures. To understand a creature, one has to see the brother in it.

From the 1969 preface to *Das Manfred-Kyber-Buch* (The Manfred Kyber Book)

The melting snow and longer days of spring brought new opportunities to photograph and observe fresh life in the Rockies. Later in the season, I decided to visit one of my favourite places in Banff National Park: a meadow not far from Lake Louise. My hope was to catch a glimpse of one of the many grizzly bears that frequented the area.

When I pulled up, at around 9 a.m. on June 2, 2004, I found a man standing beside his RV scanning the meadow with binoculars. I summed the constituent parts – a parked car, a man with binoculars, an open meadow – and deduced that there must be something worth seeing in the tall grass. I grabbed my binoculars and peered into the willows. Just 100 metres from the road, a grizzly bear slept as if it were dead.

I approached the man, hoping to find out what else he had seen. We had only just begun our conversation when a Parks Canada truck

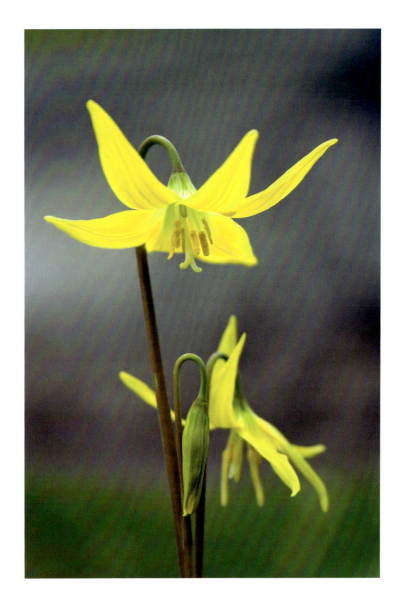

One of the first flowers to appear in the alpine meadows in the spring, after the snow has retreated, is the glacier lily. The bulb-like corms were an important food for some native tribes. It remains a highly important food source for grizzly bears.

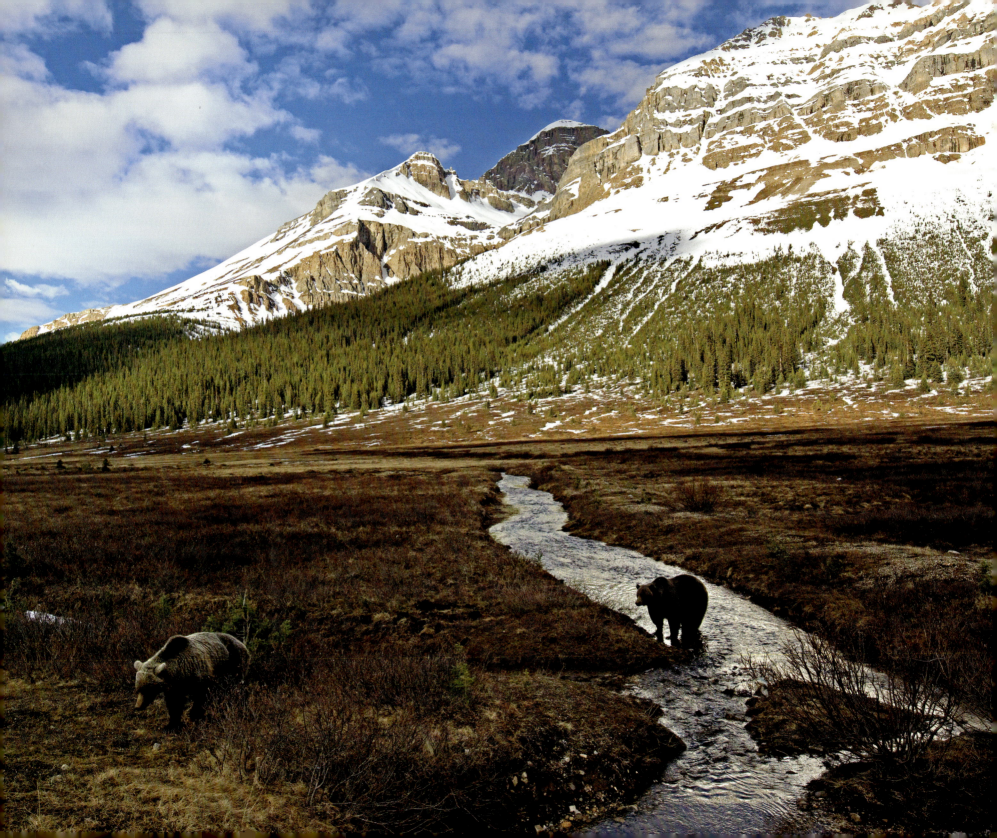

pulled up behind us, its rooftop lights flashing orange. A young park warden got out and walked up to us. He told us, in a firm and humourless voice, to get back in our cars and move on. While I was preparing to leave, I decided to take one more look at the sleeping bear with my binoculars. Just about then, the park warden pulled up and told me to leave the area immediately. I was surprised at his rough and unfriendly tone, as I did not think I was doing any harm. And as far as I knew, I was not breaking any laws.

"Why can't I stay?" I asked. "I'm off the road, my engine's off and I'm sitting quietly. The bear does not seem to mind. It's sleeping."

"The bear is too close to the road and we don't want it to become habituated to people," he said. "We don't want people to stop, so please move on."

Confused and more than a little frustrated, I began to drive away. In my rear-view mirror I saw the park warden pull up near the bear, so I stopped to see what he was up to. To my surprise, he started to blare annoying music from a loudspeaker. "Go on, bear!" he yelled. "Get outta here!"

The bear did not even blink. The warden did not seem amused, though I certainly was.

The flagship species of the Canadian Rocky Mountains, the grizzly bear. The most recent numbers (2009) estimate 60 bears in Banff, 80 in Jasper and 12 each in Yoho and Kootenay national parks, far fewer than many people would suspect for a protected area this size. In fact, the protected areas found in the Canadian Rockies may be too small to ensure a completely safe haven for national-park bears, especially considering that males may have a home range as large as 2,000 to 3,000 km², an area as large as Yoho and Kootenay parks combined (2,719 km²).

A few hours later, I stopped at the Castle Mountain Chalet to fill up my coffee mug and get a sandwich. Inside, I ran into the same park warden, but this time he was a little friendlier. He suggested that instead of focusing on roadside bears, I photograph a grizzly with two cubs known to hang out around Helen Lake, far away from any roads. The warden considered this female grizzly, who turned out to be Bear 36 (Blondie), to be their best example of Parks' attempts to aversively condition bears. Wardens had used rubber bullets and noisemakers to teach Blondie to avoid highways, vehicles and people. The successful conditioning of Blondie, or so the warden said, results in a safer environment for her and her cubs, as well as increased safety for people – a win-win situation, so to speak.

I did not quite understand the logic behind his theory. For one, he chased me away from a sleeping grizzly near the road and now he is pointing me in the direction of a wakeful sow (with cubs!) in a very remote area. Secondly, people come from all over the world to view grizzly bears and other wildlife. To chase the bears and tourists away seems counter-productive. Finally, it seems to be cars speeding that put people and wildlife in danger, not cars sitting by the roadside. Why not target the speeders rather than the people who enjoy viewing wildlife from the safety of their cars? Nevertheless, I kept my mouth shut.

Given that the off-duty park warden was not going to be around to harass me, I decided to return to my favourite mountain meadow. At about 8 p.m., after driving around a little, I finally found the grizzly strolling out of the willows not far from the road. I was thrilled. But wait! There was something else in the bushes. Cubs, perhaps? To my delight, a significantly larger adult grizzly emerged from the bushes. I

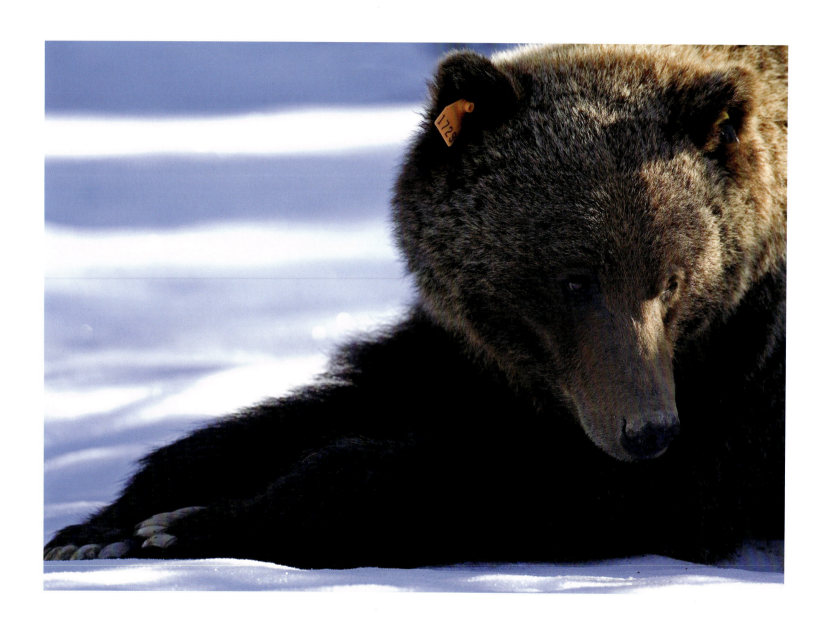

assumed the bear's great size indicated he was a male. Tiny antennae stuck up from radio transmitters affixed to both ears and he wore an orange tag in his right ear, which identified him as Bear 1729.

When the large male closely followed the smaller bear along the roadside, much like a teenage boy in love, I realized what was going on. It was springtime in the Rockies – mating season. For the next 4½ hours I observed and documented the mating rituals of *Ursus arctos*. The bears were either playing and wrestling with each other or digging for roots to eat. Well, the female was digging. The male mostly napped nearby. When they were not resting, eating or playing, they were mating. Between 8:00 p.m. and 9:45 p.m., under the pale light of a large moon, they mated six times.

They decided to rest at 10 p.m., but it was not long before the female grew restless again. Maybe the hoot of an owl got her in the mood or maybe it was just time. Either way, she stood and walked

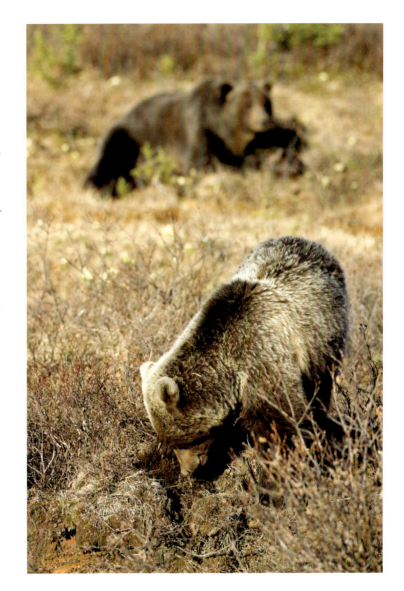

LEFT: Bear wearing an ear tag number and an ear radio transmitter. Capturing and collaring bears is not always easy and harmless. Between 1990 and 2009, four grizzly bears died during capture attempts in the Rocky Mountain national parks. Despite all the scientific research conducted on grizzlies in Alberta, the population continues to shrink, from a historical estimate of 6,000 to a current (2010) estimate of 800 grizzlies in all of Alberta (including national park bears).
RIGHT: While the female grizzly (sow) digs for edible roots, the male (boar) keeps a close eye on her and the surroundings. The ursine mating season runs from mid-May to mid-July. Once a male grizzly has found himself a potential mate, he will try to isolate her from other males and will not leave her side for days.

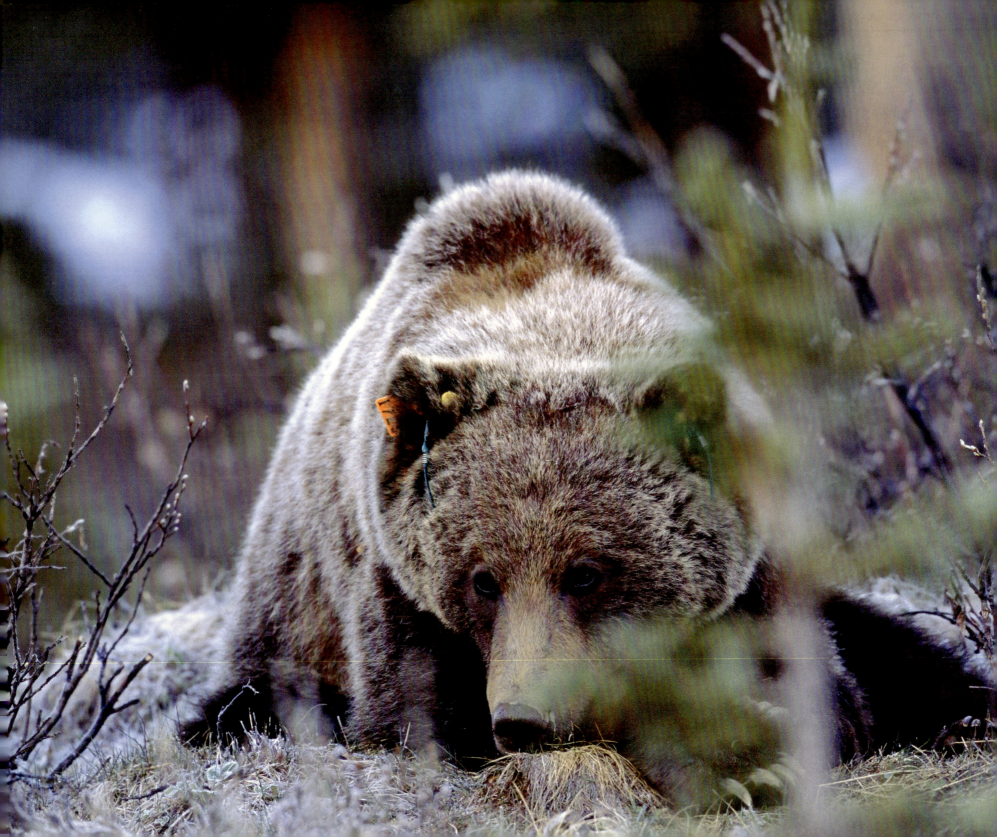

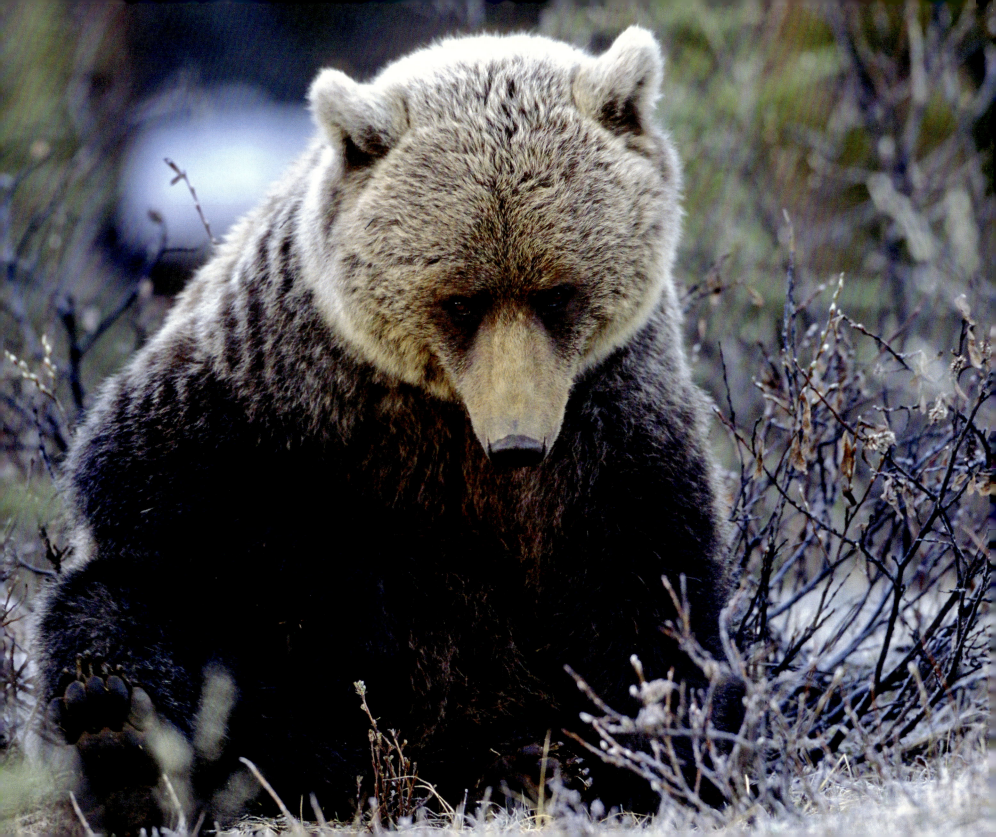

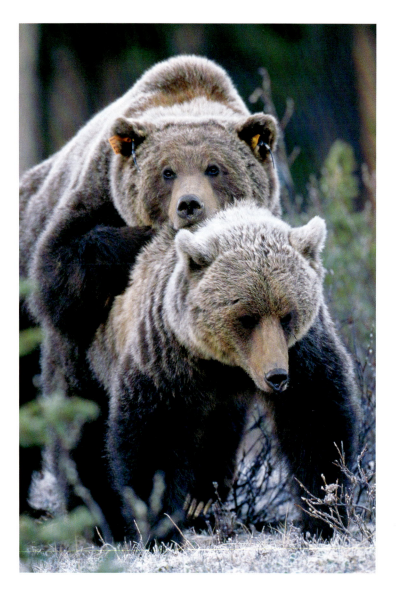

slowly through the meadow, now and again stopping to dig for roots with her powerful forepaws. The activity eventually roused the male. She noticed, rubbed herself on a small spruce and waited for him. He moved in behind her, sniffed the spruce and finally mounted her.

After passing on his genes, Bear 1729 fell asleep on top of his mate with his massive paws dangling down beside her body. Apparently not amused, the female stepped forward to dislodge her partner. But instead of dismounting, he simply marched along in step with her, as if sleepwalking. Finally, she simply turned around and bit him on the nose. But instead of taking her actions as a sign to back off, he took off into action again. It was as if she had inadvertently turned his switch from Off to On. After five minutes, she simply sat down. He seemed content to join her, draping a massive arm around her shoulders and unsuccessfully trying to pull her down on top of him. Finally, he took a well-deserved nap next to his mate. She sat, stared into my camera and massaged her belly with her right front paw for at least a minute. At 10:22 p.m., after a five-minute break, she roused her partner, demanded more action and got it.

As the evening wore on, the bear pair often ran back and forth across the road, which nearly gave me a nervous breakdown. Cars cruised the asphalt in the murky light, some of them at well over the

The bears of the Canadian Rockies have the lowest reproduction rate of grizzlies in North America and one of the lowest known for this species in the world. The reason for this is a combination of poor habitat and excessive human use. Most grizzly bears in the Canadian Rockies do not reach their breeding maturity before age 5 to 7.

speed limit. In one incident, just as the bruins crossed from one side to the other and disappeared into the nearby bushes, an suv roared past. "You idiot!" I shouted, waving my fist in the air. Where were the park wardens now?

When it got too dark to see anything, I drove back to the nearest town to take a well-deserved nap of my own. Six hours later I was back where I had left the bruin lovers the night before. To my surprise, I quickly found them waiting by the side of the road. By 8 a.m., more and more tourists crowded the roadside, causing what bear managers call a "bear jam." This was not my scene.

I decided to leave the bears and the tourists behind before the wardens showed up. On my way back to Lake Louise I passed the Parks Canada vehicle on its way to deal with the crowd. He certainly has his work cut out for him today, I thought. I hoped the young ursine couple would disappear before the warden arrived on the scene so he would not spoil their good mood.

Heart-shaped rock

PARADISE LOST

The events belong, as it were, to the place, and to tell the story of those events is to let the place itself speak through the telling.

—David Abram, *The Spell of the Sensuous* (1996)

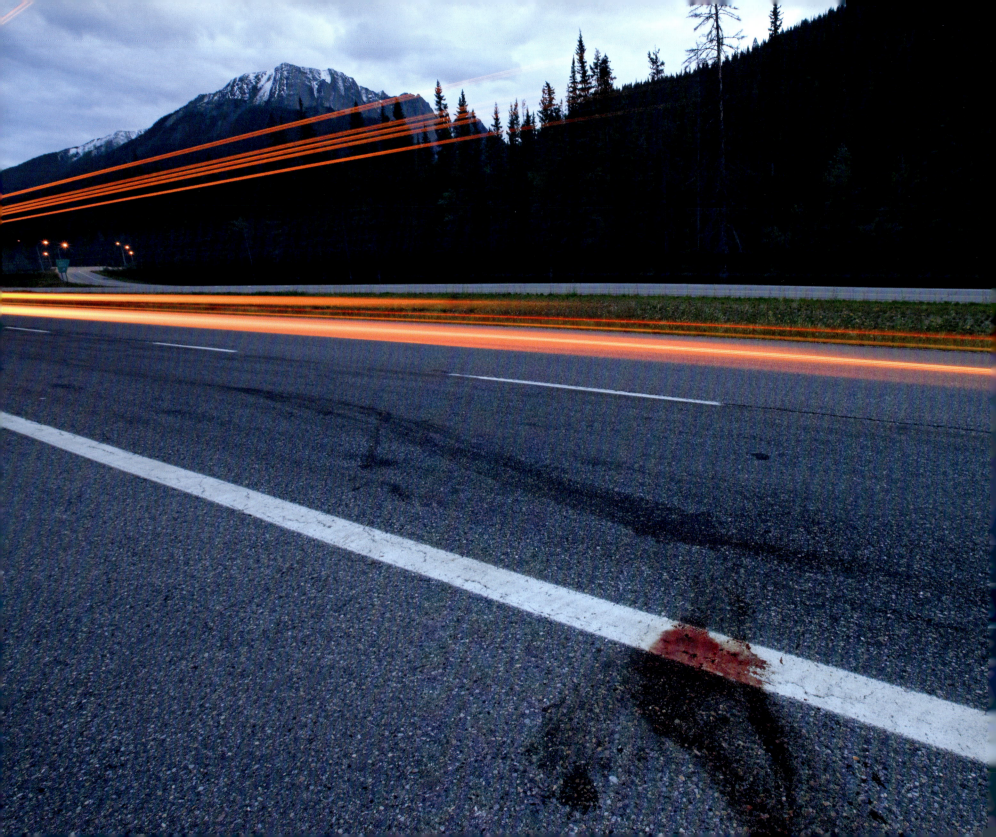

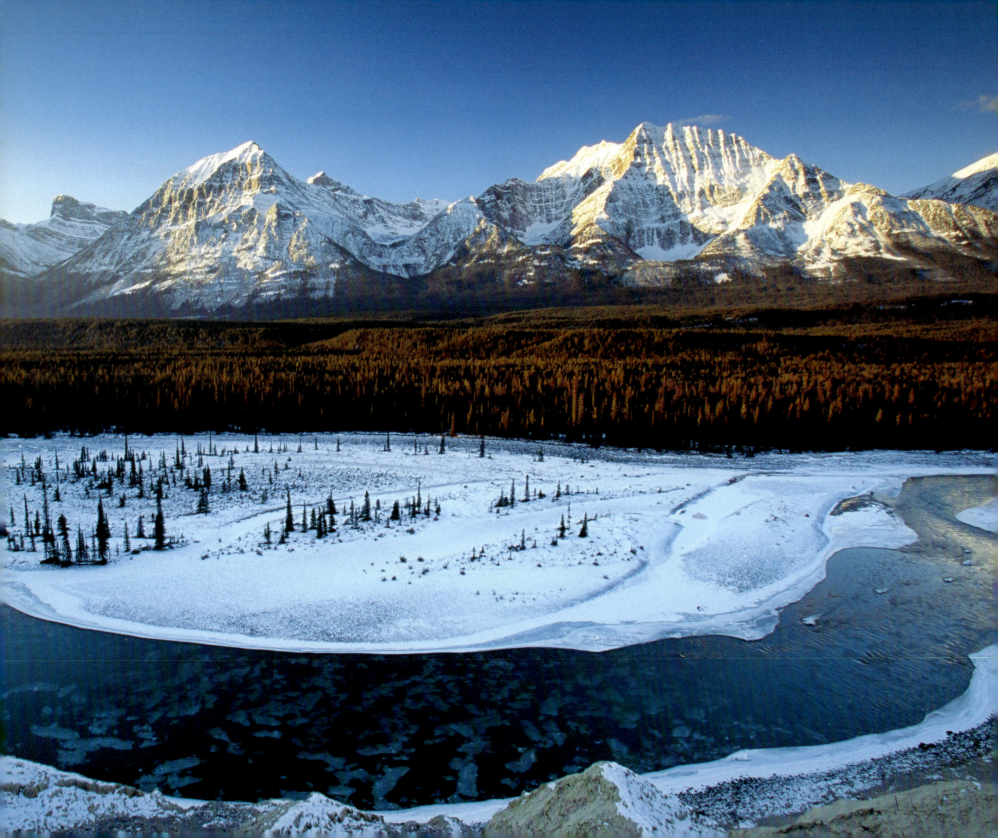

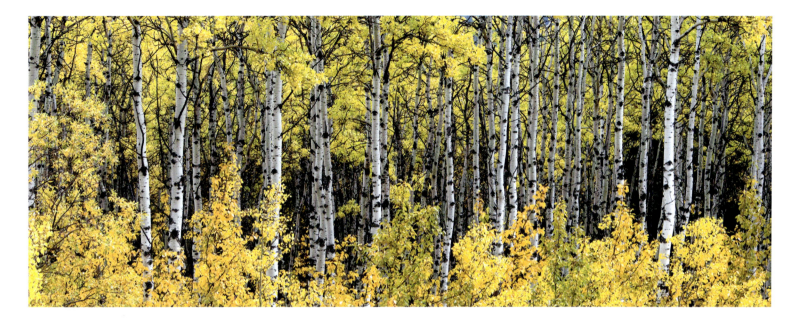

Left: The Athabasca River and the Fryatt range south of the town of Jasper. In Woodlands Cree, *aðapaskÐw* means "[where] there are plants one after another," likely a reference to the spotty vegetation along the river, according to William Bright's *Native American Placenames of the United States*.

Above: A trembling (mountain) aspen stand in autumn. Aspen have an extensive, shallow root system that sends up suckers to produce stands of genetically identical trees (clones). As all trees in a given clonal colony are considered part of the same organism, a single colony can grow to epic size and age. The largest found to date, in the Wasatch Mountains in Utah, numbers some 47,000 trunks spread over about 43 hectares and is thought to be about 80,000 years old, maybe older.

My first couple of years in the Rockies had been an unbelievable success. For a newcomer to Canada's Rocky Mountain national parks, and a relatively inexperienced photographer, I had witnessed and captured many intimate moments in the lives of an amazing array of wildlife: rams rutting, bears mating and wolves playing. I had a home that I loved and a career that I was passionate about. Despite witnessing some of the harsh realities faced by wildlife in the mountain parks, it still seemed like paradise. That, however, was all about to change.

NANUK

For the strength of the pack is the wolf, and the strength of the wolf is the pack.

—Rudyard Kipling (1865-1936), "The Law for the Wolves"

In 2006 I came across an old issue of *National Geographic Destinations* (2000) that detailed some of the threats facing wildlife in Banff National Park and the surrounding areas. I had assumed that national parks were meant to protect wildlife, but busy roads and railways, excessive development and millions of visitors were all taking their toll on the populations. Absorbing this new information was like supping on forbidden fruit, the knowledge altering the very nature of the world I was recording with my camera.

The *National Geographic* magazine mentioned that large-carnivore biologist Dr. Paul Paquet had predicted in the 1980s that unless something was done about the impact of development, wolves in the Bow Valley would disappear by the year 2000. Another concerned researcher, Dr. Carolyn Callaghan, who ran a wolf research project in Banff and the surrounding area, said, "The Bow Valley used to have three packs; now it has one." She continued: "In 1996 three of the four pups born to this pack were lost to the highway. The next year, none of the five pups survived, at least one of which was hit on the railway. During 1998 the pack had no pups and was down to three members."

Many wolves are killed because of human activities in a national park? How could that be? If there is one place on earth where wolves and other large predators should be safe, I thought, it is in a national park. Compelled, I committed myself to photographing the beleaguered Bow Valley wolf family, if only to bring some attention to their plight.

Photographing wild wolves is much like learning to play Bach on the violin: extremely challenging. Most photos you see in glossy magazines or calendars are of *Canis lupus captivus* (captive wolves) that live in small cages on "game farms." For the sake of earning – often quite a few – bucks, game farm owners often keep the genetically wild animals in tight quarters, sometimes living together with other, unrelated animals. Without the ability to roam over great distances or the possibility to create natural social networks among family members, the captive animals often suffer enormous emotional distress. Worse, this unnatural living situation can evoke hyper-aggressive behaviours between animals. Well-known artists, including photographers and filmmakers, are often all too willing to capture this unnatural brute behaviour and misleadingly portray it in their work as normal wolf behaviour. As I was about to observe over the next few years, wolves in the wild are in fact extremely social, caring and supportive of each other.

My aim to document the lives of real, wild-living wolves was easier said than done. Outside of the Medicine Lake area I had only seen wolves twice in ten years of exploring the most remote places in North America – Alaska, the Yukon, and British Columbia's Great Bear Rainforest – and venturing into some of the most isolated corners of the Canadian Rocky Mountain parks. Those two encounters resulted in exactly *one* photograph, taken a year earlier on my way home from Jasper. That day, I encountered a small wolf pup walking along the Bow Valley Parkway. He looked miserable and I sensed real desperation and sadness in his eyes. Worried about the fate of this little wolf

pup, I took a photo and emailed it to Parks Canada with a short note about the pup's health and location. I never heard anything back. Not even a thank-you.

Inspired by my success in the Maligne River Valley of Jasper National Park, I spent as much time as possible in the home range of the Bow Valley wolf family. Unfortunately, other than finding a few tracks, my efforts were fruitless. Ready to give up my plan of documenting wild-living wolves, I decided to spend Christmas and New Year's with my folks in Switzerland. Before leaving, I thought I would try it one more time.

I woke up before dawn, as usual, and drove into Banff National Park, where I came across a single set of wolf tracks. They were already half covered, but they were still clearly visible. I followed them along the road for a few kilometres before they disappeared into the dark forest. I could see how the animal had climbed the steep hill and I noticed a strange line in the snow next to the wolf tracks. It looked as if the wolf had been carrying something long and heavy in its mouth, dragging one end through the snow.

I knew that the wolf tracks were not fresh, so I decided to follow the tracks up a hill not far from the road. It was cold and dead silent. At the top of the hill, I found a place where a wolf had rested beneath a lodgepole pine. He had chosen a nice spot, where pine boughs protected the bed from the snow, which was close enough to the edge of the hill to provide a clear view of the surroundings. I looked around. Lying in the snow beside a second wolf bed, also underneath a lodgepole pine, was the leg of a mule deer. Now understanding the strange marks alongside the wolf tracks, I took a closer look. The leg was chewed to the bone, only the hoof was still intact. Signs, everywhere signs. But no wolves.

During my year-end holiday in Switzerland, I met with former Swiss game warden Georg Sutter at his home near Ilanz. Earlier that year (2006), Georg had been instrumental in my successful attempt to photograph one of the first wolves to return to Swiss soil. Only about six lone wolves roamed all of Switzerland at that time. All of them arrived from Italy to recolonize their long-lost hunting grounds in the Swiss Alps after being eradicated by humans about 150 years earlier.

During my visit I told Georg about the near impossibility of photographing wolves in Banff. They were secretive and the forests were thick and dark. It was like looking for a needle in the proverbial haystack. I confessed that I was thinking about giving up and moving on to something else.

To my surprise, his eyes brightened. He leaned forward in his seat and said, "Listen, listen." He had heard of a man, a German, who documents the lives of wolves in Banff National Park. "His name is Günther Bloch," he told me, "and he has written a book about this very subject."

Wolves have been extirpated or severely depleted in the central Rocky Mountains twice during the 20th century. It wasn't until the early 1980s that they made a comeback in the Banff Bow Valley region.

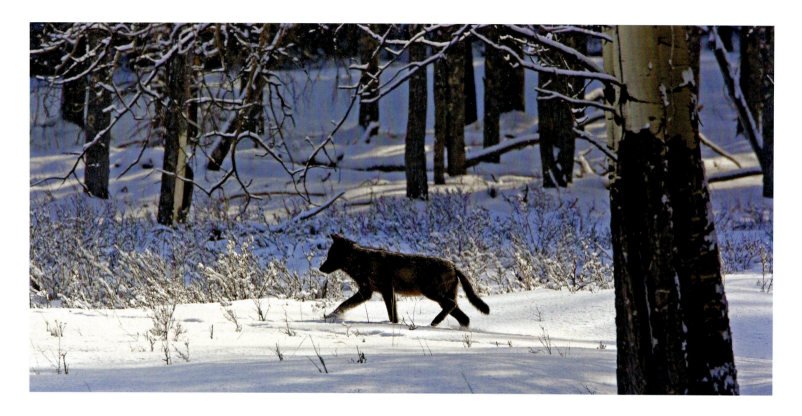

I returned to Canada in mid-January and ordered Günther's book from Germany. Two days later I asked Hälle Flygare, a former Banff park warden turned nature photographer and publisher, to join me on a trip to the Bow Valley in search of wolves. As we drove the curving Bow Valley Parkway near Backswamp, we discovered a grey SUV parked on the side of the road – a sure sign something was afoot. We did not have to wait long before we saw a black wolf cross the frozen Bow River and disappear into the forest.

Hälle got out of the car to find out what was going on. After the briefest of chats, he returned to our car shaking his head. "Those guys aren't very talkative," he said. We waited for a few more minutes and when nothing appeared we left. After dropping Hälle off at home, I decided to return in the afternoon to see if I might get another glimpse of the wolf. To my surprise, I saw the same grey SUV not far from where it was parked that morning. One man was just about to step out of the car: a perfect occasion to chat.

"Did you see that black wolf again?" I said as I approached the car.

"We're not sure if it was a wolf," said the younger of the two. "Maybe just a coyote or something."

"Yeah, right," I thought to myself. Meanwhile, the older man stepped out of the car and came over with his binoculars in his hands. I asked him a few questions but his responses were very clipped and terse, his accent distinctively Teutonic.

Banff. Wolves. German accent.

"You wouldn't be Günther Bloch, would you?" I asked tentatively.

"Well, yes I am," he said cautiously. "How did you know?"

"I can't believe it!" I said with rising excitement. "I just ordered your wolf book from Germany two days ago!"

As it turned out, he had heard of me as well. He had seen my picture of the black Jasper wolf – the one that had approached to within four metres of me – in a downtown Canmore shop and had asked the owner if he knew who had taken the photo.

"Where did you get so close to a wild wolf?" Bloch asked.

I told him about my close encounter with the wolf family in Jasper. His eyes brightened. The ice was broken.

Günther and Karin's story is similar to my own. They came to Canada as tourists in the early 1990s and have returned every year since. The Blochs have extensive experience with wolves: Karin helped raise captive wolves in the US and Günther studied canine behaviour with well-known German wolf ethologist Erik Zimen. When they arrived in Canada, they contacted Paul Paquet, the wolf expert I had read about in *National Geographic*. The Blochs offered to volunteer on Paquet's wolf research project in Banff, where Günther's specialty became observing wolf behaviour at den sites. When Paquet's research ended, Günther continued his field observations for Parks Canada until they "parted ways," as he put it, after disagreements with some staff over wolf management and various other park decisions. Now he and Karin are lone wolves of a sort, continuing their research on the Bow Valley wolves for no one but themselves and the wolves they study.

Over lunch at their place, Günther and Karin taught me all about the Bow Valley wolf family. The names given to wolf families are usually based on a prominent landmark or geographical region that defines the family's territory. The current iteration of "the Bows," as the Blochs had begun to call them, formed when two wolf packs – the Sprays and the Castles – joined in 1994. The story of these wolves, as told to me by the Blochs, is remarkable. As with most living organisms, the ebb and flow of wolf families follows the tides of food, mortality, immigration and emigration.

A female wolf named Aster was one of the founding members of the Bows and one of the matriarchs of the Bow Valley's resurgent wolf population. Born in 1991 in the Spray Valley, Aster was only 14 days old when her mother, Dusk, was killed on the highway. To much astonishment, a young female who had separated from the Sprays earlier in the season, Diane, soon returned to the pack and assumed the role of dominant female. Diane found the orphaned pups, immediately started lactating and raised the orphans as if they were her own. After saving the pups and the pack, Diane was infected with mange – an external parasite intentionally introduced by sheep farmers in Montana back in 1905 to kill wolves. In the fall of 1992, displaced as the dominant female, she became a solitary wolf once again. Despite the debilitation caused by her infection – emaciation, intense itch and vulnerability to other illnesses – she survived the winter alone by scavenging other

wolves' kills and animals killed on roads and railways. Sadly, in late spring of 1993 a train killed Diane while she was feeding on elk remains on the tracks.

Meanwhile, Aster had become the breeding female of the newly formed Bow Valley wolf family. In 1995 Aster and another female bore a total of eight pups, swelling the number of wolves in the Bow Valley wolf clan to 12. This was an incredible accomplishment. After nearly being exterminated twice in the 20th century, wolves began to recolonize Banff National Park in the 1980s. Their return was not because of any enlightened management practices on the part of Parks Canada. Rather, this time the wolves simply had the blessing of a bureaucracy that had learned to tolerate them as an important part of a healthy ecosystem instead of as vermin to be poisoned into oblivion. However, as the Bow Valley became increasingly developed and the highways and railways became increasingly busy, wolves continued to die under the wheels of trucks and trains. By January 1998 the once 12-strong Bow Valley pack had only two survivors: Aster and a male named Storm.

Günther, while telling me this story, stopped at this point to roll and light a cigarette, which accentuated the coming tragic turn. He continued, saying that for a year, there was no sign of pups. Then, in May 2000, Günther discovered two of them: Yukon and Nisha. "We saw Aster the last time on November 5, 2001, at the age of 10 years and 7 months. It's a rare thing for a wolf to reach such an age in the Bow Valley."

Shortly after Aster's natural death, a new wolf wandered into the territory of the Bows. It was 19-month-old Hope from the neighbouring Fairholme pack, which operated in the vicinity of Banff and Canmore. Hope and Storm, together with Yukon and Nisha, founded the next generation of the Bows. Hope bore a litter of six pups, but only one survived a bout of parvovirus, a disease likely transmitted to wolves by feral dogs, which causes gastrointestinal tract damage and dehydration. The sole survivor was a young black male named Nanuk.

Everything went well until just before Christmas 2002, about the time I moved to Canada. The Bow Valley pack was on the hunt, perhaps after elk or moose, in a remote part of their home range, outside park boundaries. When the Bow Valley wolves step outside the national park, they join the ranks of animals that can be hunted or trapped. And so, it happened: snares set by a trapper just outside the national park boundaries killed Storm and Yukon. A few months later, Hope left the Bow Valley in the direction of Kootenay National Park. Another attempt to recolonize the Bow Valley had ended in failure. In early 2003 Nanuk, the only surviving offspring, was the only wolf left in the Bow Valley. He was 16 months old.

Luckily, Nanuk would not stay a lone wolf for long. In February 2004 he mated for the first time with an approximately 3-year-old female that Günther had named April. Nine weeks later, three pups were born: one black and two grey. The cycle continued, and once again only one survived into the fall. Every time the pack seemed like it would bounce back, another tragedy struck. Sickened by the death toll, I could not help wondering how exactly these wolves were protected.

"The stories you and Karin have documented are shocking," I said. "I could never have imagined that wolves have such a hard time surviving on so-called protected land."

"It's a never-ending story," said Günther, his anger rising. "That's the most frustrating part of our job here. We live through so many tragic stories. But it's our life. Wolves *are our lives* and that's why we keep returning to Canada."

The next year, 2005, Nanuk and April had six pups: four black and two grey. All went relatively well until June 28. April and Nanuk were

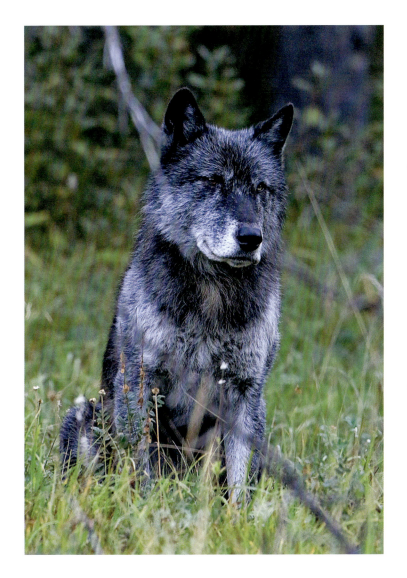

Nanuk, a true survivor, at the age of 5½ years.

hunting elk when April was struck hard by a well-aimed hoof. Her injuries were severe and she eventually died. The pups all succumbed to starvation.

Ever the survivor, Nanuk found himself another mate by the end of 2005, a black wolf named Delinda. "I love Delinda," said Günther, "she is my favourite wolf." Nanuk and Delinda raised four pups in 2006. A car on the Bow Valley Parkway killed one and injured another badly. "But Delinda showed us what a good mother she was," explained Günther. "We documented on film how she transported food to the injured wolf. Once, in November 2006, for example, she carried a deer head over nine kilometres."

"That's it!"

"What's it?" asked Günther.

I told Günther about the strange tracks I had found on the parkway last December just before I left for Switzerland. "It looked to me like a wolf was carrying something in its mouth. I decided to check it out and found an old deer leg that was chewed down to the bone."

"Yes, that's exactly what happened," said Günther. He continued: "Those were probably Delinda's tracks. Unfortunately, the injured one didn't survive after all. But the good news is that two pups – Chinook and Lakota – did survive. The Bows are up to four wolves. That's the situation now. Hopefully, Delinda, Nanuk and the new pups will be able to rebuild the family. Too bad Karin and I have to go back to Germany for the summer. It'll be your job to document what happens while we're gone."*

* My subsequent collaboration with Günther and Karin Bloch resulted in our book *Auge in Auge mit dem Wolf: 20 Jahre unterwegs mit frei lebenden Wölfen* (*Eye to Eye with the Wolf: 20 Years with Wild-living Wolves*), which documents many detailed behavioural observations and a 20-year story of wolves in Banff National Park.

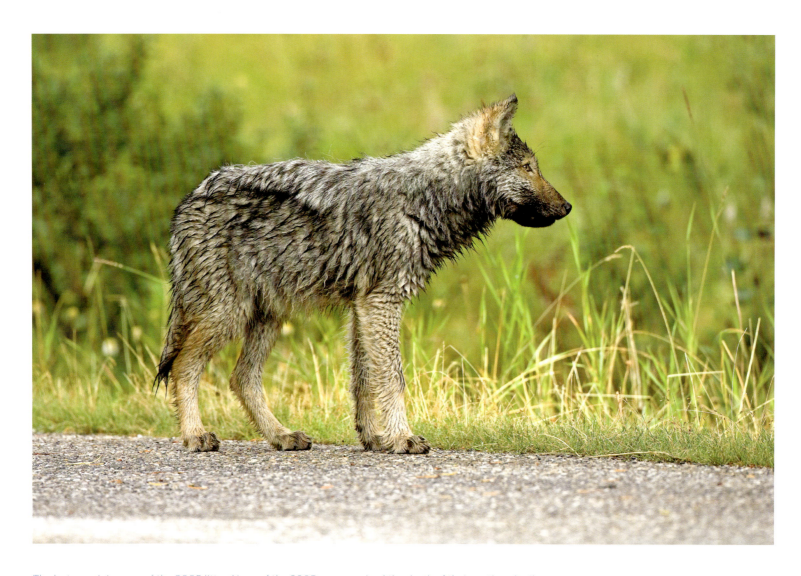

The last remaining pup of the 2005 litter. None of the 2005 pups survived the death of their mother, April.

ALONE WITH THE BOWS

The naturalist is a civilized hunter. He goes alone into a field or woodland and closes his mind to everything but that time and place, so that life around him presses in on all the senses and small details grow in significance. …The hunter-in-naturalist knows that he does not know what is going to happen. He is required, as Ortega y Gasset expressed it, to prepare an attention of a different and superior kind, "an attention that does not consist in riveting itself to the presumed but consists precisely in not presuming anything and avoiding inattentiveness."

—Edward O. Wilson, *Biophilia* (1984)

The one activity that I loved most in Switzerland was walking quietly through the forest. Now in Western Canada, the forest is a place where cougars, black bears and grizzlies still roam wild and unfettered. For safety, it is recommended that hikers travel in groups and make lots of noise, a precaution I could not afford. If I wanted to get serious about documenting the lives of the Bow Valley wolves, I had to move slowly and quietly through the woods.

My goal was to find the wolves without causing them so much as a whisper of disturbance. Günther had learned his initial observation skills in the spring of 1992 from wolf expert Paul Paquet. Passing along some of that knowledge, Günther left me with precise instructions on how to conduct these delicate operations. Despite the tutelage, unobtrusive observation in the deep Canadian wilderness was a daunting task, so I decided to rally some in-person expert assistance.

Georg Sutter, happy to bring his wide-ranging knowledge of wildlife behaviour to the project, flew in from Switzerland during the first week of June 2007. For over 30 years, Georg was a professional game warden in Switzerland's Kanton Graubünden (a kanton is similar to a province in Canada). Like game wardens everywhere, he performed many roles. Mostly, though, he managed hunting and protected wildlife populations – eagles and grouse to red deer and ibex – from human disturbance and poaching. When a lone wolf appeared in Graubünden, in 2002, Georg followed the newcomer's every move by documenting its tracks, scat and kills. I knew he would be an invaluable asset to help find the Bow Valley wolves.

Guided by Günther's knowledge of the area, George and I searched the Bows' territory for signs of recent use. Eventually we had a good sense of the areas they favoured, so we decided to focus on one particular place where Delinda and company passed through regularly. Rather than charge in like unwanted wedding guests, we set up a discreet observation post that offered a broad view of the area. Morning after morning, we observed for hours and hours, for many days. We did see a lot of wolf activity, but there was no sign of pups.

One day, while I was pouring a cup of strong coffee from my Thermos to keep me awake, I saw some movement in the bushes about 100 or so metres in front of me. I stopped, the cup half full, and waited. What was it? A moose? An elk? An instant later, a grizzly bear materialized from behind a massive spruce. I watched with anticipation while the bushes continued rustling. When the second grizzly scrambled out from behind the spruce, I nearly spilled my now totally unnecessary coffee on my pants.

I tapped Georg on the foot and pointed for him to look. Georg had never confronted a grizzly before, never mind two of them. Although

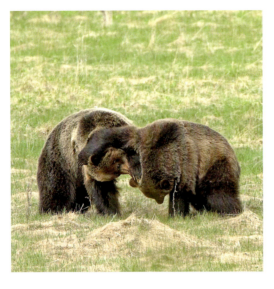
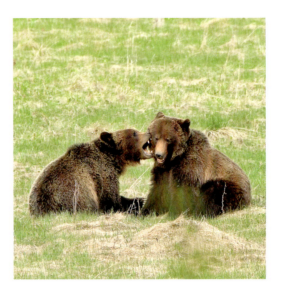
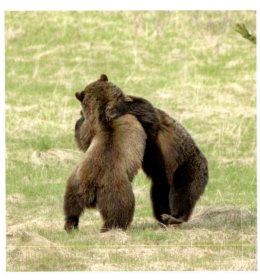
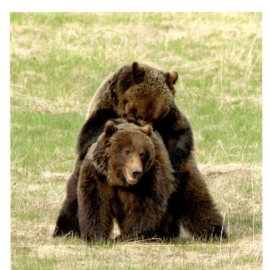

he was a professional game warden, Switzerland had long ago rid itself of bears. His eyes grew wide, indicating a combination of surprise, joy and worry – the same response many of us have when we see a bear in the wild for the first time.

I do not know if they saw us or not, but we decided to give the bruins some space. As we backed off, the bears moved on into an open meadow and started to wrestle like overgrown teenagers. They stood on their hind legs and tried to pull each other off balance. One of them was slightly smaller than the other, but not especially so. Their behaviour was similar to the mating pair I had seen previously, but I never got the sense that these two were courting. I believe they were siblings that had been chased off by their mother the year before. They may have denned up together last winter as they made the transition from family life to a more solitary existence. Georg and I watched them play from a safe distance and took a few photos before retreating to the car.

A week later, sleep deprived and overflowing with memorable experiences, Georg left for Switzerland. Even with his helpful assistance, I still had not determined whether the Bows had newborn pups. With Georg gone, I continued the search on my own.

Soon I found trampled vegetation and scattered bone fragments in a small meadow, which suggested that wolf pups may be using the area as a playground. Beyond these visual signs, I also caught several auditory clues of high-pitched wolf pup voices. Once I had located the approximate location of the newborn wolves, I decided to avoid this most sensitive area for the sake of remaining incognito. "If I hide nearby long enough," I thought to myself, "I might just get lucky and see one of the pups from the distance when it is exploring the greater surroundings." So, I sat under the dense branches of a spruce tree for days on end, with mosquitoes swarming me like tiny fighter planes. There were sunny days, spruce trees and hundreds of misery-inducing mosquitoes, but no wolf pups.

On July 3, 2007, after four hours of sitting in perhaps the most uncomfortable position imaginable, I decided to give up. As has happened so many times, just as I was about to leave in a huff of disappointment, something magical transpired. As I was stretching my arm out to remove the camera from the tripod, I saw some movement in the willows. I held my breath and slowly withdrew my hand. The willows parted, revealing a black wolf pup. It was about 10 weeks old.

The young explorer focused on something in the middle of the meadow. He took a few small steps forward and filled my viewfinder. I pushed the shutter. CLICK. The tiny wolf jumped back and looked around with a *what was that* curiosity in his eyes. Then he stepped cautiously forward again, looking directly at me hidden beneath the tree. He obviously did not know what to make of me. All he saw, I imagine, was the big, round mirror of my lens poking between the tree branches. CLICK. That was it. He disappeared as quickly as he had come.

I saw four different young wolves over the next six weeks, but I kept hearing rumours about the Bows' new pups. A tourist had photographed four of them from the window of a train, but Parks Canada had recorded five pups at one of their camera traps. Where was the fifth one?

Bears are very playful animals and they show this through a variety of behaviour. They can entertain themselves with a stick or an old bone or, without a doubt the most fun to watch, have a wrestling match with a sibling. After separating from their mother, young bears may choose to stay together with their sibling for some time.

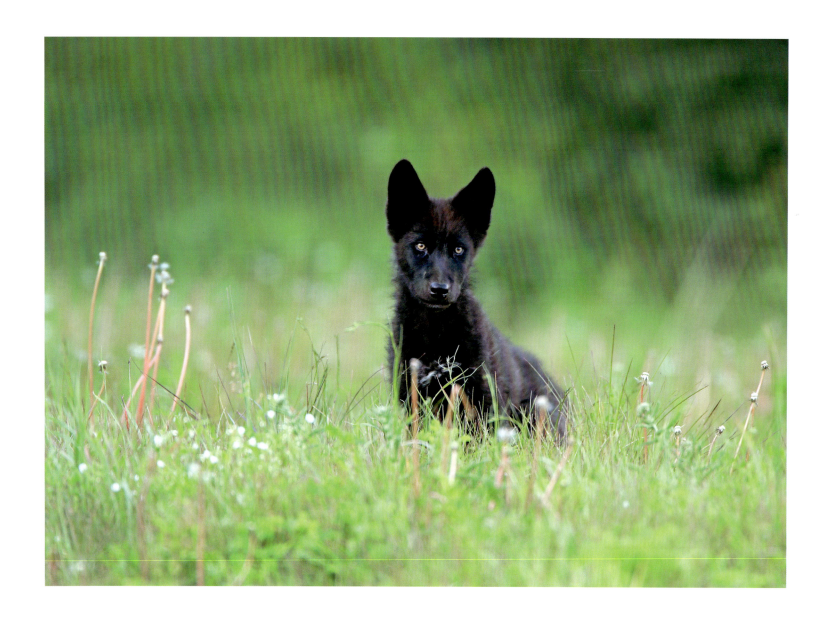

LEFT: Wolf pups are both blind and deaf when they are born and only weigh about 225 grams (half a pound). Their eyes open at about two weeks, their ears at about 20 days. By five weeks the pups have grown considerably to about 6 kilograms (13 pounds). Between 5 and 10 weeks, wolf pups develop from dependent toddlers to active individuals. They are by then able to explore their immediate surroundings, to interact and to learn from their physical and social environment. The image shows Sundance at the age of about 10 weeks.
RIGHT: Revisiting a site to photograph an oddly located elk skull, I discovered that the tree had been blown over. The skull was still attached but was now facing toward the sky.

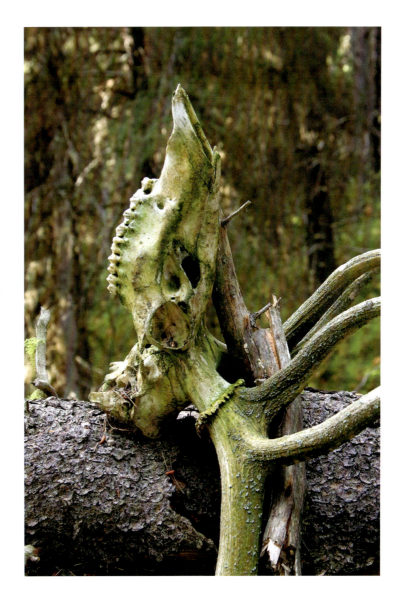

Up until this point, my strategy had been to hunker down at prime observation spots and wait for hours (and days and even weeks), often without seeing anything. I knew I had to change my tactics, so I started to walk the woods more often, trying to find new clues. One hot afternoon in mid-August, I stumbled upon a strange sight while following one of the most heavily used game trails. I found the skull of a bull elk, complete with its magnificent antlers. Its location was the bizarre thing: the skull was trapped between two trees, about one and a half metres above the ground and facing downward. I found no other bones. It was as if it had been placed there on purpose.

As I tried to figure out what had happened, I came under attack. A spruce cone landed hard on my head, then another, another and another. What the hell? I jumped back as another cone flew down, just missing my face, which was tilted upward looking for the culprit. A red squirrel, busy at his work, was high up in the tree and did not even notice me. He was harvesting cones for the long winter, which he would pick off

the branches and throw to the ground. Amused by the machinations of my attacker, I grabbed my camera and documented the bombardment.

As a nature photographer, I thought I already had a deep connection with the natural world. Yet, I realize that my search for wolves, in both Canada and Switzerland, has intensified that connection exponentially. I have developed an understanding of what it might be like to be a wolf and how wolves work. For instance, walking dozens of kilometres of trail has enhanced my awareness of the strategic placement of scat. Wolves place their scat at deliberate locations, such as important intersections or trails, to leave behind information that details who uses the area and how often. When I find a well-used trail with a lot of fresh scat on it I avoid it in the future so I remain as incognito as possible by not leaving my own scent and marks.

My senses have become extremely sharp, as I have learned to rely on smell and hearing more than ever before. I can home in on a dropping pinecone, each tap of a woodpecker or a branch rustling in even the slightest breeze. I can even now discern the musky smell of elk and deer that have come and gone before me. The world has exploded into an ecstasy of experience that I had never known until now. My work with wolves has allowed me to know nature intimately: its rituals and seasons, its plants and animals. Its mysteries. The wolf, indirectly, has truly introduced me to nature, teaching me what it is and how it works. They remind me that humans are not nature's ruler, just one equal part of its complex wholeness: different, but no more important than the red squirrel, the wapiti or the grizzly bear.

Perhaps we are similar to the beaver in the way we transform our surroundings to suit our needs and desires. But contrary to the beaver, our activities have begun to diminish the quality and quantity of life around us. What we call "natural resources," as if the diversity of life on Earth has been nurtured for millions of years simply to satiate our desires in the technological age, are suffering. Our voracious appetites have polluted our water, altered our climate and begun one of the most severe extinction events in the history of the planet. We need to rethink our relationship with nature. Only through direct contact with the natural world – observing, listening, smelling and exploring – are we truly able to look beyond ourselves and understand how we are connected. Walking in the woods and observing the animals, especially the large carnivores like wolves and bears, intuitively reminds us of who we are, how we came to be here and how to proceed into the future.

With thoughts like these heavy on my mind, I left the chattering squirrel, who by now had noticed me. Admiring the mystical elk skull one more time, I turned and walked into an opening in the forest. Then I saw a black shadow flit through the trees. My luck had returned along with the ghosts of the forests! Chinook, one of two surviving pups from last year's litter, strode through the trees, but she was not alone. Following soon after was Delinda and her *six* beautiful

This red squirrel is not bombing the photographer out of protest, but simply harvesting spruce cones that will support it through the winter.

The Bow River flows quietly through the Banff Bow Valley at dusk. The Bow Valley is the ecological heart of a larger ecosystem that extends far beyond the legislated boundaries of the national park.

wolf pups: three black and three grey! Forget the tourist's photo of four pups or Parks Canada's images of five; there were six!

Delinda led the family slowly up the trail, the pups dashing here and there to investigate. Finally, they all walked down to the bank of the Bow, crossed the railway tracks, and as a train approached, swam across the cold, clear river. I was impressed by their fitness and the fearless behaviour of the juveniles. On the far bank, they jumped onto the stony beach and disappeared into the woods toward what I assumed was their new rendezvous site.

It had taken me over four months to find out how many pups had been born into the Bow Valley wolf family. I could not wait to report the good news to Günther and Karin, who were still in Germany. How exciting, ten wolves! After all those years of tragedy, it looked like the Bows were back in full force.

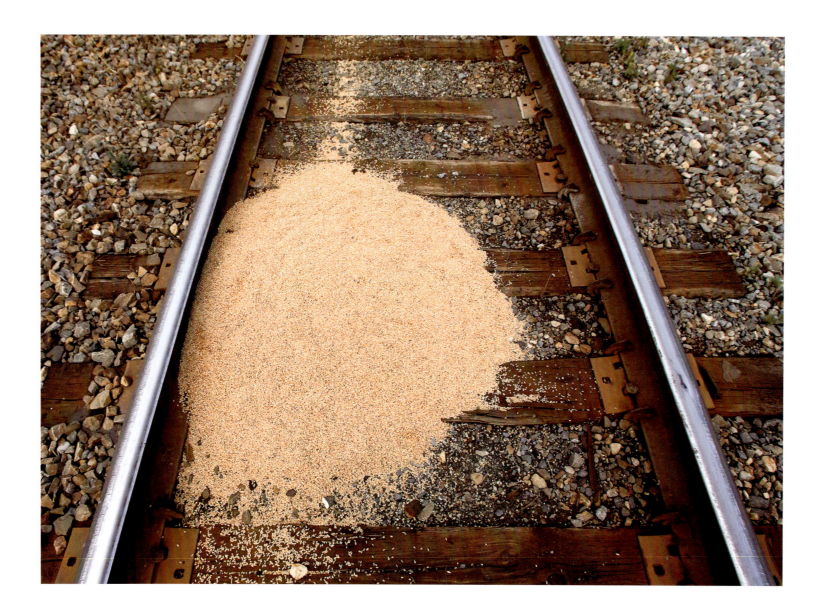

DEADLY TRACKS

Today's problems cannot be solved if we still think the way we thought when we created them.

—Albert Einstein (1879-1955)

On the way back to my car, a strange pile between the railway tracks caught my eye. It looked like golden sawdust. But why was it there? As I got closer, I realized that a huge pile of grain had spilled from one of the Canadian Pacific Railway's westbound hopper cars. Spilled grain is one of the most serious causes of wildlife mortality in Western Canada, particularly in Banff National Park. Whether it is abandoned along the tracks or accumulates on the platforms at the ends of hopper cars, displaced grain attracts all sorts of animals, from chipmunks to grizzly bears. Unfortunately, the promise of quick calories too often results in devastating consequences.

There are an astonishing number of stories about the extraordinary costs paid for spilled grain, but I will touch on just a few. For instance, a female grizzly, Bear 66, was killed by a train on August 19, 2005, at CPR mile 92.7. She had three young cubs at the time of her death. Three weeks later, two of her unattended cubs were killed by traffic on the Trans-Canada Highway after they climbed through the fence at Vermilion Lakes. Parks Canada felt that the remaining cub, Mistaya, could not survive on his own, so they captured and relocated him to the Calgary Zoo until June 2008, when he was transferred to a new permanent exhibit at the Saskatoon Forestry Farm Park and Zoo.

On May 26, 2007, a black bear sow known as Bear 6 and her three cubs climbed onto a CPR train near the BC–Alberta boundary. They were not hitching a ride; they were after the spilled grain on a hopper car. Bear 6 jumped off as the train started to move, but her cubs stayed on and ended up in Field, BC, about 20 kilometres west. I can only imagine the sow's stress when she realized her cubs were gone. Fortunately, Parks wardens reunited them. Two days later, two of the cubs ended up on another train to Field. They were reunited one more time, but the story does not end there. Ultimately, Bear 6 came out of her den with three tiny cubs and re-entered it at the end of the year alone. According to warden Hal Morrison, one cub was killed on the highway, but what happened to the other two is open to speculation.

During his visit, Georg expressed his concern about the highway and railway. I agreed, but mentioned the existing highway wildlife crossing structures between the east gate and Lake Louise, with more being built today. Georg, a seasoned naturalist and keen observer, pointed out that some of those crossing structures lead the animals right into the "fangs" of the railway. "No wonder so many animals get killed here," he said, "Just look at the vegetation near the tracks: beautiful

Grain spillage is a constant and unsolved problem in the mountain parks and it attracts hundreds of animals to the tracks, from chipmunks to elk, from bluebirds to the mighty grizzly bear. Both CPR and CN purchased a single vacuum truck to clean up some of the spilled grain in the parks (CP owns two trucks, one operating in Banff and Yoho national parks, the other in the Revelstoke area). It is worth noting that a vacuum truck operates only five days a week from mid-March through late October. No vacuum truck is designed to operate during the long winter months, which is when the largest volumes of grain cross the Rockies.

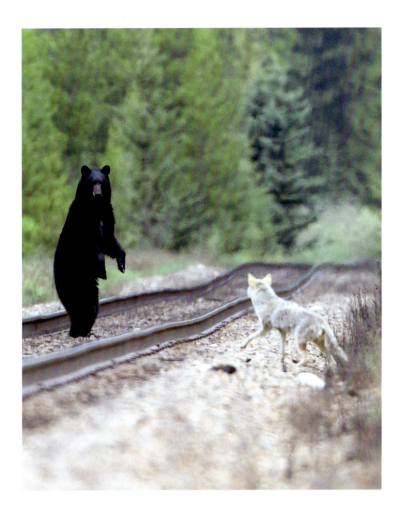

and irresistible. And once an animal gets hit by the train it attracts other wildlife, which feed on the dead animals and soon get hit too."

Georg's remarks reminded me of the words of former park warden Hälle Flygare, who was one of the first to propose the idea of fencing the highway in the late 1970s. On the day Hälle helped me to search for wolves, the same day I met Günther for the first time, the former park warden said that although the fences have reduced ungulate mortality, they have not stopped the killing of wolves, coyotes and bears. Many animals simply slip through holes or climb over the fence to meet their deaths. "And," Hälle added, "[the fences are] certainly no solution for these bloody trains."

As I pondered the pile of golden grain at my feet, a large white truck drove toward the tracks. It was the CPR's vacuum truck, designed to suck up any grain spilled on the tracks. "Wow," I thought, "weeks go by with nothing and today I'm overrun with great photo opportunities." The truck drove up onto the rails and moved in my direction. It stopped right in front of the grain spill and a middle-aged man stepped out.

"How you doin'?" I asked in my most polite voice possible. "Is it okay if I document your work here?"

"Sure," he said, returning to his truck to inhale the mass of grain with his industrial vacuum. After he had finished, we chatted for a moment,

While the vacuum truck may clean up the larger spills, small amounts of grain remain on and near the tracks and it keeps on attracting all sorts of animals, such as this black bear and coyote. It is not unheard of that fully loaded cars sometimes end up empty at their destination on Canada's west coast, meaning some cars drip as much as 100 tons of grain on the tracks along the way. When larger spills occur, some animals are at times able to eat more grain than their digestive system can handle and it puts them in danger of dying of septic shock.

during which he commented: "Yeah, we always get the blame, but look at the highway. How many animals get killed there? But once a grizzly bear gets killed by one of our trains, then we're in the headlines again."

I knew he had a good point. "Nonetheless, the trains with all their grain are a huge problem for wildlife, wouldn't you agree?"

"Sure, but look, I'm working my ass off here. We only have one vacuum truck for this district, which includes everything east of Field, and I'm not always able to get here quickly enough to remove the grain spills. I have many, many miles to check and clean. I'm doing my best."

"Do you have any idea how many animals get killed?" I asked.

"No, not really, but lots, that's for sure." He continued: "We had three moose hanging out between Vermilion Lakes and Backswamp for a while. All of them got killed by the train. No wonder we don't have any moose around here anymore."

On October 27, 1883, the CPR laid tracks near the foot of Cascade Mountain, creating the base of what would soon become Banff's railway station. Symbolically, this time represents the beginning of an epoch during which transportation routes increasingly threaten the wildlife of Canada's Rocky Mountains. Reports of animal fatalities began much earlier, but by 1955 the office of the Chief Park Warden recognized the serious problem in a report that read: "It is evident … that the railroad and highways are the greatest wildlife hazard in [Banff National] park." Yet, still today, the impact of transportation routes on Banff's beleaguered wildlife population, including the highly sensitive grizzly bear population, endures as one of the greatest concerns.

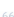

In June 2007 the *Rocky Mountain Outlook* reported that the "Canadian Pacific Railway has wiped out an entire family of grizzly bears in Banff National Park." First, on June 18, a train near Five Mile Bridge killed a grizzly sow with two yearling cubs. Park wardens left her two yearling cubs, a male and a female, to survive in the wild.

Within 24 hours, trains had killed both of them.

"We are really saddened by it," CPR spokeswoman Breanne Feigel told the *Calgary Herald* on June 20. "It is definitely a tragic loss. It is not something we take lightly."

The CPR may be saddened by these deaths, but after over a century of ample opportunity and technological improvements, they have still not managed to solve the problem! The railway is the single largest killer of grizzlies in the Rocky Mountain national parks. Of course, it is not just about grizzlies; the number of other wild animals killed every year on railway lines is nothing short of shocking (see also pp. 186, 187 for more details).

In 2007 alone, CPR and CNR trains killed a combined 17 bears in Banff, Jasper and Yoho national parks. It is important to note that these are only the confirmed dead animals. The true number is certainly much higher, especially where a mother bear is killed and leaves helpless cubs behind. Among the dead in 2007 was the entire grizzly bear family shown in this picture.

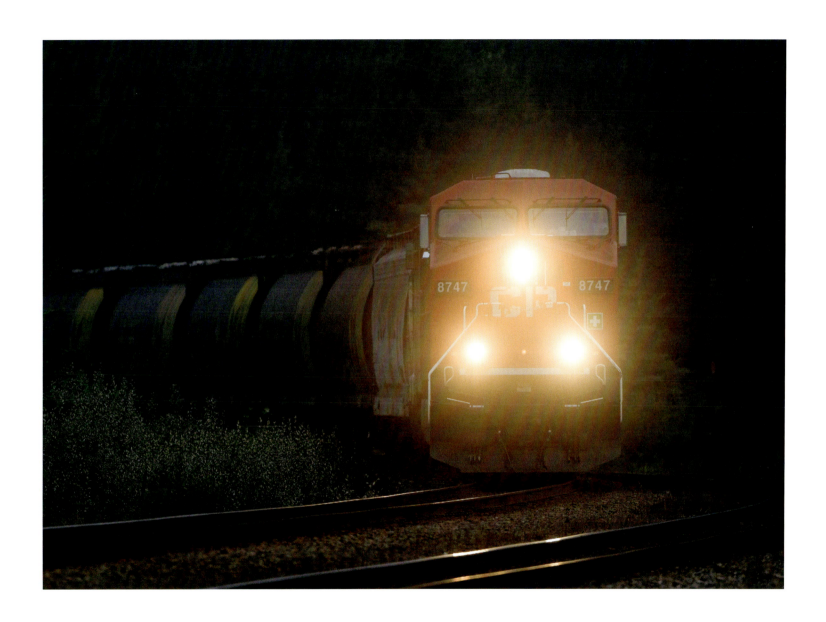

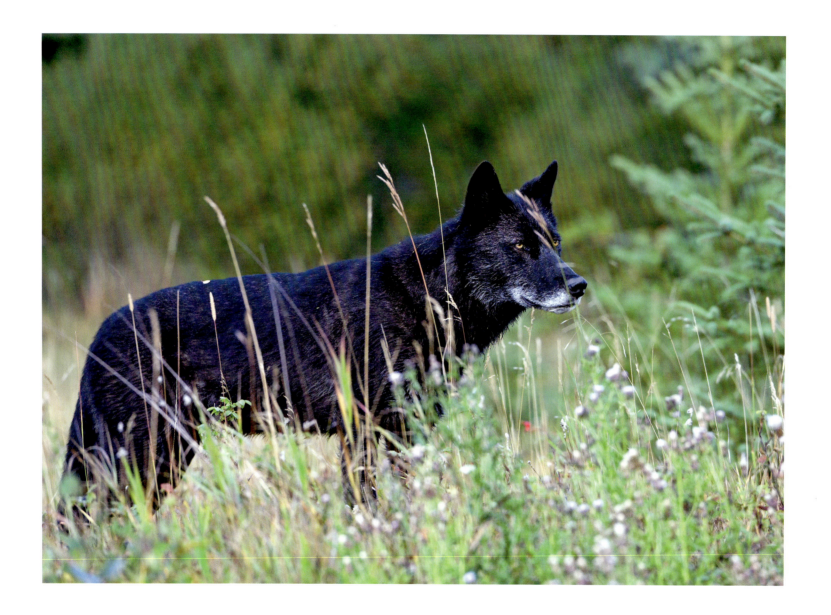

JOINING THE HUNT

*The caribou feeds the wolf, but it is the
wolf who keeps the caribou strong.*

—Old Inuit saying from the Kivalliq Region in northern Canada

Late summer provided some of the best wolf-observation opportunities of my life. The Bows moved their pups to a rendezvous spot close to the Bow Valley Parkway, which enabled me to see them more often. The pups were about 4 months old and had grown considerably. They were now rambunctious (if small) members of the pack, running, playing and fighting like German shepherd puppies.

Since their first days with the wolves, Günther and Karin have named each one in order to keep track of them. Unlike some biologists, who prefer numbers so they do not become too attached to their subjects, Günther and Karin chose actual names to identify them. Together, the three of us named the six pups of 2007. We named the four females Mickey, curious, independent and grey-brown; Fluffy, very dominant, with a fluffy coat streaked with grey; Sundance, the shy black pup I had photographed in the spring; and Ranger, a reserved, submissive black pup named after the creek where I first photographed her. Then there was Silvertip, the black, long-legged male with silverish fur; and White Fang, a large, very social grey male with a very distinctive white muzzle.

I often found the family near, or even on, the road. They seemed to recognize my blue Jeep. In fact, on more than one occasion, one of the wolves would show up on the road, look at me and go about its business. If another car showed up, however, the wolves would all

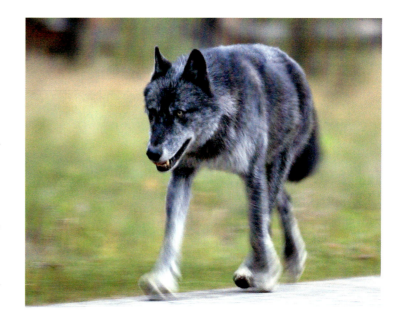

Who's the leader of the pack? Erik Zimen wrote in 1981: "No member decides alone when an activity is to begin or end, or which way or at what speed the pack is to move, or exercises the sole power of command in any other activities that are vital to the cohesion of the pack. The autocratic leading wolf does not exist." It is because of this kind of observed knowledge that many wolf researchers do not use the term alpha wolf anymore, because it implies a strict family hierarchy. According to Mech and Boitani, such a strict hierarchy, from alpha wolf to omega wolf, can't be documented in the wild. In the case of the Bow Valley wolves, Delinda (to the left) was more often than not the decision maker. But this did not hinder Nanuk (above) from enforcing his will every once in a while, nor did it hinder youngsters from leading the pack at times, too.

disappear and only resurface when everything was quiet again. Their trust humbled me and confirmed how intelligent wolves are. They could clearly distinguish one car from another and had some system for determining which cars to trust and which to avoid.

In early September the breeding pair, Delinda and Nanuk, came out of the forest and onto the road. Delinda, as usual, led the way, while Nanuk followed close on her heels. Delinda passed my car without hesitation. Nanuk, however, kept his distance. He was clearly less trusting than his mate. They had six hungry mouths to feed, so they were on the hunt.

Staying back 80 metres, I followed the two four-legged carnivores, in my 4-wheel-drive. When another car showed up in the distance, Delinda and Nanuk disappeared into the forest. It was now 7:46 a.m. and I had a pretty good idea where they would go. So I drove to a little pullout five kilometres down the road, parked the car and grabbed my camera, tripod and binoculars. Heading down the hill toward the river, I searched for a good spot to wait.

An hour later, I was just about to return to my car when I saw Delinda in the distance. "If Delinda continues this way, she may end up right in front of me," I thought as I knelt down behind my camera. I looked back up the valley, thinking I should try my luck and install the wide-angle lens. Delinda was fast approaching, while Nanuk closed in as well. Before I knew it, I saw Delinda out of the corner of my eye. My head bent to the viewfinder as she passed right in front of me, my camera shutter blazing.

Where is Nanuk? I looked to my right and found him standing statue still, staring in my direction. No surprise there, since, as Günther would say, Nanuk is personality type B: more reluctant, introverted and cautious. Nanuk always checks things out first, then acts. Delinda is the other way around, a type A personality: less skeptical and more straightforward. She acts first. I was not the only one to notice Nanuk's reluctance, though. Delinda stopped and turned her whole body to look at him. *Come on!* Nanuk took a few steps down toward the river and waited, never taking his eyes off me.

Delinda stared at Nanuk as I looked at her. Then she turned her head toward me and stared hard. Normally, I would not dare to stare back at an animal I wanted to photograph. Usually I look away, playing the disinterested, harmless dupe. This time, I was hypnotized by Delinda's stare. She seemed annoyed, perhaps at me for causing the delay and at Nanuk for hesitating.

Impatient, she trotted toward me. A cold shiver ran down my back and I said, "Hey!" Delinda stopped, a bit surprised by my voice, and returned to where she stood a few seconds earlier. Then she looked back at Nanuk as if to say *See, no problem. Come on.* Nanuk still did not trust the situation. He turned away from the river and jogged into thick brush. Delinda watched him disappear and looked back at me again. By this point I was feeling a bit guilty for delaying them, so I kept my head down. Delinda moved in my direction, but this time she veered to my left. A few small trees were all that stood between us. She appeared about four metres in front of me, gave me a look and then trotted up toward the game trail Nanuk had just crossed.

The next morning, I drove to another area the Bows often used. Lakota, the wolf I eventually knew the best, was sleeping under his favourite spruce. During our previous encounters, I had noticed Lakota seemed destined to take on the main babysitter role in the family this year, but this time I could not see the pups around. Maybe his sister

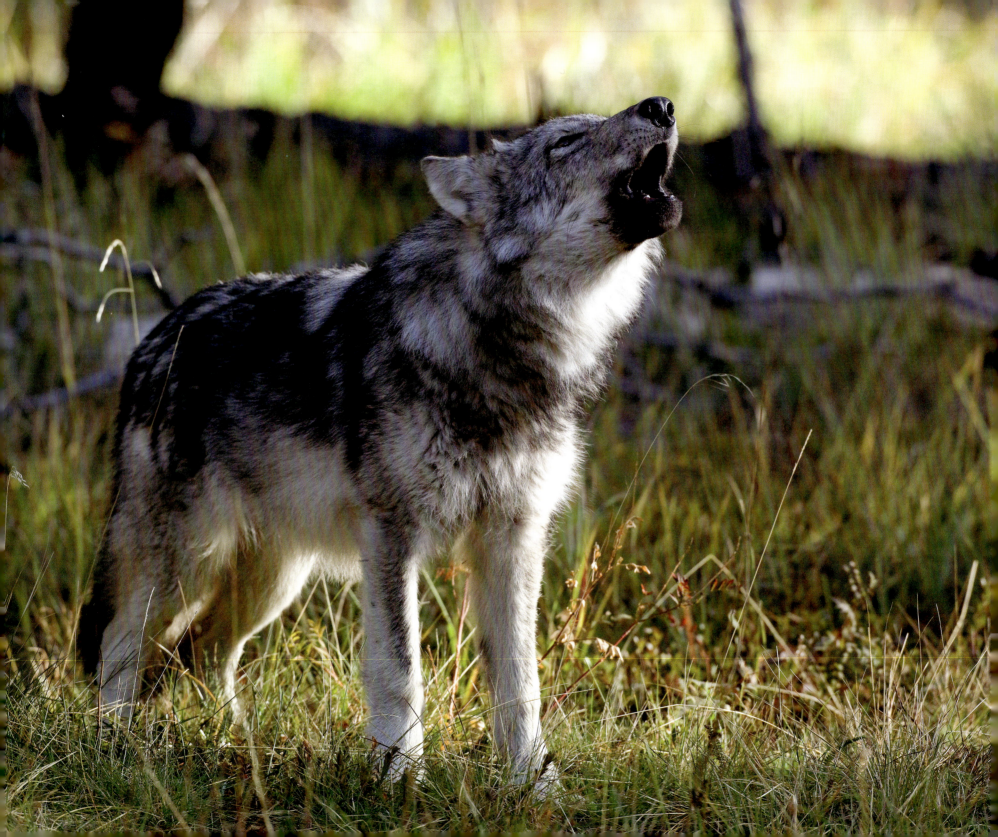

Chinook was nearby, but I did not see her either. Chinook was, by far, the shyest wolf I have ever met. Throughout my many encounters with the Bow Valley wolves, I only managed to capture a handful of photographs of her. Lakota was different; he accepted my presence and I loved him for that.

Suddenly, Delinda and Nanuk appeared out of the forest on the road behind me, followed by all six pups and, to my surprise, even Chinook herself. Lakota joined the convoy. In a matter of seconds, I went from observing one wolf resting to watching the whole family of ten waltzing down the road. Delinda passed by my car without a second look, and this time Nanuk followed without hesitation. Lakota followed suit. Only the pups and Chinook kept their distance and took a detour around my car.

They all reappeared in front of me, with the four adults increasing their pace into the distance. The pups tried to follow, but fell behind one after the other. Soon realizing they were not meant to follow, the pups disappeared into the forest as the adults disappeared around the curve. What should I do? Do I settle in and try to get some nice pup shots? Or should I try to follow the hunting adults? I decided to join the hunt.

The adults moved at a brisk six kilometres an hour. Every once in a while one of the wolves would break formation and investigate something on the ground before returning into position. Delinda led the party, followed by Chinook, Lakota and finally Nanuk. The group continued without hesitation until Delinda called a quick halt, her ears and eyes focused into the dark forest. The other wolves stopped, watching Delinda. Nanuk went to her side, staring in the same direction. A few seconds of eternity passed. Then, without observable warning, Delinda leapt into the forest. Nanuk, Lakota and Chinook stood their ground, watching. Sounds of branches crashing echoed through the forest. Now Nanuk's turn, he jumped forward and disappeared into the woods, followed by Chinook and Lakota. There! I saw a white-tailed buck running for its life, the wolves at his side. It was difficult terrain, fallen trees everywhere, a chaotic forest.

Lakota and Chinook, realizing they would not be able to catch the deer or their parents, ran back onto the road full speed, right by me. They were obviously trying to head off the deer by getting ahead of it on the flat, paved road. Two hundred metres later, both Lakota and Chinook re-entered the woods. There was more crashing before stillness fell over the forest. Not a sound anywhere. I drove up and down the road, looking for the ending to the story, but there was nothing. Finally, I saw Chinook standing alone on the road. She seemed to have lost contact with the rest of her family and started to howl. I listen for an answer. A distant howl broke the silence and she ran into the forest again. The show was over.

Fluffy tries successfully to get in touch with her family members by howling.

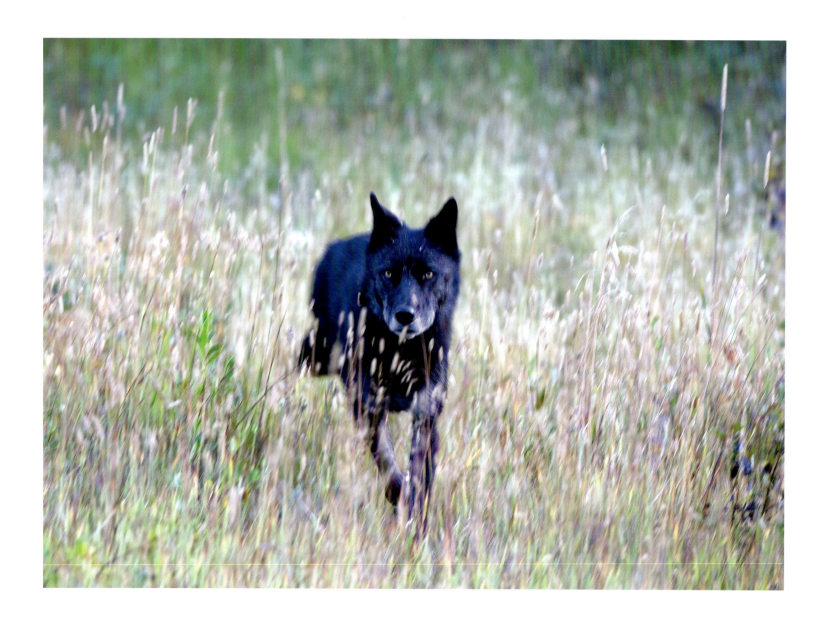

Experienced wolves are vital in successfully taking down large prey, according to Doug Smith, the biologist in charge of the Yellowstone Wolf Project, as quoted by *Billings Gazette* reporter Ruffin Prevost. Females such as Delinda are "typically out in front, picking out which elk to attack." The larger males, however, are important for the final takedown. Young wolves often participate in hunts, but they are the least successful ones.

The white-tailed deer is not an easy catch. White-tails are formidable runners and jumpers. They can sprint up to 48 km/h (30 mph) and leap as high as 3 metres (10 feet) and as far as 9 metres (30 feet) in one single bound. When in danger, these animals raise their tails to "wave" danger to fellow deer in the area.

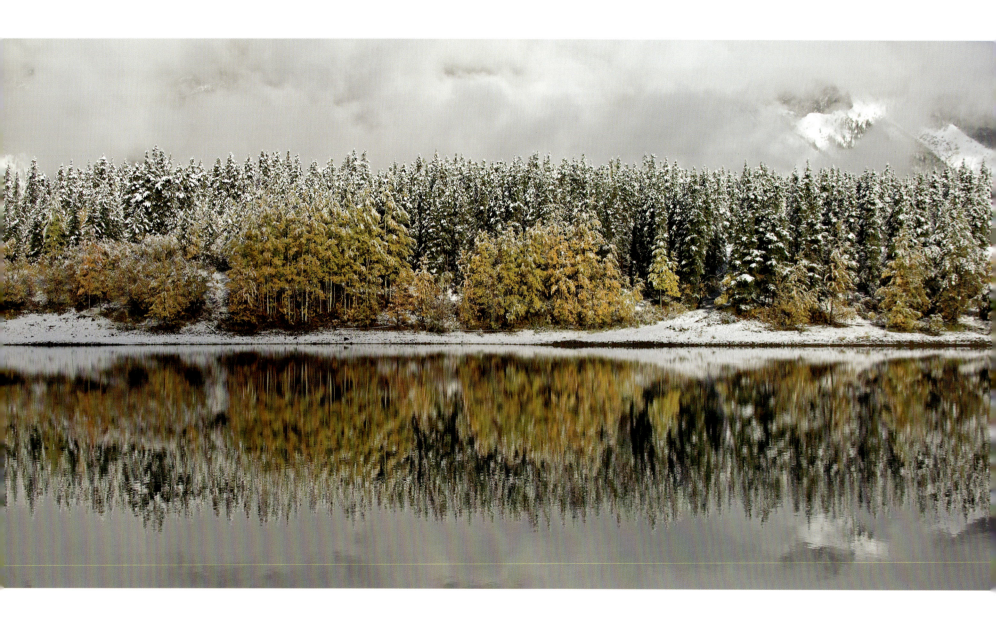

SHARING THE ROAD

The love for all living creatures is the most noble attribute of man.
—Charles Darwin (1809-1882)

Fall came and went. The yellow leaves of the aspen trees lay under a foot of fresh snow. It was time, once again, for me to leave the Bow Valley for a few weeks. But before I left I wanted to see the Bow Valley wolf family one more time.

It was snowing hard when I met Günther on the Bow Valley Parkway. John Marriott, another professional nature photographer, was also on hand. Günther had already found fresh tracks, so we made our way to Moose Meadows. We arrived just in time to see Delinda cross the road and disappear into the meadow. Howling in the woods off to our right was the youngster that Günther had named Mickey.

We all agreed that Delinda or another of the wolves would show up soon, so we spread out. I positioned myself where I thought Delinda might cross the meadow again, a spot that offered a majestic background for a photograph. John and Günther sat in their cars down the road and around the corner. A few minutes later Delinda appeared on the road, proving my intuition correct. She followed the tracks my vehicle had left, which was easier for her than walking through the deep snow. She saw me, but walked right by as if I was not even there. Then she stopped abruptly and looked back in the direction she had come from, then back again toward where she was going. I could have cried. She would not look at me, which was what I needed to get a good photo. So close, yet so far away.

Something was bothering her. I looked in the rear-view mirror and saw what had attracted Delinda's attention. It was another car. She turned around and, crouching slightly, hopped off the road into the deep snow. One click and I had the picture I was hoping to get. In the meantime, the approaching car pulled up right behind me. It was a Parks Canada vehicle. I had no doubt Delinda knew the car.

"Wolf, eh?" said the park warden as he approached my open window.

"Yeah, she just crossed the road right in front of me."

"Hmmm. That's no good. We don't want the wolves to use these roads."

"Why?" I could not believe what I just heard. Wolves find the most efficient way to travel; they know exactly what they are doing. Using the roads, ski tracks and frozen riverbeds helps them save precious energy, enabling them to move greater distances faster.

"Well, they get habituated to all this traffic and start to lose their natural fear of people," he said. "And then they get in all kinds of trouble. We don't want to see that."

I understood his logic. The idea is that if an animal gets used to people it loses its "natural fear" and endangers not only humans, but also itself. This assumption is problematic on various levels. For starters, one should look at what is "natural" animal behaviour. For example, near my native hometown in Sedrun, Switzerland, there is a small hunting preserve where red deer – the counterpart of North American elk – are not allowed to be hunted. With the beginning of the fall hunt, deer gather in small, protected enclaves during the day and leave the

Snow comes early and stays late in the Canadian Rocky Mountains. The image shows Wedge Pond, in Kananaskis Country, in late September after a first major snow fall.

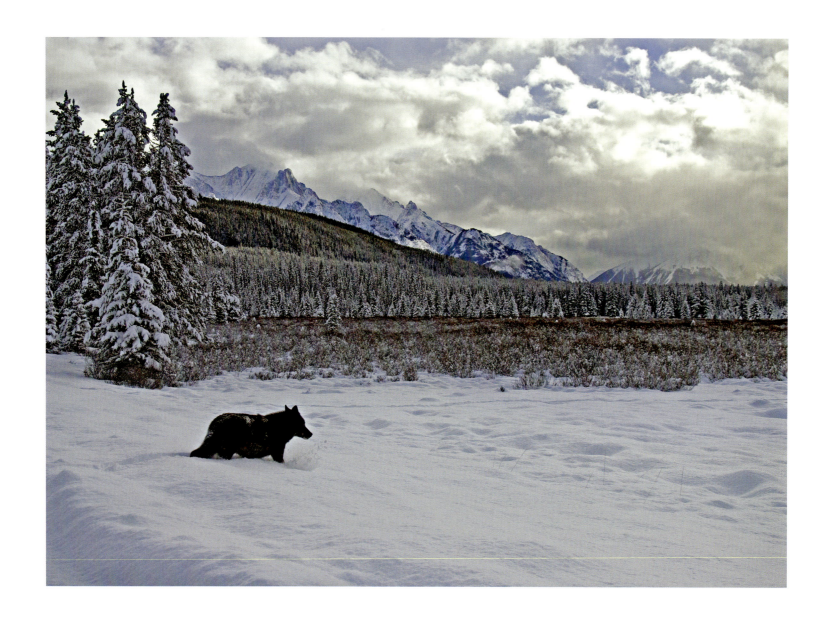

safe haven only under the cover of night, to feed on nearby pastures outside the protected areas. When dawn looms, they all flock back inside the preserve and leave many hunters in desperation.

The actions of the red deer illustrate how human behaviour influences human-animal interaction and the way animals perceive humans. Humans do play a somewhat shady role in the eyes of wild animals. Some humans simply avoid them, others approach with the intention of petting them and still others like to harass or kill them for pure pleasure. A Jasper or Banff elk has learned that in specific areas inside national-park boundaries, it will be safe from human hunters day and night. The elk maintain a highly active and visible profile, while remaining tolerant of people.

What is "natural" behaviour? Deer being nocturnal and taking off as soon as they see or smell a human? Or deer tolerating humans in their space, as observed in many national parks around the globe? Both are natural. This conclusion seems fine so long as the animals in question do not belong to a group of large omnivores or carnivores.

In 1754 Anthony Henday, one of the first Europeans to move toward the Rockies, found wolves that behaved differently toward humans than one finds in the 21st century. *Canis lupus* customarily appeared at the edges of their camps. In his journals Henday notes that the wolves "do not meddle with any person: We cannot afford to expend our ammunition on them." This wolf behaviour was not abnormal. Years later, in 1793, Alexander Mackenzie, while finding his way as the first European overland to the Pacific, claimed that "a wolf was so bold as to venture among the Indian lodges."

What is the pristine state of natural wolf behaviour? It depends. Just as with the elk behaviour described above, wolf behaviour also depends on the environment the animal is born into and what experiences it or its ancestors have had. It is a complex topic. In a 2003 report called "Management of Habituated Wolves in Yellowstone National Park," one can read the following:

Central to wolf habituation management is an understanding of wolf behavior, especially what constitutes normal versus abnormal. Overall, wolves are naturally wary and elusive, and avoidance of humans by healthy wild wolves is the norm. Wolves living in fragmented habitats, or areas with partial to frequent human presence, generally show a high degree of tolerance towards human activity and infrastructure, but still exhibit avoidance and fear in direct encounters. In such areas, wolves traveling near human developments, using roads as travel corridors and showing a certain level of curiosity towards human activity, should all be considered "normal" wolf behavior, because these behaviors reflect wolves' natural ability to adapt to their surroundings.

It is misguided to believe that wolves or bears will invade towns if they become accustomed to humans. People would never allow that behaviour to evolve, at least not in present-day Canada. In addition, the idea that aversively conditioned wolves will not use roads is a grand misconception. Even the shyest of wolves will use human infrastructure. For example, the Swiss wolf that I photographed in 2006 uses

Wolves will avoid deep snow as much as they can, and wherever possible they prefer to travel on human-created pathways such as ski or snowmobile tracks. This enables them to cover larger distances faster and with minimum waste of precious energy.

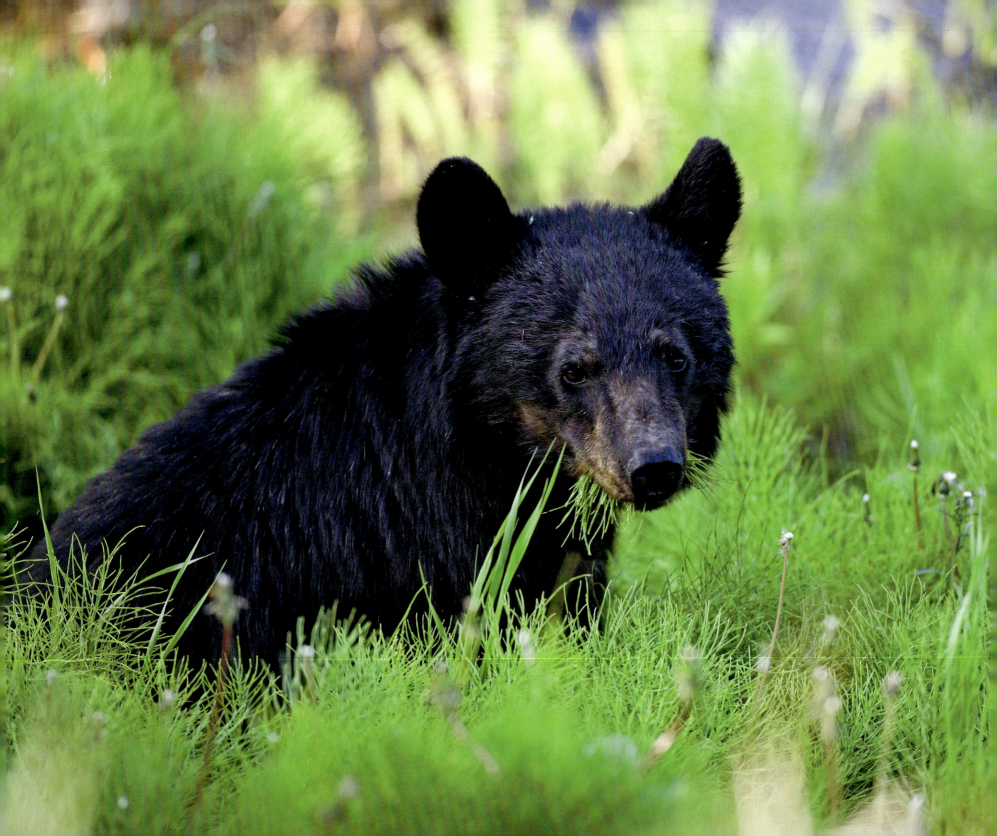

roads regularly. Of course, he does not use them during the day since his personal experiences and genetically driven instincts do not promote such behaviour. Another example is a reclusive, collared female wolf in Transylvania, Romania, that was documented on a 1997 BBC *Wildlife Specials* episode called *Wolf: The Legendary Outlaw*, hosted by David Attenborough. The female, who at the time had nine newborn pups to feed, used the cover of night to conceal her regular trips across large parts of Brasov, so she could check for stray or unguarded sheep on a pasture at the opposite end of the city.

While I understand how spending time on or near roads is potentially dangerous for wild animals, it seems unreasonable, if not outright ridiculous, to expect they will not use these travel corridors. After all, the high-quality habitat in the valley bottoms, where most roads are located, attracts wildlife. It is one thing to fence off the Trans-Canada Highway or the Lake Louise campground to keep animals out, but to think we can condition individual animals to avoid roadsides, in national parks that are criss-crossed with hundreds of kilometres of roads, is not only futile but contrary to the essence of protected areas. If roads are unduly compromising the area's ecological integrity, then *they* should be managed, not the animals.

One anecdote in particular serves to illustrate the vexing contradictions inherent in Canadian mountain parks "protection" mandate. Every spring, I can usually find an unruly-looking black bear on the same steep slope covered in lush green food near the North Saskatchewan River. I named him Struwwelpeter, after a character in a popular German children's story about a boy with long, wild-looking hair who does not groom himself properly. When I went looking for him this spring, I found a phalanx of cars parked beside the road, their occupants standing around with cameras in hand. I knew instantly that Struwwelpeter had created another bear jam.

The light was harsh. It was not the best time of day to take pictures, so I grabbed my binoculars and walked over to the excited tourists. Of course, it was Struwwelpeter. "Nice to see you again," I thought to myself as I walked back to my vehicle. I was just about to leave when a Parks Canada vehicle pulled in behind me. Two men got out of the car and walked over to the crowd, sending one tourist after another back to their cars. The younger of the two wardens approached those who had remained in their cars. When he reached mine, he asked me to move on. I asked why and he explained, "We don't want people to harass the bears."

As I prepared to leave, I looked over at the other park warden, who, to my great surprise and disgust, was throwing rocks and dirt at the feeding bear. I started the engine and made ready to drive past the bear, who in the meantime had been driven across the road by the exuberant, rock-wielding warden. Struwwelpeter was now very visible. Of course, another bear jam began to form, this time even bigger than the first one. My journalistic instincts kicked in and I decided to sit back and watch the whole charade from a distance. The tourists had again clambered out of their cars to photograph Struwwelpeter, who ignored the crowd in favour of food.

The park wardens followed and this time the older, more aggressive-behaving warden seemed more determined than ever. As the "we don't want people to harass the bears" speech echoed in my ears, he

A black bear takes advantage of lush green spring vegetation near the Yellowhead Highway in Mount Robson Provincial Park.

Who's observing who? A young wolf cautiously watches some excited but well behaved tourists before disappearing into the forest. Being able to watch wildlife in close proximity is not only a true tourist magnet but also enables people to connect with the natural world on a very intimate level. However, it can cause significant disturbance to the animals inhabiting the national parks if done disrespectfully.

launched a bear banger and a reddish flare at the innocuous bruin. Struwwelpeter fled in panic while the bystanders stalked back to their cars shaking their heads.

I returned to the same spot that evening to find Struwwelpeter back on the roadside eating dandelions. When a large vehicle resembling a Parks Canada SUV approached, he ran toward the forest. As soon as the car had passed, Struwwelpeter relaxed and came back to continue eating his dinner, ignoring me completely.

This kind of bear behaviour is nothing new and it illustrates the challenges of using aversive conditioning to keep bears away from the roads. As far back as 1944, famed naturalist Olaus Murie considered hazing bears ineffective. "Experience has shown that the bear learns to recognize the particular person or car that administers the shock or other punishment, and he simply avoids that person or car in the future but does not fear other persons or cars," he wrote in a study on Yellowstone bears. The same can be said, as I personally witnessed many times, for wolves and elk.

Aversive conditioning can work under certain circumstances, but the resources required can be enormous. In order for aversive conditioning to be effective, bears must be monitored around the clock for weeks and even months at a time. Even then, some bears may revert to preconditioning behaviour once the conditioning is discontinued. In 1990 Yellowstone National Park abandoned roadside hazing, due to the inordinate resources required and inconsistency of results, and began to manage people rather than the bears that were tolerant of people. Parks Canada, however, still maintains that roadside bears may pose a threat to themselves and people because they are "habituated."

Most wildlife managers tend to believe that habituation is undesirable because familiarity with humans and their trappings makes these large mammals potentially dangerous. James C. Halfpenny, a biologist and animal behaviourist for Yellowstone National Park, suggests that habituation is just one component of the remarkable complexity displayed by wolves and bears. These intelligent animals can adapt to various situations. As long as the animals and people play by the same rules – and people understand that animals have as much say in what those rules are – we can coexist in relatively close quarters.

In Yellowstone, where Halfpenny works, tourists who watch wildlife from the roadsides are not only tolerated, they are encouraged. Yellowstone went through an evolution in bear management similar to Banff. In the last 50 years, they moved from predator control to roadside feeding and garbage-addicted bears, then to destroying and relocating so-called problem bears, and finally to aversively conditioning habituated bears that hang around roads and developed areas. However, unlike Banff, Yellowstone has gone one step further in its evolution. Shifting away from hazing roadside bears, Yellowstone made the move toward managing the people who want to watch them when they are, say, making love on the side of the road.

The new strategy seems to work. According to Halfpenny, Yellowstone's Bear Protection through Education program has made

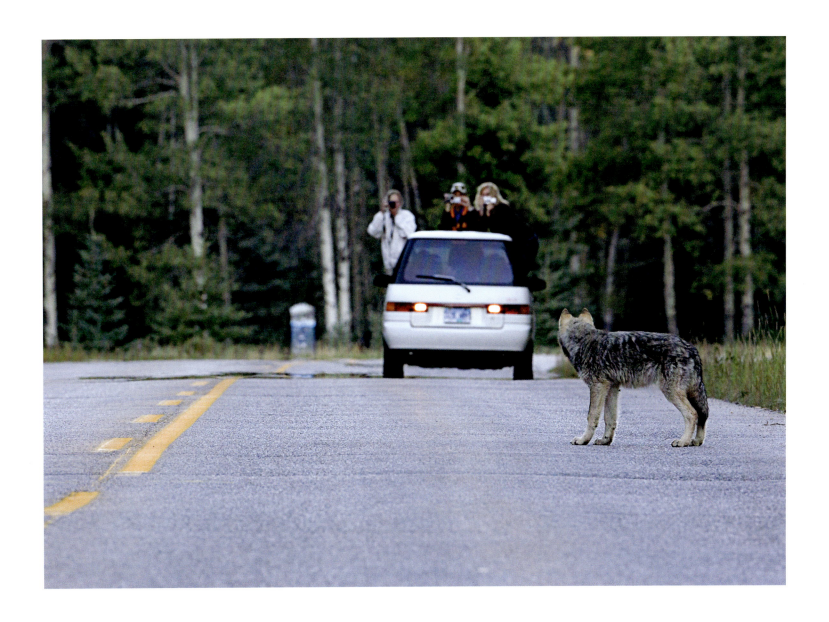

Yellowstone a leader in managing bear viewing. The animals do their thing, while rangers (the U.S. version of wardens) keep people on the roadside, no matter how close or far the animals are. In fact, Yellowstone visitors are now allowed to stand about 23 metres (25 yards) from a female grizzly with cubs! Professional roadside bear interpreters first focus on the safety of people, then manage traffic and bears. Their message is to take the time to share with a wild, natural bear.

Banff National Park has a similar project called the Roadside Bear Guardian Program. It started as a partnership between Parks Canada and the Friends of Banff. I have seen the bear guardians at work a few times, with mixed results. It only really works when the bears are far away from the roads. The guardians put up telescopes for people to use, and they educate visitors about bear biology and behaviour. But when bears are close to the road, the public is hustled back to their cars. The bears are then hazed off, only to return, as Struwwelpeter did, and cause another bear jam once the wardens have left.

Why has Banff not adopted the successful Yellowstone model? I spoke with a few Parks Canada human/wildlife specialists and Banff bear guardians to find out. Their responses are summed up best by the following email message I received from one of the bear guardians:

…sometimes it's as simple as [the fact that Parks Canada staff] are the only ones working, they have multiple things going on and they can't keep babysitting… So they end up hazing a bear if [bear guardians] are not around, in hopes that it will free them up to tend to other things. And the list goes on and on. […] Yellowstone… does not deal with the crazy speeds that we deal with on 93N…

There is another reason why the Canadian Rocky Mountain national park system still uses the old model of bear management. It has to do with fear. Over the years, I have concluded that there exists paranoia toward large animals, especially bears. Various sources build up and nourish this paranoia. Newspapers and television news always focus on the relatively rare negative encounters between bears and people, but they rarely cover the positive encounters that far outnumber the attacks and maulings. Cheap *horror* movies about wolves, cougars, sharks, alligators and other predators also exaggerate and sensationalize the true nature of these animals.

Even Parks Canada uses fear to "educate" the tourists who have no experience with bears. While many tourists come to Banff with a very distorted and naïve view of wildlife in general, signs such as ALL BEARS ARE DANGEROUS are one of the first things they see when they enter the park. A paranoid understanding of bears is further accentuated by publications that warn: DO NOT HIKE ALONE and MAKE A LOT OF NOISE while travelling in bear country.

Bear attack books are also problematic. One of the first things I did when I moved to Canmore was buy a highly praised book on bear attacks. There are many books on this topic, but this one, so I heard, deals with attacks in a scientific way. Apparently, everybody who lives in bear country should read it. So I did. I never finished the book, simply because it scared the living hell out of me. Instead of being educated about bear behaviour, I developed a *bear-attack-book complex*.

Let me be clear on this: I do not want to be disrespectful toward the authors of these types of books. Some are world-renowned experts in their fields and I am certain that most had good intentions. However, two things particularly disturb me about these books:

First, many of these books describe in graphic detail the injuries caused by bear attacks. These horrific descriptions are often so visual and gory that it distracts from the real purpose of the books, which is to educate readers about bear behaviour and what actually caused the attacks.

Second, most of the bear attacks involve "food-conditioned" bears. In the early days of national parks, be it in Yellowstone or in Banff, people fed bears like they were goats in a petting zoo. Furthermore, bears were allowed to scavenge garbage dumps near towns inside national park boundaries, which caused many dangerous situations. In Banff's case, bear attacks have dropped dramatically since they closed the dumps and bear-proofed garbage cans in the 1980s. Ultimately, gory bear-attack books create not only exaggerated fear but also a false picture of natural bear behaviour.

In combination, our natural fear of the unknown blended with skilful storytelling ultimately leads to a state of paranoia. Paranoia eventually leads to exaggerated management actions such as aversive conditioning and the unnecessary destruction of wild animals that are erroneously thought to be dangerous. Worse, paranoia leads to apathy, which simply allows the cycle to continue.

Certainly, bears should not be portrayed as teddy bears either. They are large, strong and potentially dangerous wild animals that we must learn to understand and respect when we choose to live in or visit bear habitat. However, national parks should not be managing bears because of our irrational fear of them. In national parks, we should leave bears (and wolves) alone. Instead, park staff should be educating, managing and controlling *people*.

Seeing a wild animal such as a relaxed grizzly bear around people is a real treasure. It teaches people about bear behaviour, such as what bears like to eat, and that most of the time they are not aggressive and dangerous beasts. Yes, there is always an exception to the rule, just like the neighbours' dogs. Nevertheless, the ability to observe large carnivores along park roads is also of great value to the conservation of bears and wolves worldwide. Just imagine how such a positive roadside experience might influence a Swiss family when brown bears or wolves make a comeback in the Alps. That family will be more likely to support the recovery of these magnificent mammals than those who have only ever experienced them through bear or wolf attack movies or books. And believe me, bears and wolves need all the support they can get in the "civilized" Alps!

Black bears are primarily forest animals, and thanks to their sharp, curved front claws, they are also formidable tree climbers.

THE BATTLE FOR NANUK'S HILL

We patronize them for their incompleteness, for their tragic fate of having taken form so far below ourselves. And therein we err, and greatly err. For the animals shall not be measured by man. In a world older and more complete than ours they move finished and complete, gifted with extensions of the senses we have lost or never attained, living by voices we shall never hear. They are not brethren, they are not underlings; they are other nations, caught with ourselves in the net of life and time, fellow prisoners of the splendor and travail of the earth.

—Henry Beston, *The Outermost House* (1928)

I returned to Canada in January 2008, in good spirits. The Bow Valley wolf family had a great 2007 and I was looking forward to watching them grow and thrive over the next few years. There were now ten wolves hunting among the rivers, the roads and the railways in the Bow Valley. Things were looking better than they had in a long time, thanks to the new dream team of Delinda and Nanuk.

There was a lot of work waiting for me, mainly getting my wall calendars and greeting cards ready for the coming tourist season, but I was looking forward to rejoining Karin and Günther in search of the Bows. Because mid-January to mid-February is mating season, I decided the tourists would just have to wait and I readied my camera gear to go.

In February we found blood in Delinda's urine, an unmistakable sign that she was in estrus and ready to mate. Copulation was only days away. Unfortunately, we did not see or find further signs of her for the next month. The Bows had simply disappeared. It was frustrating at times, but I guess the wolves wanted their privacy. That's the way it goes with nature photography.

It was the end of March 2008 and I decided to hike into an area where Günther and I had observed the Bow Valley wolves in the past. It is a perfect place for the wolves to get away from the busy Bow Valley Parkway, the tourists and the trains. The trail led me through thick forest to a relatively large meadow. In the middle was a little rise which I had named "Nanuk's Hill," because it was his favourite place to hang out.

When I arrived, Silvertip, now almost 1 year old, rested near Nanuk's Hill. He seemed nervous. He would lie down for a few seconds, get up, move to another spot and then repeat the restless pattern. Finally, he seemed to have found a spot he liked. In a dog-like manner, he circled a few times before lying down once again. A few minutes later a coyote appeared and started to howl. Silvertip took this as an invitation to start a chase and both canids disappeared into the forest. If Silvertip is here, I thought to myself, other family members may be close by.

An hour later, just as it started to snow lightly, another wolf showed up. It was Silvertip's sister, Fluffy. Fluffy walked slowly out of the forest into the open meadow, checking the wind constantly with her fine nose. It looked like she might have caught my scent, but I thought this unlikely considering the wind was blowing toward me. She also did not look in my direction; her full attention was on the forest.

Something suddenly moved in the trees directly in front of Fluffy and she retreated with her tail between her legs. "This is not her style," I thought, recalling how Fluffy was one of the more dominant wolves in the Bow Valley. "What's going on?" I wondered. Something big and furry was certainly in the trees. But the sounds and movements it made did not give me the impression that it was one of the usual

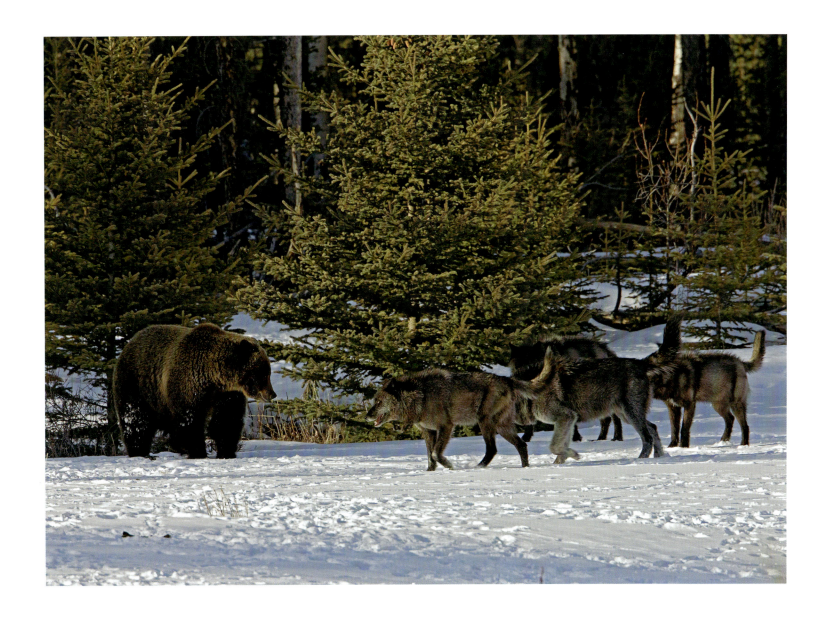

suspects, such as a moose or an elk. A chill scurried down my spine as I realized it could only be one thing.

A massive brown grizzly head peeked curiously through the trees and looked around. Another chill flew through me as I realized I had been sitting in the woods for so long without noticing him, or vice versa. My first thought was to get the hell out of there, but that would mean blowing my cover and who knows how the bruin would react. Instead, I just kept my cool and waited for darkness to cover me so I could respectfully retreat to my car.

Meanwhile, Fluffy and Silvertip, who had returned, walked tentatively up to the bear. They were obviously very insecure about what to do with the problem that had just walked into their living room uninvited. Silvertip stepped forward, but as soon as the bear lifted its head, he jumped back. Fluffy tried the same strategy, with the same result. Frustrated, or maybe scared, they left. I thought the show was over, so after watching the bear for a while, I left too.

Two days later, after going out to look for the wolves, Günther called me in a frenzy. I had told him about Fluffy and Silvertip taking on the big bear, so when he could not find any sign of the Bows, he went to see if they were back at Nanuk's Hill. When he arrived, he found the entire pack – minus Chinook, who had decamped earlier in the year – in a standoff with the grizzly. The battle for Nanuk's Hill had begun.

Günther and I left at dawn the next morning, Tuesday, April 1, 2008. It was a cozy −18°C and we had front-row seats at one of the most magnificent spectacles nature has to offer. What more could a naturalist/photographer want?

The grizzly walked out of the forest at 8:48 a.m., head low, advancing straight toward Nanuk. I was surprised how calm the big bruin was as

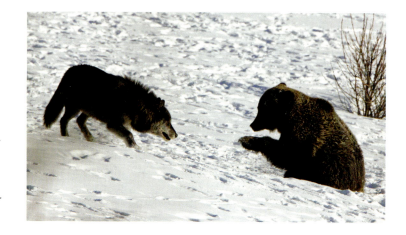

he faced off against a pack of nine wolves. One on one, grizzly bears are definitely at the top of the food chain in the Rocky Mountains. However, it is not unheard of for a pack of wolves to attack and even kill an adult grizzly. The grizzly did not seem particularly worried; perhaps it was not the first time he had been in this situation. Because of his demeanour and obvious courage, I called him the Brave One.

It was not the vicious, knock 'em down, drag 'em out attack that one might expect. In fact, it was downright comical at times. Several times, the grizzly simply lay flat on his belly staring at the wolves, waiting for their next move. Two or three times he even somersaulted forward toward the approaching canids, only to sit once again on his behind, both paws stretched out to his sides like the most graceful of kung fu fighters. The bear appeared to consider it something of a game and he seemed to be having a lot of fun playing it.

Nanuk, on the other hand, was not amused. He tested the bear repeatedly, eventually engaging it in a duel. The bruin stepped up to

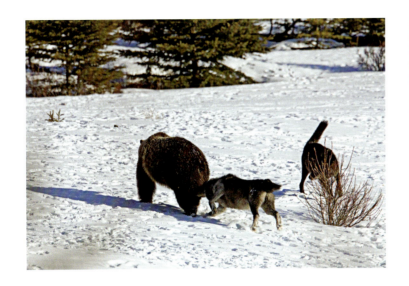

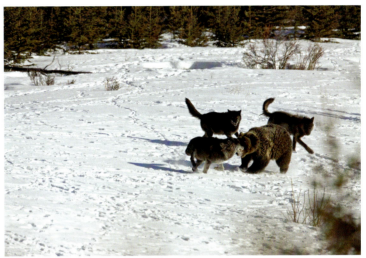

Only two times during the entire combat was there actual physical contact between the bear and one of the wolves. In this case, Nanuk used the bear's momentary inattention to bite his rear. None of the animals involved got hurt during this multi-day battle.

The grizzly is surrounded by Nanuk (front), Delinda (back, left) and Silvertip (back, right). The appearance of the very pregnant Delinda on the battlefield instantly intensified the skirmish.

the challenge, which allowed the rest of the family members to move into the bush to get whatever the bear was hiding in there. As the battle heated up, more and more wolves arrived, including, to our surprise, delight and worry, Delinda. She was obviously very pregnant and showed no patience for the intruder as she lunged and snapped at him at every chance. As the grizzly turned to face Delinda, Nanuk moved in and bit the bear's exposed rear-end! It was the beginning of a cat-and-mouse game between the two largest animals on the scene. An hour later the bear retreated into the forest while the wolves lay scattered around in the open meadow, enjoying what little warmth was offered by the early April sun. The show seemed to be over.

"Damn it," Günther mumbled into his beard, "I have to be in Canmore early this afternoon." I walked him out to the car and then, worried I might miss the grand finale, turned around and walked right back in alone.

At 6 p.m. the Brave One burst from the forest with Nanuk and his oldest son, Lakota, hot on his heels. Shoulder to shoulder, father and son moved aggressively toward the bear. The yearlings Silvertip and

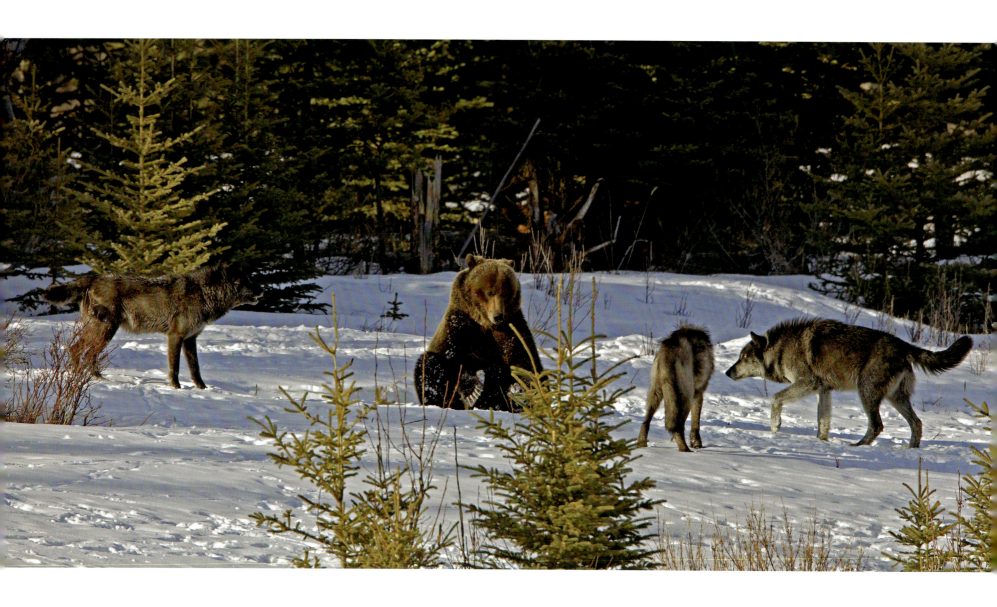

Sundance moved in to help as well. The situation had clearly become more serious for the Brave One. For the first time, he looked worried. He rose up on his hind legs and smashed his right front paw down into the ground, snow flying into the air as if a mortar round had just landed. The wolves aborted their attack. The big bruin swatted at the ground again and again, while the startled wolves retreated. As for me, my mouth hung wide open and my heart pounded so hard I thought it would come out of my chest.

Rather than backing off entirely, the wolves began playing by tugging this way and that on an old piece of elk hide lying in the snow. This almost ritualistic battle could not be about food if that elk was all there was at stake. What remained of the carcass was not worth the time and energy to walk across the meadow. Why had the bear and the wolves risked injury, even possible death, for a few bones and a tattered piece of hide? Were the wolves planning to den in the area? Only the bear and the wolves could answer these questions. The rest is pure speculation.

An hour passed. When the wolves finally finished playing with the hide, Nanuk walked over and urinated on it, marking it official property of the Bow Valley wolf family. The bear, watching the show from the safety of the forest, lumbered out of the trees as if on cue. He walked right over to the wolves' property and sniffed it intensely. Nanuk approached cautiously, head down, offering no signs of aggression. The bear, still sniffing the urine-marked hide, did not show any hostility either. He merely eyed the approaching wolf closely. Nanuk came closer and closer, forcing the Brave One to finally lift his head. They were eye to eye, each standing in front of the other, noses nearly touching. It was a moment of truce, a moment of magical power. Amazed, I pressed the shutter button and took one single picture. Then both animals looked in my direction, as if to see whether the sole spectator was enjoying the show. And by God, was I!

Nanuk distanced himself from the bear and lay down only a few metres away. The Brave One, on the other hand, took the hide in his mouth and shook it wildly, like a dog shaking a rug. Nanuk ignored him. It was not until the bear lay on his back and lifted the scrap of hide into the air with all four legs that Nanuk leapt up and attacked the bear. The bear seemed to actually enjoy the return of his playmate. Still lying on his back, he stretched his massive paws toward the approaching wolf. I thought I saw a smile of satisfaction on the bear's face, but Nanuk was not amused. He circled the bear, looking for a chance to attack, but the bear's only response was to cover his face with the fur until only his eyes were visible. Peekaboo!

It must have been the ultimate humiliation for Nanuk, because he attacked quickly, forcing the bear to his feet. The Brave One chased Nanuk across the meadow for half an hour, until both lead actors seemed to run out of energy. The light was disappearing and I started to pack up. As I left, the bear lay on his belly chewing an elk bone, while Nanuk slept just a few metres away. "Peaceful," is the only way I can describe the scene before I hiked back to my car and made the short drive back to civilization.

It wasn't until the afternoon of April 1 that Lakota, the eldest son of Nanuk and Delinda, showed up at the battlefield. Pictured opposite, Lakota is to the left, Silvertip in the middle, Nanuk to the right.

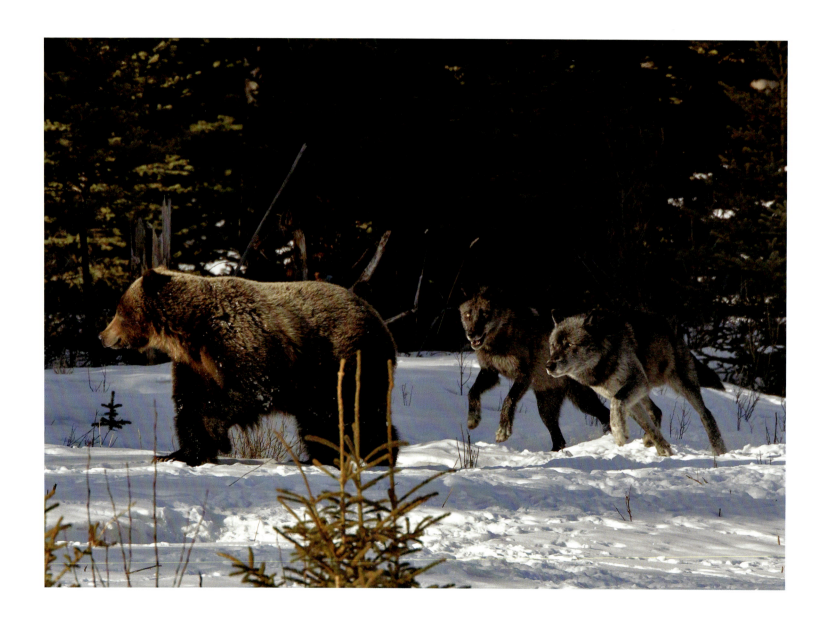

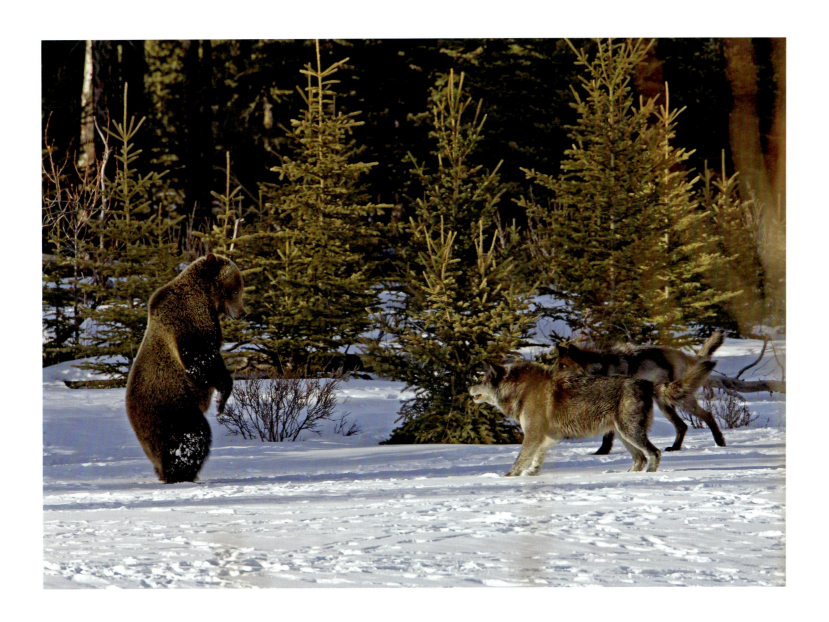

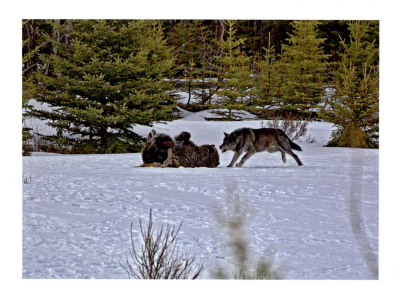
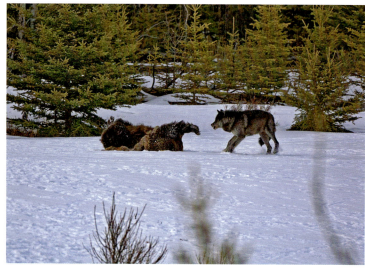
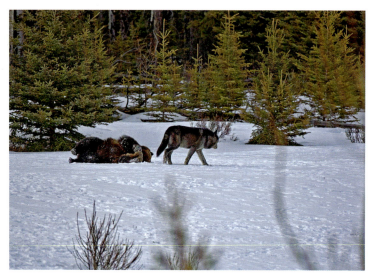

PREVIOUS SPREAD: As soon as Lakota arrived, the most serious charge of the entire battle was launched. For the first time, the Brave One seemed truly worried, and he responded by rearing up on his hind legs to showcase all his might.

THIS SPREAD: The bear took possession of an elk hide, played with it and provoked Nanuk once again. It ended with a fierce attack by Nanuk, ultimately forcing the bear to his feet. The Brave One repeatedly smashed his paws down into the snow with brute force.

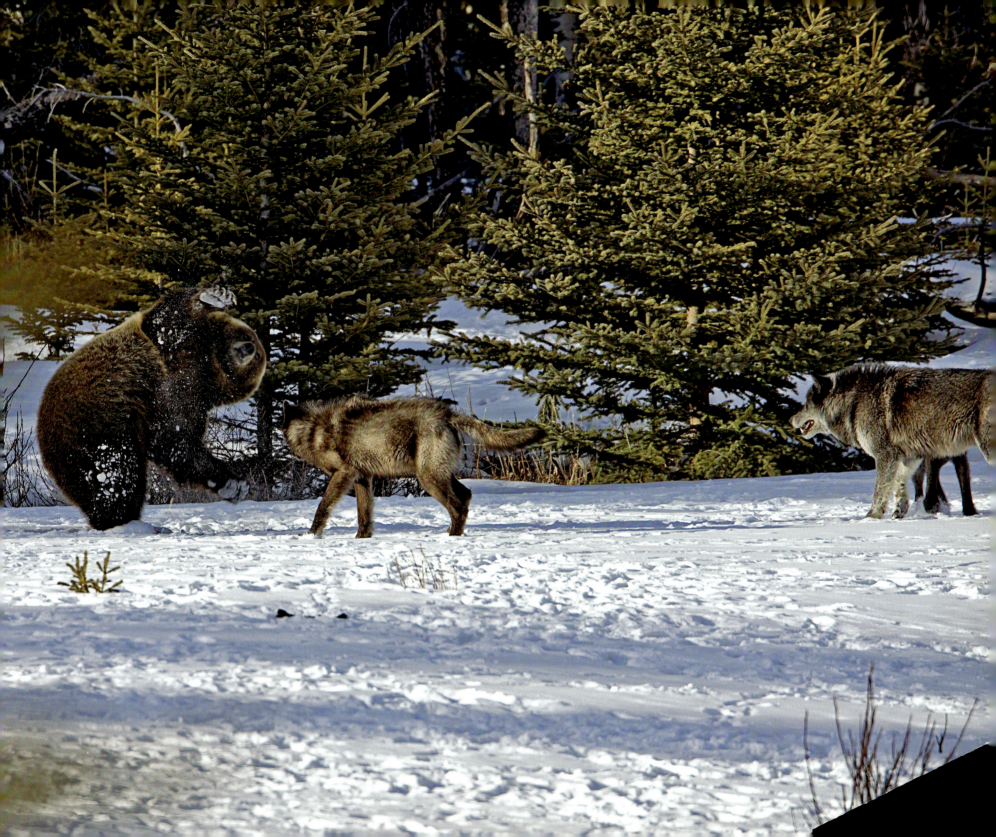

I returned the next morning to find the wolves in control of Nanuk's Hill. There was no sign of the bear. I was curious to know what had happened during the night, but the wolves did not give me time to think. They got up and left the scene in the direction of the Bow River. Fifteen minutes later the bear showed up. To my relief, he still looked as good as ever. He went over to Nanuk's Hill, sniffed around on the ground and then followed the tracks of the wolves into the woods. It only dawned on me then that the male grizzly bear was actually following the wolves. Not because he was lonely, but because he knew that where there were wolves, there was a good chance of stealing a meal.

Of course, it is also possible that the bear following the wolves had nothing to do with food. A few days earlier I had watched Lakota interacting with another brown bear. The two animals chased each other repeatedly over nothing more than a frozen old T-shirt. First the grizzly took it. Then the wolf stole it back. It may even have been the same bear. This type of keep-away is played in schoolyards all over the world. On some level they simply seemed to be enjoying themselves.

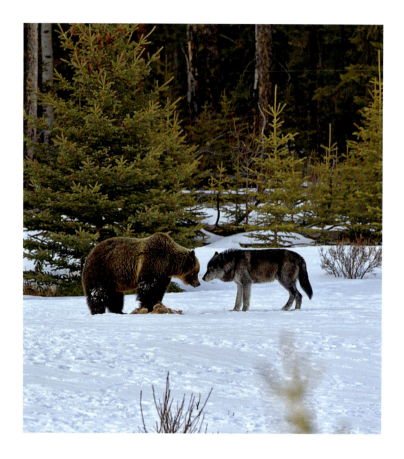

And the winner is? After a few long and stressful days, Nanuk approaches the bear in a non-threatening posture until he is only a few centimetres away from his mighty adversary. The bear shows no sign of aggression either. Eye to eye with each other, a moment of truce is reached. Only the shutter of the author's camera breaks the silence, causing both animals to look in his direction.

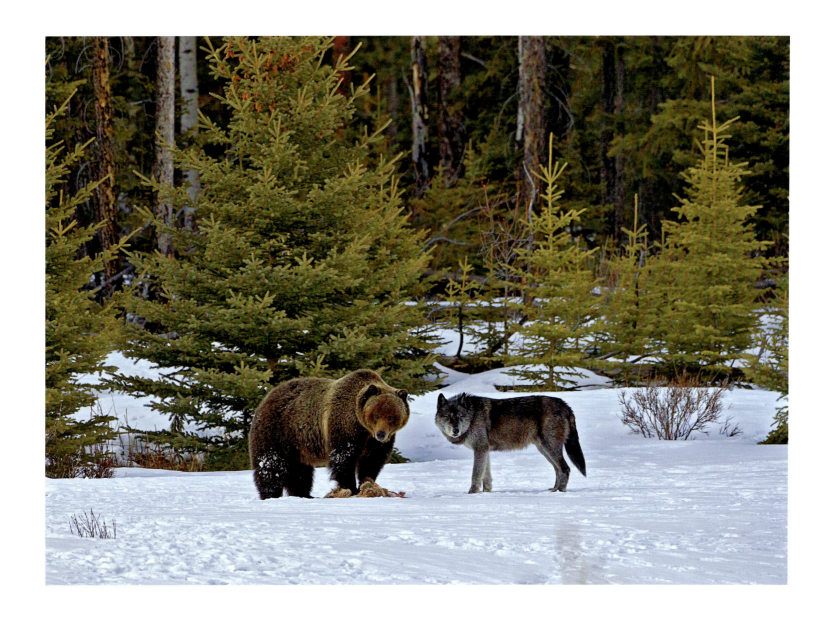

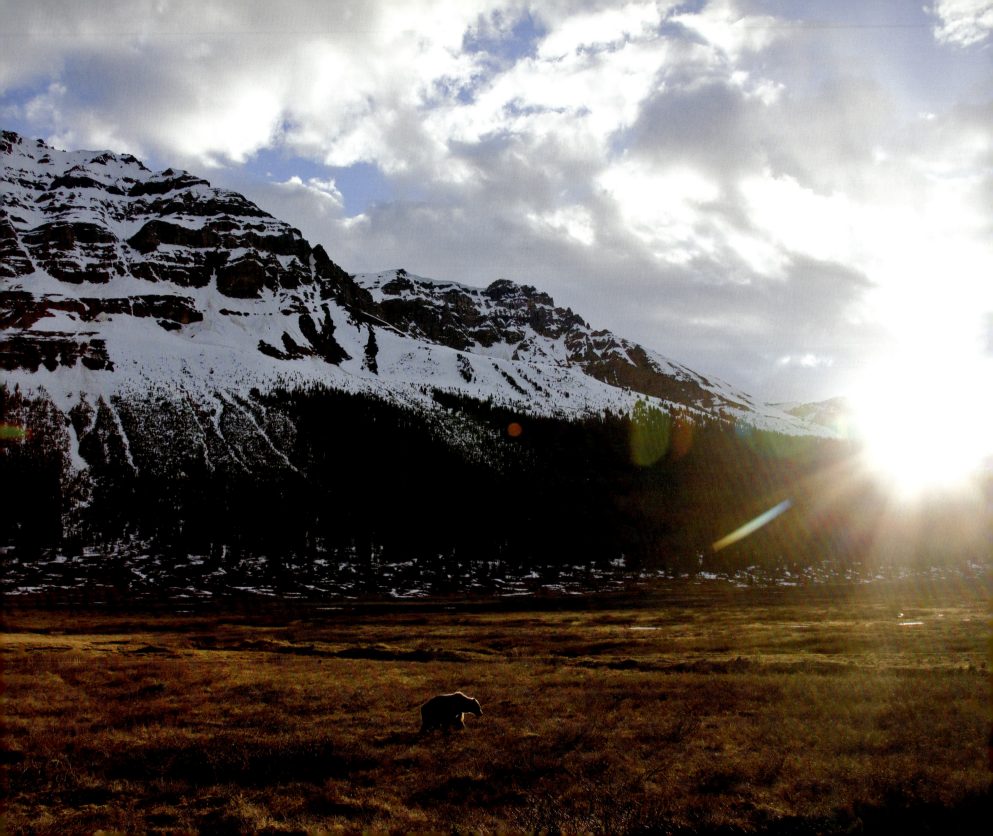

BEARS IN LOVE – PART II

Bears keep me humble. They help me to keep the world in perspective and to understand where I fit on the spectrum of life. We need to preserve the wilderness and its monarchs for ourselves and for the dreams of children. We should fight for these things as if our life depended upon it, because it does.

—Wayne Lynch, *Bears: Monarchs of the Northern Wilderness* (1993)

Two months later, at the end of May 2008, I was cruising the Bow Valley Parkway when I ran into fellow photographer John Marriott. He mentioned he had seen a grizzly bear with an ear tag only a few days ago: "It's 1729, a beautiful bear, but unfortunately he is limping badly. He doesn't seem to be doing very well."

On the way home I thought of the first male bear I had observed mating, in 2004. I had seen the ursine Casanova again in 2005, but not in 2006 or 2007. I wondered whether this was the same bear. At home, I dug out my slides and checked the ear tag number on the grizzly bear I had photographed. It was Bear 1729. I dropped all my other projects and took a weekend off from the Bow Valley wolves to look for the injured bear. I speculated that a car may have hit Casanova. After all, I had witnessed his narrow escape back in 2004 when he and his partner just missed being hit by a speeding motorist as they crossed the road at twilight.

Stopping in Lake Louise to grab a coffee, I bumped into a friend of mine and mentioned the injured bear. To my surprise, he told me there was not one bear, but three, hanging out near Lake Louise. As it is with creatures in love, he said there was also some fighting for the right to mate with the female. It was getting late, so I ran back to my car and raced to the spot where I hoped to find the bear. Just as the light began to fade, in waltzed Bear 1729. Casanova was back.

He looked just as impressive as I remembered him, but it hurt me to see how badly he was limping. He was moving north without any hesitation, but he could not seem to put weight on his left hind leg. Still, his pace was steady as he headed for a nearby pass. Then he stopped rather abruptly when he reached the summit. It was as if he decided to leave the area as fast as possible, but when he reached the pass, he was having second thoughts.

Just before crossing into the next drainage, he stopped and turned his whole body to face back the way he had come, raising his nose into the air to take a few deep breaths. Perhaps it was not easy for Casanova to take the last few steps over the summit. Knowing the full story as I write these lines, I have no doubt I witnessed a bear reflecting with nostalgia on what had happened to him in the days prior to this moment. Then he turned around walked over the ridge without looking back. I would not see him again for over a year.

The story of Casanova is remarkable. Alberta Fish & Wildlife officers caught him at the David Thompson Resort, just outside Banff National Park, near Nordegg, on August 6, 2003, when he was still a young bear. They relocated him to the Chungo Creek area northwest of Nordegg, which borders the southeast corner of Jasper National Park. Despite decorating him with an ear tag and two ugly radio transmitters, one in each ear, Alberta Fish & Wildlife had hardly any data on this bear. Apparently, nobody took the time to check on his whereabouts. After

Casanova on his way into "exile" at sunset.

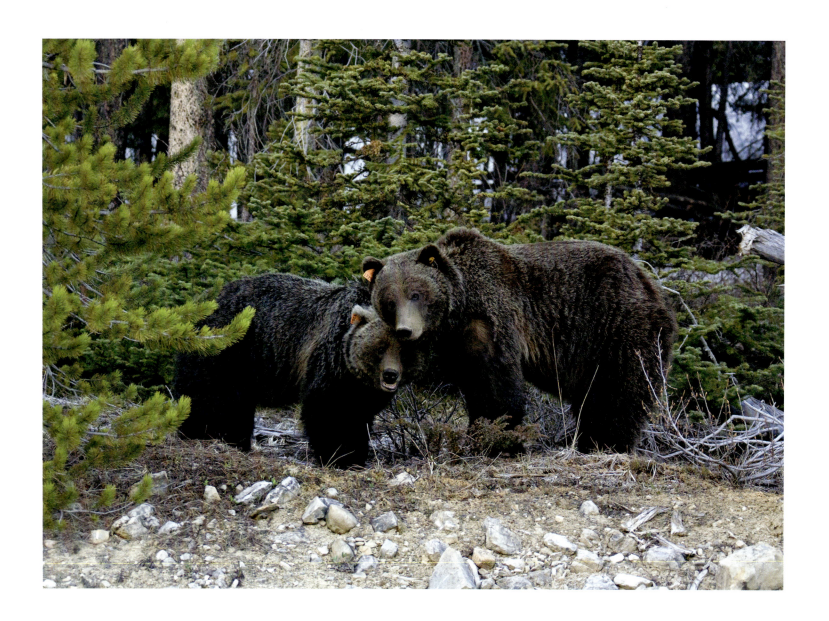

I spoke with Parks Canada bear expert Mike Gibeau, we decided that Casanova's main home range seems to be where he grew up, in the mountains and foothills on unprotected land east of Banff National Park. However, come spring, Casanova makes his annual pilgrimage into Banff National Park in search of a mate.

The first time he was seen in Banff National Park was in 2004, the same year I tried to capture grizzly bear behaviour in photos. Both Casanova and I got lucky that year: he found his first mate and I photographed my first mating pair of grizzlies. I found him again in 2005, with a female bear wearing ear tag #9301. I named her Jolie, the pretty one. Her time with Casanova gave her two cubs.

While researching the life histories of these bears, I discovered that Jolie was the daughter of Bear 36, also known as Blondie – the bear the warden had pointed me in the direction of back when I first met Casanova. Blondie was about 18 years old now and had had seven cubs during her lifetime, though only two of them lived long enough to venture out on their own. Jolie was obviously one of them.

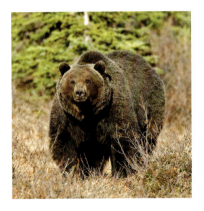

LEFT: Casanova and Jolie mated in May 2005. Their encounter gave Jolie two cubs.
RIGHT: Arnie shows off his impressive appearance. Male grizzly bears travel large distances in early spring in search of a potential mate. Once a receptive female is found and has accepted the male, the couple may stay together for several days.

By the time I found Casanova this time, in 2008, he had travelled into Banff National Park from his home range in the foothills, as he had so many times before. This time he ran into a familiar face, Jolie, the pretty one. Having already chased off their grown cubs, she was ready to mate again. Apparently, Casanova and Jolie had started courting in mid-May, but an even bigger male soon arrived on the scene. During an intense fight with the new big guy on the block, unfortunately, Casanova sustained an injury that forced him to leave his mate.

After watching Casanova leave the area, I decided to return first thing the next morning to find the reason for his exile. I did not have to search long before I found Jolie and her new lover crossing the road. My God, he was big! He had an enormous body but a relatively small head. He reminded me of a body builder, so I named him Arnie.

In the ensuing 26 hours, I observed the same rituals I had witnessed a few years before. The two lovers kept each other company, Jolie leading the way while Arnie followed close behind like a puppy following his master. When I stopped for the day, the bears were still playing, wrestling and mating. The next morning, a trail of fresh scat indicated they had followed Casanova over the pass. A few hundred metres below the summit, I found the two lovers wrestling playfully in the willows. After fooling around for some time, the male sat down and stared intensely at his partner. Jolie moved close to his side and placed her paw gently on Arnie's shoulder. He looked up at her and then slowly glanced over at me with that big, wide grin that only love can evoke. This was romantic bliss.

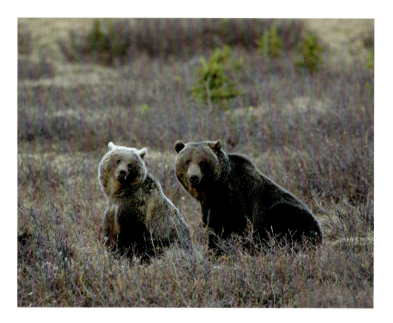
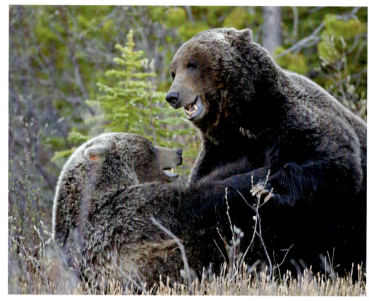

After fighting off Casanova, Arnie took over and was readily accepted by Jolie. Their breeding routine was the same as witnessed in 2004 (Casanova and an unnamed female) and 2005 (Casanova and Jolie): lots of gentle playing, wrestling, digging for roots (mainly the female), napping and resting (mostly the male) and of course mating. On all observed occasions, it was the female that dictated what was to take place where and when.

I thought about that scene on the long drive home, her arm around his shoulder and Arnie grinning right into my camera. More often, though, I thought of Casanova abandoning Jolie with resignation and hoped he would recover and find another mate. Maybe I would see him again next year. And if I was really lucky, maybe next year Jolie would be escorting some newborn cubs through the alpine meadows.

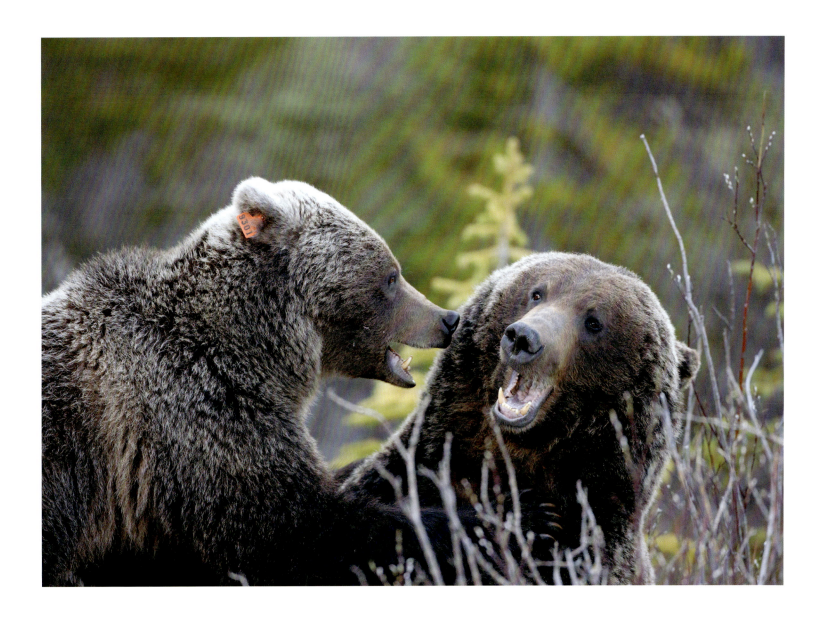

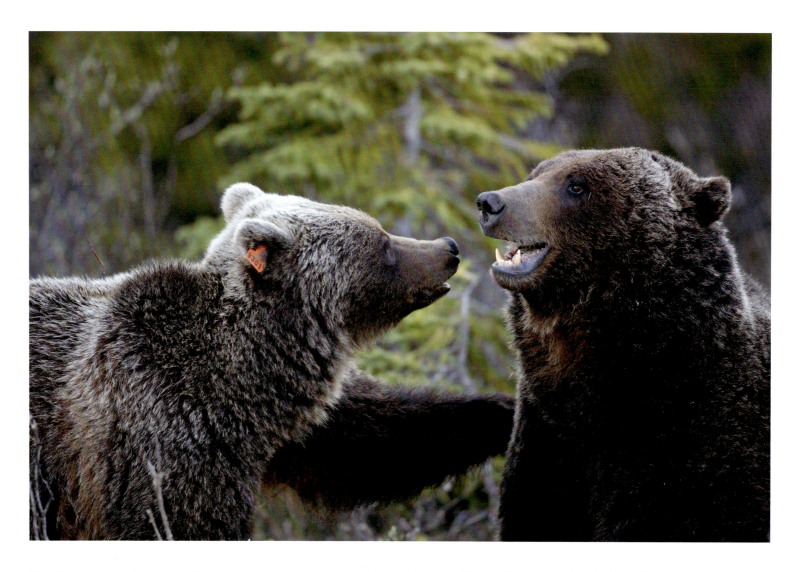

As Jolie puts her massive paw gently on Arnie's shoulder, he looks up at her and then over at the author, arguably full of pride and joy.

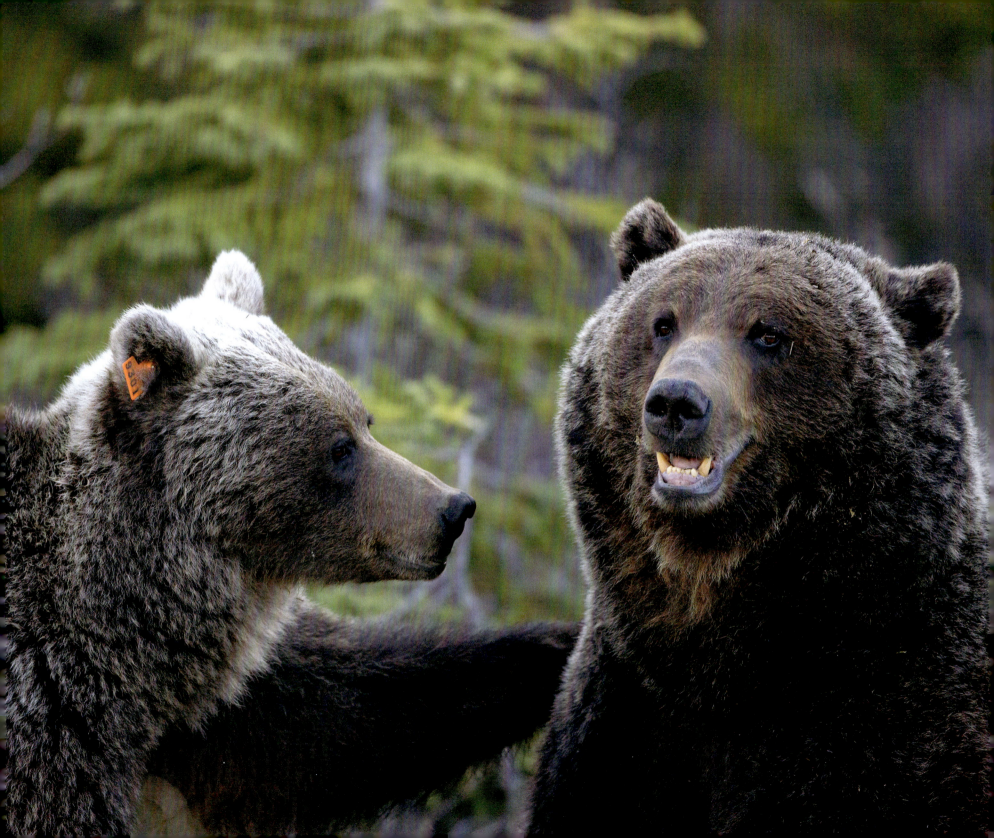

PLAYING GOD IN THE CANADIAN ROCKY MOUNTAIN NATIONAL PARKS

By the 1970s, when I was soaring and turning and circling over the dry bones of elephants on the barren plain at Tsavo, a curious situation had arisen, in which the accepted theories were failing to provide a successful basis for the management of living resources. It seemed to me that it is one thing to play games in a laboratory and pretend that nature is like an artificial container of fruit flies, but quite another to fool ourselves that such a game should be played out with the remaining treasures of wildlife and wild habitats in the realities of our complex and discordant world.

—Daniel Botkin, *Discordant Harmonies* (1990)

LEFT: Mount Rundle, Banff National Park.

ABOVE RIGHT: Heavy fog mixed with smoke in the Kananaskis area, southeast of Banff park. Fire has long been a very important component of life, death and renewal in the Canadian Rockies.

RIGHT: The so-called Hoodoo Creed prescribed burn in Yoho National Park in 2005 created a mosaic of burned and unburned tracts. In all, about 14 km² of mature forest was burned. While prescribed burns may be beneficial for some species, they also destroy important habitat for others, such as the mountain caribou. The caribou are heavily dependent on impenetrable old-growth forests that provide not only refuge from predators but also food and shelter during the harsh Rocky Mountain winters.

In the summer of 2008 Günther took me to the Fairholme wolf den that he had observed for weeks while collecting data for a research project many years earlier. Heading north of the Trans-Canada Highway, somewhere between Banff and Canmore, our route to the den took us through acres of blackened trees and burned forests. Since the early 1980s, Parks Canada has brought fire back into the Rocky Mountain national parks. Influenced largely by lightning strikes and First Nations fires, Parks Canada conducts prescribed burns to simulate the natural fire cycle that ruled the forest before Europeans began putting out every forest fire they saw.

In the winter of 2002/03, a prescribed burn was conducted near the well-known Fairholme wolf den. The fire got out of control and blazed over the wolf family's core territory, forcing the pregnant breeding female and her partner to leave the area. Displaced from its home ground, the male wolf got killed on the highway three weeks later near the town

Left: In the early days after the creation of Banff National Park, carnivores such as wolves and cougars were seen as vermin to be eliminated. And as Robert W. Sandford's book *Ecology & Wonder* points out, the slaughter didn't stop there. In 1886 one W.H. Whitcher recommended to the Minister of the Interior that additional vermin to be destroyed by park staff should include coyotes, foxes, lynxes, weasels, wildcats, porcupines, badgers, eagles, falcons, owls, loons, mergansers, kingfishers and cormorants.
Opposite: Elk graze near First Vermilion Lake, with Mount Rundle in the background in Banff National Park. Elk have been part of the Canadian Rocky Mountain landscape for thousands of years, as indicated by the archaeological records and early explorers' observations cited in the Banff Bow Valley study final report in 1996.

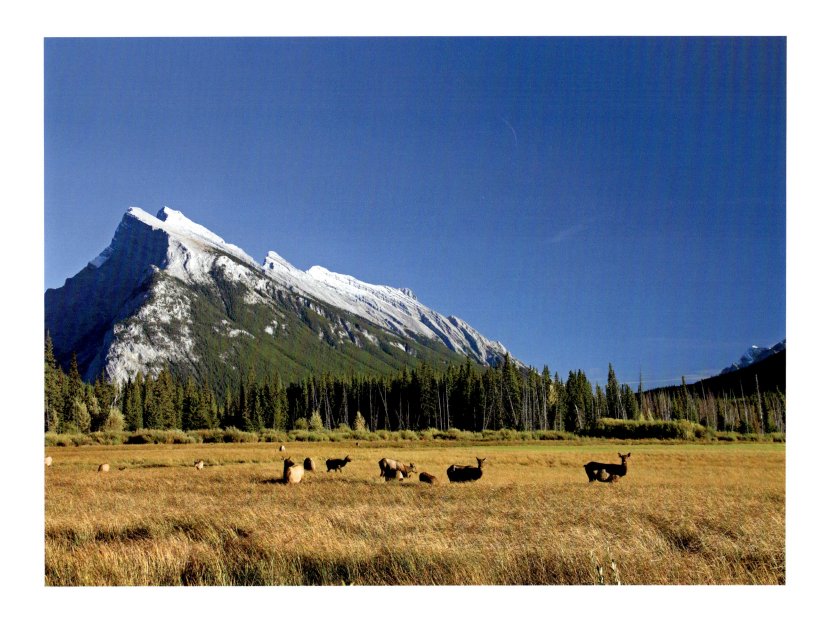

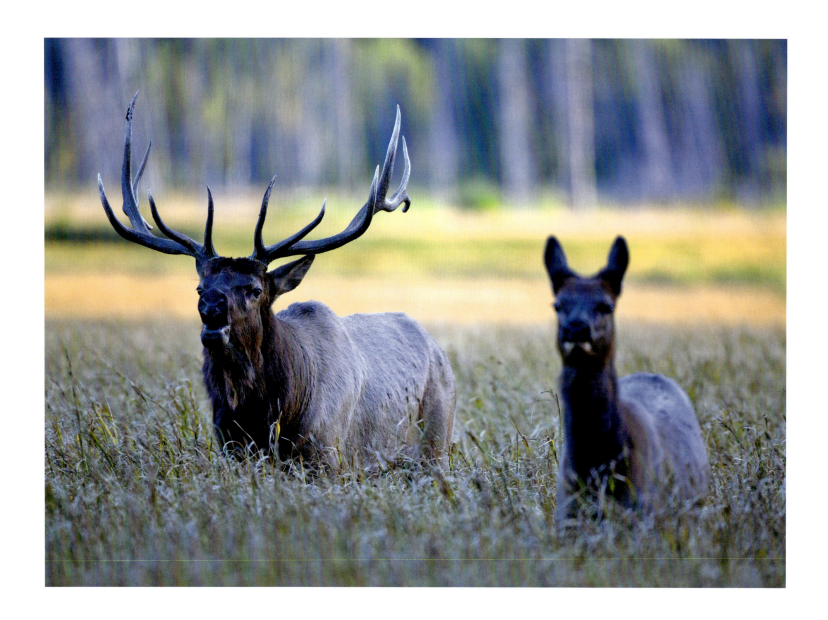

Before European Contact, elk flourished in what today is Banff National Park. With the arrival of trapping, hunting and railway construction in the 19th century, however, the elk population collapsed. Many railway workers hunted, for pleasure as well as subsistence; and considering that some 12,000 people were working in the mountains during the project, the impact must have been devastating not only to elk but also to flora and fauna in general, according to geographer Laurie Dickmeyer in "The Banff Bow Valley: Environmental Conflict, Wildlife Management and Movement."

of Canmore. Sadly, that fire hammered the final nail into the Fairholme family's coffin. We left the burn and followed a power line for a kilometre or so before re-entering the forest. Günther slowed down, checked the wind and listened. Finally, we walked into a clearing. "There's the den," Günther said, pointing. We walked up to the entrance to confirm what we already expected: the den had been vacant for years. Günther continued, "The fate of the Fairholmes is one of the best examples that Parks Canada is mismanaging these mountain national parks." Our journey that day was a difficult one for Günther.

The saga of elk in Banff National Park provides a clear example of how management is a highly contentious issue. For starters, how many elk should be *allowed* to live in the Bow Valley? Well, no one really knows how many lived there before the arrival of Europeans. Some maintain that Aboriginal hunting pressure kept numbers low, while others claim elk may have been abundant but not well documented. Consequently, every statement about normal elk density in the Bow Valley is debatable, simply because it is not known what is "normal."

One thing we know for sure is that in 1885, when Banff National Park was established, few elk remained within the park boundaries. By

The alternative word for elk, wapiti, derives from the Shawnee word waapiti, meaning "white deer." Wapiti would actually be the better word for this large deer, since in Europe "elk" refers to a different animal altogether: the moose. The British call moose "elk," as do the Germans with "Elch" and the Swedish "älg," to name but a few. It seems this somewhat unfortunate choice of word started when early European explorers, who were familiar with the smaller red deer of Europe, came to North America and had the impression that this large deer looked more like a moose than a deer.

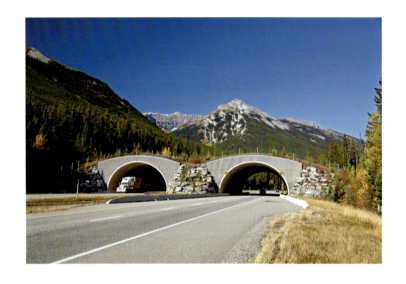

Top: The first wildlife-crossing structures were built in Europe in the 1950s. About three decades later, Banff National Park constructed its first crossings and installed ungulate-proof fencing along the Trans-Canada Highway in 1982. According to Parks Canada in April 2009, 11 different species of large mammals had used the 24 wildlife crossings between the park's east gate and Castle Junction 186,000 times since 1996. However, these numbers may be somewhat misleading. Grizzly crossings, for example, increased from seven in 1996 to more than 100 in 2006, although the actual number of individual bears using the structures remained constant over that time, at between two and four, according to Parks Canada unpublished results.

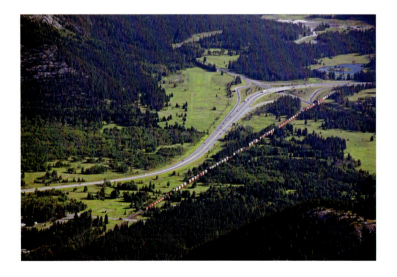

Bottom: The massive human ecological footprint is a serious threat to the overall biological health of our planet. Among the major threats to wildlife populations is the fragmentation of habitat and the construction of physical barriers such as highways and railways. This July 2008 aerial photo shows the Trans-Canada Highway, the Lake Minnewanka/Banff townsite interchange and the CPR line through Banff National Park. In the upper middle of the photo is the grass airstrip that was decommissioned as a direct result of the Banff Bow Valley study in 1997. However, despite Parks Canada's intention to close the airstrip and a finding by Transport Canada in 1995 that "the aerodromes [i.e., the grass airstrips of Banff and Jasper] do not play a significant role in ensuring aviation safety," the Government of Canada determined in 2008 that for reasons of "aviation safety," both airstrips would be relisted.

the early 1900s, all elk had been extirpated from the Banff Bow Valley. Superintendent reports from that period often mention overharvesting by humans as the probable cause of their disappearance. Nearly three decades earlier, bison had also been exterminated from the area, with the last one reportedly shot near Lake Louise in 1858.

By the late 1800s the area was already an impoverished shadow of its pre-European self, but the creation of Banff National Park escalated the endless game of ecological manipulation: the judging of living beings as good or bad, friend or enemy. In an effort to eliminate the so-called vermin from the park, Parks Canada began its long war on cougars, wolves, coyotes, eagles, owls and other unwitting species. For instance, the 1995 Banff Bow Valley study indicates that between 1924 and 1936, wardens of Banff National Park killed 33 cougars. The fate of wolves was not much better. Wolves in the central Rocky Mountains were scarce by the early 1900s. By 1914 none remained in the Bow Valley.

Wolves are nothing if not resilient, so they had naturally recolonized the national parks by the 1940s. However, a rabies scare further exacerbated a somewhat inherent hatred of wolves. Between 1935 and 1955, bounty hunters killed about 20,000 wolves in BC. In Alberta, between 1942 and 1955, the wolf population was reduced by 12,000 individuals. Despite only diagnosing one rabid wolf, 90 per cent of Alberta's lupine population was eliminated.

While wolves did recolonize other parts of Jasper and Banff over time, it was not until the early 1980s that the first ones returned to the Bow Valley to reclaim their traditional territory in the heart of Banff National Park. Foreshadowing what was to come, the first wolves were killed on the Trans-Canada Highway in September 1986 and January 1987. The Fairholme wolf family staked its claim in the eastern part of the valley in the winter of 1999, excavating the den on the Fairholme Bench where Günther had done his behaviour observation.

Ungulates were among the more fortunate species after the creation of Banff National Park, likely due to their popularity as game animals. A few native elk had begun to recolonize the Bow Valley around 1915, and between 1918 and 1920, park managers even imported a few trainloads of Yellowstone elk to help bolster the depleted herd. By the 1940s the elk population in the Banff Bow Valley had rebounded dramatically. Between 1944 and 1953, average autumn population estimates were around 648 individuals. However, population estimates vary greatly, dubiously doubling from 1,200 in 1944/45 to 2,500 in 1945/46.

Suddenly, park managers believed elk were overrunning Banff. For nearly three decades, beginning in the early 1940s, managers actively controlled elk populations in the Bow Valley through annual culls and live transplant programs. Between 1941 and 1969 a total of 3,923 elk were killed, with a peak of 352 in 1946. Government-initiated elk slaughters, along with railway kills, were the main causes of elk morality during this period. Ultimately, elk populations shrank dramatically.

After the cessation of the elk slaughter program in 1969, management attention shifted to the increasing number of elk being killed in collisions with vehicles and trains. Rising volumes of highway traffic in particular took a dramatic toll on elk populations during the 1970s and 1980s. Mostly prompted by the simultaneous increase in risk to motorists, Parks Canada began to erect elk-proof fencing along portions of the Trans-Canada in 1983. Yet, Banff's roads and rails still took the lives of 150 elk in 1986 alone. Eventually, however, these fences did reduce the number of elk killed on the highway by more than 90 per cent.

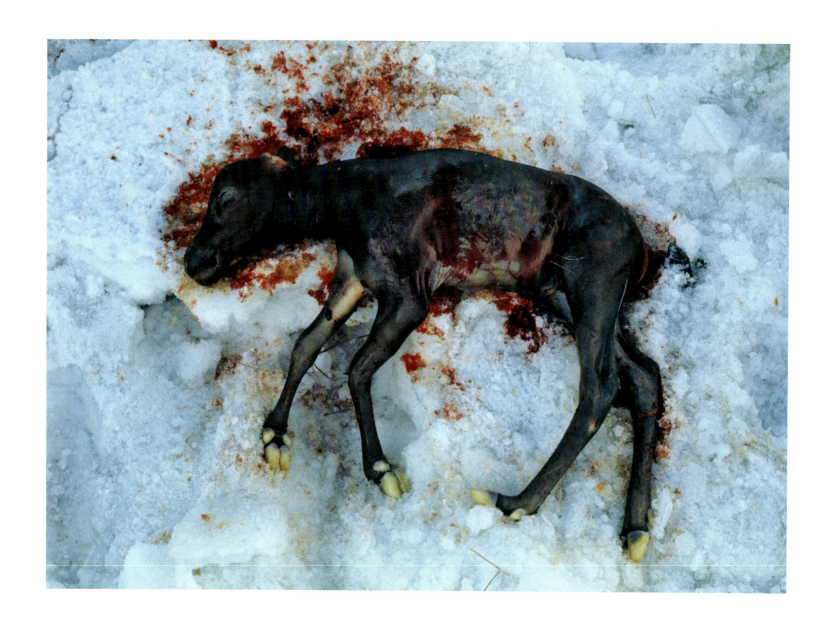

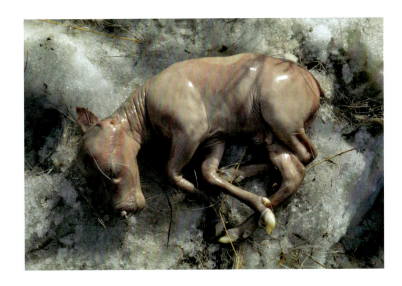

Unborn elk calves lying on the road and between the railway tracks in Banff National Park. The impacts of these encounters with a car and a locomotive were so severe that the pregnant elk were sliced up and their unborn calves thrown out. Images courtesy of Hälle Flygare, former park warden.

Cliff White, a retired environmental sciences coordinator for Banff National Park, told the *Rocky Mountain Outlook* newspaper in March 2009 that in the "late 1970s, the Bow Valley elk population was relatively low because of mortality on the unfenced Trans-Canada Highway." He elaborated: "But by the early 1990s, the Bow Valley elk population had bounced back to around 1,000. [...] As well, the return of wolves to the Bow Valley in the 1980s had, by 1998, dramatically reduced elk numbers throughout the Bow Valley, except near the Banff townsite, where elk were seeking a safe haven from predators."

White did not mention, when pointing a finger toward the wolves, that according to the Banff Bow Valley study (1995), the primary causes of elk mortality in the late 1980s and early 1990s were human activities and influences. From 1985 to 1992, between Banff Park's east gate and Lake Louise, trains and motor vehicles claimed 66 per cent of elk deaths, while wolves were responsible for only 18 per cent. Thus, despite Cliff White's assertion in the newspaper, humans accounted for three and a half times more of the total elk mortality than wolves did during this period.

While it may be true that four-legged predators such as wolves and cougars encourage elk to congregate around the Banff townsite, Parks Canada's highest officials often miss the opportunity to provide the public with a more complete picture of what happens in the Bow Valley. The Banff townsite attracts ungulates not only because of the lack of predatory pressure but also because of the large amount of lures (i.e., food) on soccer fields and golf courses. According to the 2007 Management Plan, between 100 and 400 elk annually use the Banff Springs golf course because of a plentiful supply of attractive vegetation.

Believing that elk in and around Banff were a public safety hazard, and that wolves were not likely to reduce elk numbers so close to town, park managers intervened again between 1999 and 2003. During that time, park staff relocated 251 of the so-called town elk to other areas, either in or outside the park. Unfortunately, once beyond the park boundaries, these human-tolerant elk were easy targets for hunters. For those town elk remaining, Parks began aversive conditioning, such as bringing in dogs to chase the elk out, to increase the animals' wariness and restore their migratory behaviour. By 2003, park managers had reduced the number of elk from the Central Bow Valley herd to 121 animals, from 467 in 1999.

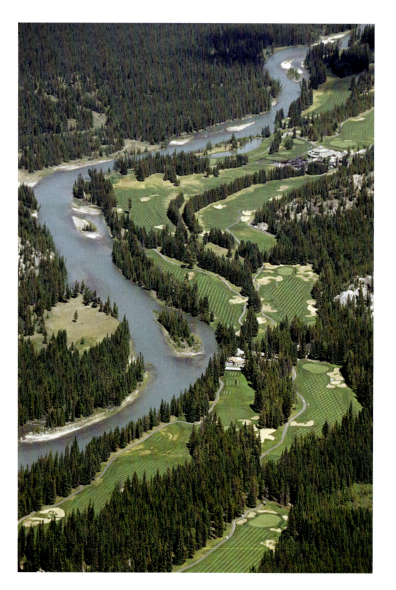

Some wolves, however, did learn to prey on the town elk in the late 1990s and early 2000s. The Fairholme family, for instance, took down many elk near or even within the town, which directly challenged the myth that wolves would not come near town to prey on elk. As a result, Parks Canada staff came to see the wolves as public safety hazards too, particularly once the number of town elk was reduced and the wolves had to look for something to replace their previously abundant food source. Two young Fairholme wolves began to show up near campsites, which led to Parks eventually shooting them. Those deaths, along with the prescribed burn that destroyed much of their territory and the

Opposite: Collared elk in Banff National Park. Elk populations have been and continue to be actively manipulated by Parks Canada within park boundaries, not only in Banff but also in Jasper.
Left: Where once native hunters and gatherers camped along the Bow River one can find nowadays the Fairmont Banff Springs Hotel's 27-hole golf course. As a 2007 amendment to the Banff National Park Management Plan says: "The Spray Valley is an important wildlife corridor between Kananaskis Country and the Bow Valley. Because of its location between the Lower Spray and the Bow River, the golf course interferes with wildlife movement through this area… other factors affect wildlife movement between Sulphur Mountain and the Spray Valley. These include vehicles on the golf course loop road, operation of the sewage treatment plant, and hiking and skiing along the Spray River." The overall number of elk in the Banff Bow Valley has been, despite some misleading statements found in the press, steadily declining since the 1990s, from an estimated 914 animals in 1988 to approximately 267 in 2009.

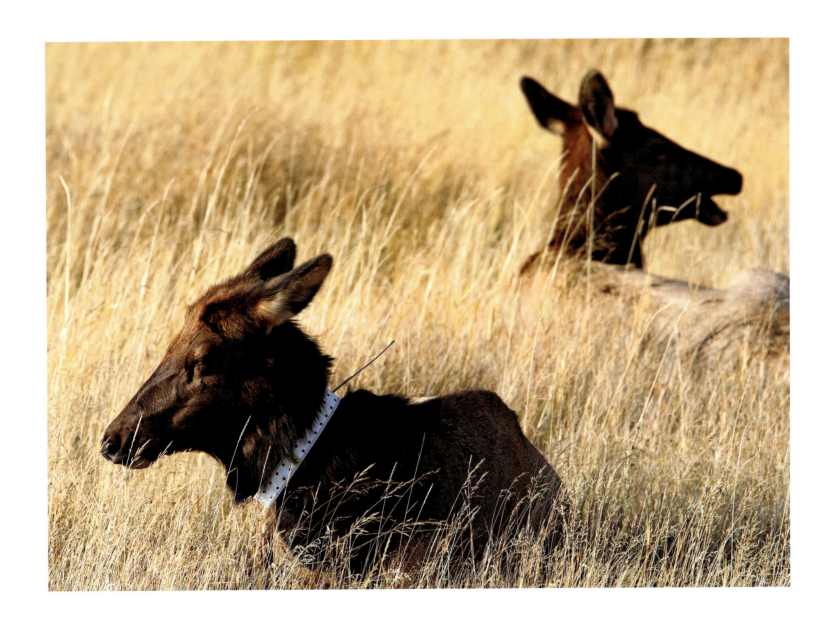

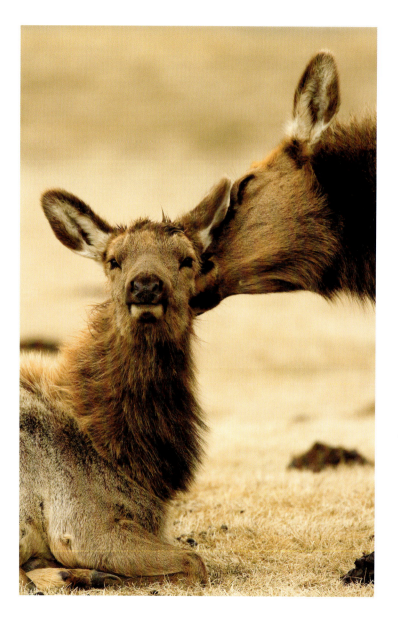

A mother elk grooms her nearly 10-month-old calf with great care and affection. In 1996 the Banff Bow Valley study recommended fencing off the townsite to reduce confrontations between people and elk and allow a natural predator/prey relationship to re-evolve.

reduction of necessary sustenance (i.e., elk) around the Banff townsite, simply overwhelmed the Fairholme family.

"Parks Canada's management decisions disrupted the natural order of things," said Günther on the way home from the abandoned Fairholme den. "They ultimately led to the collapse of the Fairholme wolf pack [in 2003]."

Is it too much to ask that, in a national park, we minimize human intervention and interference to allow the natural predator/prey dynamics to play out by the rules of nature rather than by the preferences of humans?

Yet, despite previous lessons, management practices have not changed much since 2003. For instance, in order to address the so-called elk problem, human/wildlife specialists are considering all sorts of manipulative techniques, from injecting elk with experimental birth control drugs to the use of shock collars to prevent them from using habitat near the townsite. Tom Hurd, a Parks Canada wildlife biologist, told the *Rocky Mountain Outlook* in May 2009 that "the final option is a temporary increase to remove 40 elk in 2010 and 30 elk in 2011, followed by 10 to 12 a year after that until there are about 80 to 90 cows remaining near Banff. Habituated elk removals from the in situ cull were 12 in the winter of 2006/07, 20 in 2007/08 and 16 in 2008/09." Hurd maintained that Parks will "…continue aversive conditioning, but [Parks doesn't] think [that this] by itself is the answer to encouraging migration…[aversive conditioning is] more a public safety measure designed to keep elk out of town and reduce habituation."

All of this in the name of controlling what Parks Canada perceives as a burgeoning elk population around the Banff townsite. In a previous *Rocky Mountain Outlook* article, in February 2009, for example, Hurd claimed the Central Zone elk population had increased from fewer than 100 to more than 250 in the previous four years. But although Parks Canada maintains that elk numbers have more than doubled, the reality is that the elk population has significantly collapsed.

Let me explain. Parks Canada differentiates between three zones when conducting aerial counts: East, Central and West. The East Zone covers from the east gate of Banff Park to the Minnewanka interchange, excluding the golf course and the Tunnel Mountain campground. The Central Zone is from the Minnewanka interchange to Five Mile Bridge, including all of Tunnel Mountain campground and the golf course. The West Zone is the area west of Five Mile Bridge up to around Lake Louise. With these zones in mind (see map on p. 181), consider that elk are migratory animals, albeit some more than others, and do not necessarily remain in only one of Parks's three zones.

We cannot discuss Banff Bow Valley elk herds realistically when only focusing on only one part of the overall population. Yes, the Central herd may have more animals than it did four years ago, but the Western and Eastern herds may now have far fewer. And this is exactly the case. For a true elk population estimate, you must take the count of elk around the townsite (the Central herd) and add the counts from the West and East zones to get the whole population. Overall, the number of elk in the Banff Bow Valley has dropped from an estimated 914 animals in 1988 to only 254 in 2008.

While numbers are important, focusing only on them detracts from the larger picture. The problem is not the elk or the wolves. The problem is the townsite: human interference and infrastructure that undoubtedly hinders a healthy and sound ecosystem where nature can evolve on its own terms. Unnatural food in the townsite attracts elk, which are happy to forgo migration in an extensively fragmented landscape to instead raise their young in a place where the risk of being killed by wolves, bears, cars or trains is lower. Of course, wolves then try to come into town, too, to access this abundant food supply of elk, but locals and Parks staff treat them, as well as their potential prey, as severe public safety concerns.

The only real way to improve ecological integrity would be to relocate the townsite. Another option would be to allow all the animals to use the town as part of their territory. Or, probably the simplest solution: dramatically reduce the human footprint in and around the town by closing the golf course and fencing off the townsite so that neither wolves nor elk pose a "threat" to the human inhabitants that do not know any better.

While park managers focused much time and money on reducing and manipulating elk populations in the Bow Valley, they let Banff's mountain caribou population disappear altogether. The southern mountain caribou of Banff and Jasper, called "woodland caribou," are remnants of what were likely huge herds from after the last big glacial interval 11,000 years ago. Warnings of declines in these caribou populations began during the mid-20th century. By the end of the century, the population in Banff National Park was precariously small and at serious risk of what biologists call a stochastic event: a disease, say, or a speeding truck that wipes them all out at once. Just such an event occurred in April 2009, the same year Parks Canada was culling 16 of its elk, when an avalanche north of Lake Louise wiped out every one of Banff's remaining four or five caribou. The sad fact is that, despite

scientific warnings dating back over 50 years, Parks Canada did virtually nothing to avoid or prevent the total disappearance of *Rangifer tarandus caribou*, the woodland caribou.

There is no need for more science, more reports, more meetings or more dialogue if those things continue to lead nowhere. The real need is for more leadership, more commitment and more accountability at the highest levels of the political apparatus. How many heads rolled when the caribou population disappeared because no recovery plan was developed for them in Canada's most famous national park? None. If the politicos responsible for managing Canada's wildlife populations can blind-eye the evidence and allow the caribou to totally disappear without any repercussions, what hope is there that they will look after the declining mountain caribou herds in Jasper or the struggling grizzly bear populations?

Banff's last caribou herd went extinct when the four or five surviving animals got caught in an avalanche north of Lake Louise in April 2009. Jasper's southern mountain caribou herds, estimated at about 500 animals in the 1960s, were down to about 87 in 2009. The animal in the picture opposite is part of the Tonquin herd, which numbered 74 in 2009. It is worth noting that, according to Paul Paquet, no wolf predation of caribou has ever been recorded in Banff National Park, and that the herds of the mountain parks of Banff and Jasper started to decline in the 1950s, at a time when human control had nearly eliminated all wolves from the parks!

Speaking on behalf of Parks Canada, which is responsible for managing species at risk in Canada's national parks, we are a world leader when it comes to recovering species at risk and we are achieving real conservation results.
—Alan Latourelle, CEO of Parks Canada Agency
letter to the editor, Edmonton Journal, *January 14, 2010*

Alan Latourelle may well believe what he says, but the evidence continues to support that Parks Canada is anything but a world leader when it comes to preserving the ecological integrity of their parks. In the mountain national parks alone, persistent development forces animals to increasingly endure jarring relocation and death. Manipulating populations and reducing them to arbitrary target numbers leave elk in a precarious position. Moreover, black bears die by the dozen every year, with a recent report (2010) indicating that a *minimum* of 477 black bears were killed in the mountain national parks between 1990 and 2009. Appallingly, humans caused 449 of those 477 deaths. Struggling moose, grizzly bears and wolves are also being slaughtered by trains and cars at an unsustainable rate.

The Rocky Mountain national parks are, sadly, mortality sinks for some of the most iconic species of Canada. Parks Canada needs to seriously act on its legal obligation to manage with ecological integrity as paramount, rather than allowing business and transportation lobbies and tourists to dictate and undermine the long-term future of Canada's "crown jewels." Yet, few people seem to care, at least not enough to make the necessary changes.

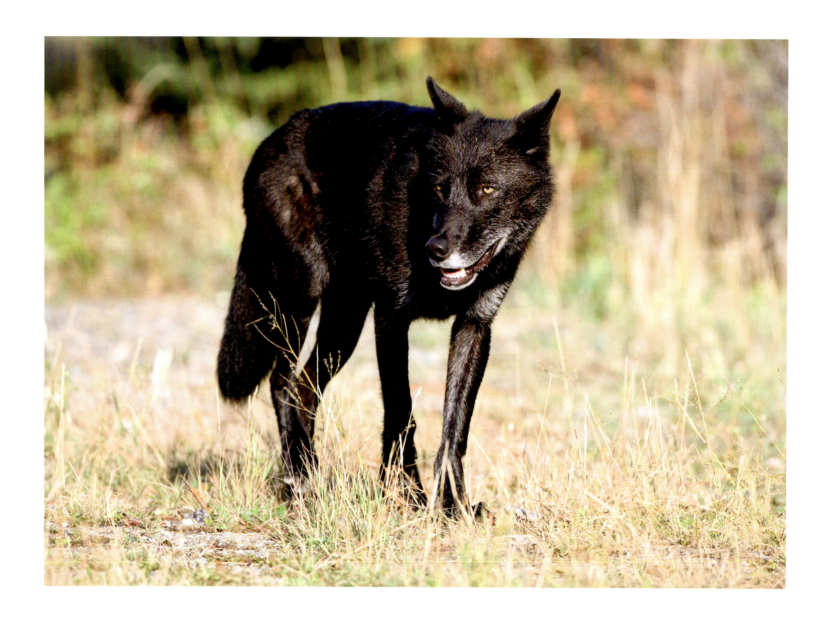

THE END OF THE BOWS

Somewhere to the eastward a wolf howled; lightly, questioningly. I knew the voice, for I had heard it many times before. It was George, sounding the wasteland for an echo from the missing members of his family. But for me it was a voice which spoke of the lost world which once was ours before we chose the alien role.

—Farley Mowat, *Never Cry Wolf* (1963)

"I've got terrible news, Peter." It was Günther. He paused and all I could hear on the other end of the phone was breathing. After a moment, he continued, "Delinda was killed on the highway a few days ago."

The news dropped me down into my seat. August 25, 2008, the day a vehicle killed Delinda on the highway, would become the day that everything changed.

"I was called in by Parks Canada officials to identify her," Günther continued. "You can imagine how I felt, seeing her dead like that."

Ten days later, the day I returned to Canada after a summer in Switzerland, I learned that another tragedy had befallen the Bows. On September 4, 2008, Silvertip, Delinda's son, also died on the Trans-Canada Highway, not far from where his mother had died two weeks earlier. Again it was Günther's responsibility to identify the body, so I joined him.

I watched as a park warden dragged the two dead wolves from the freezer, their faces frozen into grimaces. Delinda's eyes were open and her body looked to be in good shape. I could not tell a car had hit her. The same was not true of Silvertip. His head had been ripped wide open, exposing his brain. I could still see the terror in his frozen eyes.

ABOVE: Silvertip died not 50 metres from this heavily damaged section of fence along the Trans-Canada Highway. It took Parks Canada more than six weeks to fix the breach. Two weeks before Silvertip's death, his mother had been killed by a vehicle on the fenced part of the highway. LEFT: Delinda, whose death was in many ways a huge blow and ignited the end of the Banff Bow Valley wolf family. The percentage of wolves surviving their first year in the wild is hard to determine. Various studies put the figure at anywhere from 6 per cent to 80 per cent. Delinda and her partner, Nanuk, were undoubtedly highly successful parents in this regard. In 2006 two of their four known pups survived their first year (two were killed on the Bow Valley Parkway). In 2007 all six of six known pups survived, an amazing 100 per cent! Delinda and Nanuk built the perfect team in bringing some stability to the beleaguered wolf population of the Banff Bow Valley.

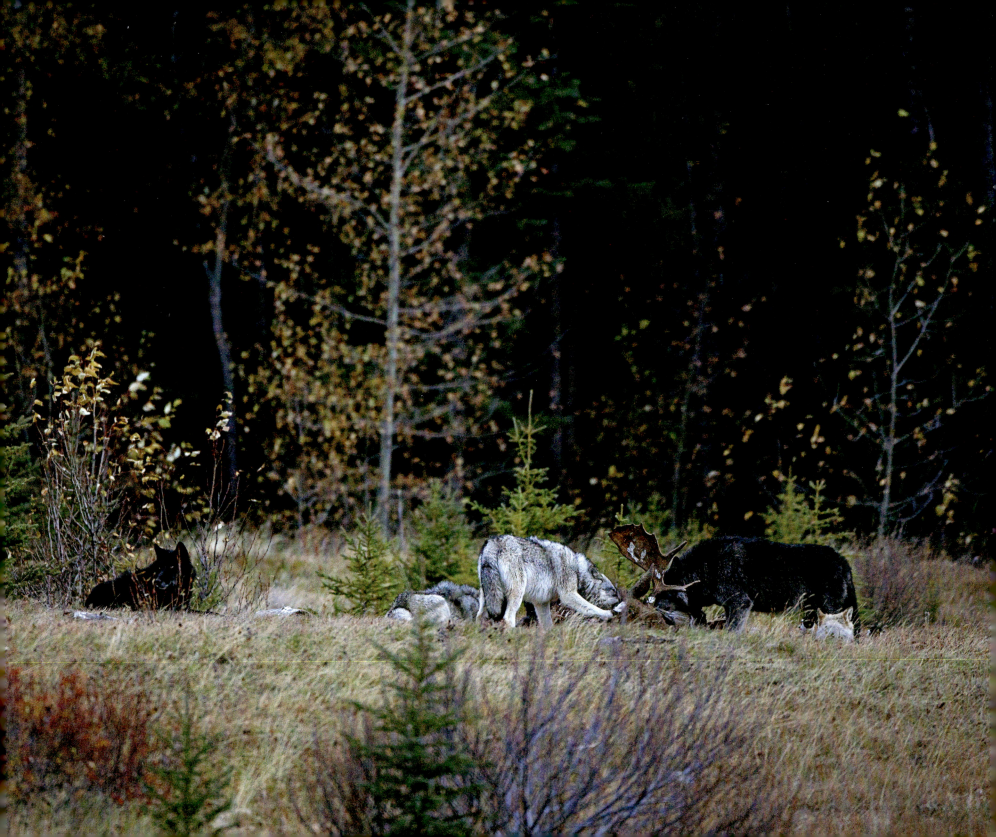

It was a terrible sight. I quietly took some pictures of the two dead wolves and walked back outside into the cool air.

I needed to visit the site of the collision. Near the bloodstains painting Silvertip's spot, I saw that a huge white spruce had fallen across the top of the protective fence, damaging it. Silvertip may have come over this spruce onto the highway, searching for his disappeared mother. Maybe he had found some of Delinda's scat or a scent mark and followed it through one of the many holes in the fence. We will never know. The fact is that within two weeks, Delinda and her son Silvertip both died on fenced parts of the Trans-Canada Highway. Despite our reports to Parks Canada, it took at least six weeks to repair the damaged fence. Broken fences not only put wildlife at risk, but also endanger the lives of the people who drive on the Trans-Canada, yet Parks Canada does not check the fences regularly for damage or holes.

A few weeks later a wolf from a different family was found wandering around on the traffic side of the fence. In a joint effort, Parks Canada staff and the RCMP tried to get the wolf off the highway. They opened up all the gates, hoping it would find its way back onto the safe side of the fence. It did not work. The wolf did not trust the open gates. Instead, he slipped quietly back to the wild through one of the many holes in the fence. How appropriate.

The Bow Valley wolf family feeding on a moose carcass in October 2008, after the deaths of Delinda and Silvertip. From left to right are Sundance, White Fang, Fluffy, Nanuk and Survivor (Ranger is hidden behind Fluffy and White Fang). Youngsters such as Survivor are heavily dependent on their parents to learn survival skills. Unfortunately, their learning is constantly being disrupted by human-caused deaths.

Although Silvertip's death went largely unnoticed, Delinda's drew widespread interest. In part, the attention was because her larger-than-life photo decorated one of Banff's newest transit buses. Her death even warranted an article in *Maclean's*, Canada's most prominent national newsmagazine. Suddenly everybody knew the deceased black wolf by the name Günther had given her. "It's tragic and it has affected me deeply," said Banff mayor John Stutz. "The fact that it's the one on our bus, well that will be a lasting tribute."

Where have these deeply affected people been all these years? Delinda was not the first wolf killed on the highway or the railway. What changes have these deeply affected people brought forward or supported to ensure that the slaughter stops?

The statement that made me the angriest was one by Banff National Park spokesman Mark Merchant. "It was an important wolf," he said, "but with the death of this dominant female, the next dominant female will simply take over." The survival of individuals in a safe and healthy ecosystem does not seem to matter to Parks Canada, only populations and numbers. And if that means the Bow Valley is a mortality sink for wolves (and bears) that come in from the backcountry to replace the dead and the dying, well then, that must be fine too. But as the case of the missing caribou makes perfectly clear, the attrition of individuals can extirpate whole populations, even as Parks Canada sits on its hands and watches.

The loss of Delinda came as a huge blow to the Bow Valley pack. Delinda had been an important stabilizing factor and now she was gone. Along with her presence, the family lost her knowledge of hunting techniques and food availability, her survival tactics and territorial awareness, and importantly, her social skills. Her mate, Nanuk, was once again without a partner. The dismantling of the Bows was in full swing.

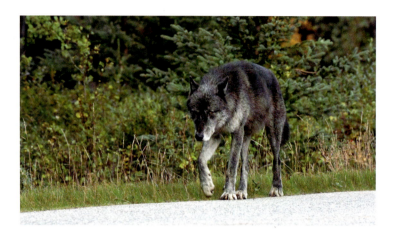

Later in the fall of 2008 we figured out who remained in the clan. On October 15, my birthday, Günther and I watched the remaining Bows feed on an ungulate carcass near the Trans-Canada Highway east of Castle Junction. All of the remaining 2007 youngsters were there: Fluffy, Sundance, Ranger and White Fang. And Nanuk. We never discovered the fate of Mickey. Chinook, the daughter of Nanuk and Delinda from 2006, had decamped early in the year to points south, likely to Kootenay National Park. Lakota, Chinook's brother, is apparently no longer part of the family and has been seen a few times near Lake Louise. To our surprise, we also saw a youngster, the only surviving pup of the disastrous 2008 summer. We called him Survivor. He was just 6 months old.

Nanuk was not as active as I remembered him. He was never the most energetic of wolves, but if the family needed him, he was there. I thought about the time the Brave One showed up on Nanuk's Hill and Nanuk took care of the bruin and kept him in his place for days. He took full responsibility, as only the best leaders do. Nanuk was the brave wolf that bit the massive grizzly bear on the butt as he approached his pregnant mate, Delinda. Now, only five months after that glorious fight, Delinda was dead and so was a bit of Nanuk's heart, or so it seemed to me. He had no desire to play with his children; he simply fed peacefully on the carcass with the other family members and then disappeared back into the forest, out of sight. It was not the first time he was alone, but every creature has limits.

LEFT: Nanuk had to endure many difficult losses in his life. How would he and his remaining family, such as Fluffy, be able to cope with the loss? What and how do social and highly intelligent animals such as wolves feel? Jim and Jamie Dutcher documented in their film and book *Living with Wolves* the grief and mourning in a wolf pack after the loss of a female relative to a mountain lion. The pack lost their spirit and their playfulness and their howls took on a very different than normal, almost eerie quality. They seemed to be in mourning. It took about six weeks for the pack to return to normal.

OPPOSITE: The Brave One in his prime, during the epic battle with the Bow Valley wolf family in late March to early April 2008. One year later he would be killed by a CPR train. When it comes to bear mortality in Banff National Park, the CPR right of way is, per kilometre, six times deadlier than highways, according to Benjamin Dorsey of Montana State University in a May 2010 Parks Canada Research Update talk. Dorsey also pointed out certain "high risk" areas found along the CPR tracks. One of these is near Five Mile Bridge, where a total of six grizzlies have been killed since 2007. Among the dead were the family on p. 66 and the Brave One.

Winter came and with it more troubled times for Nanuk and company. In February 2009 a vehicle hit another Bow Valley wolf, this time on an unfenced part the Trans-Canada Highway just east of Lake Louise. It was Ranger, the shy black female born into the Bow Valley family in April 2007. A few weeks later, on Highway 93 south not far from Castle Junction, another vehicle struck down a wolf. We knew the Bows had been in the area that night. In fact, Günther found wolf tracks going in the same direction the wolf was when it was hit by a car. Since that day, we have never seen Survivor again. It seems Survivor was not that lucky after all.

I wish I could end it here, but like a Cormac McCarthy novel the bad news just would not stop. In May I found out that a train had hit and killed a large grizzly bear near Five Mile Bridge in Banff National Park. The news worried me. Bears like to use the same territories year after year, so I instantly thought of the Brave One. I phoned park warden Steve Michel and he agreed to meet me in Banff to show me the bear. It lay motionless, face down, not 20 metres from the railway.

"That's where he collapsed after being hit by the train around 1 a.m. on the 15th of May," Steve explained as he scrolled through the pictures on his laptop. He continued: "He was a huge male grizzly in his prime, 272 kilograms (600 pounds). That's really big for this area and especially for this time of year." He stopped on a close-up of the bear's massive face. Based on the photographs, the location, the time of year and his exceptional stature, we both agreed that it was likely the Brave One. I had photographed him just a year before in the epic battle with the Bow Valley wolf family. My frustration, anger and sadness grew as I tried to process this new loss.

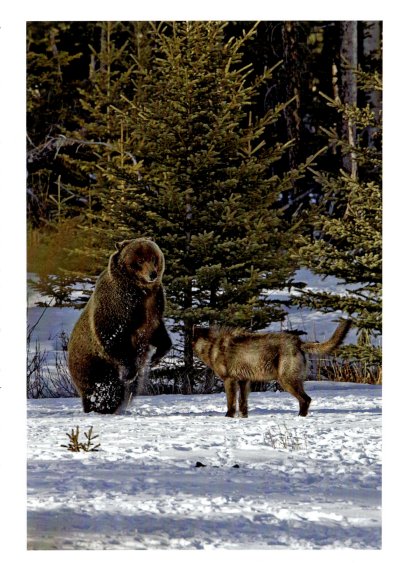

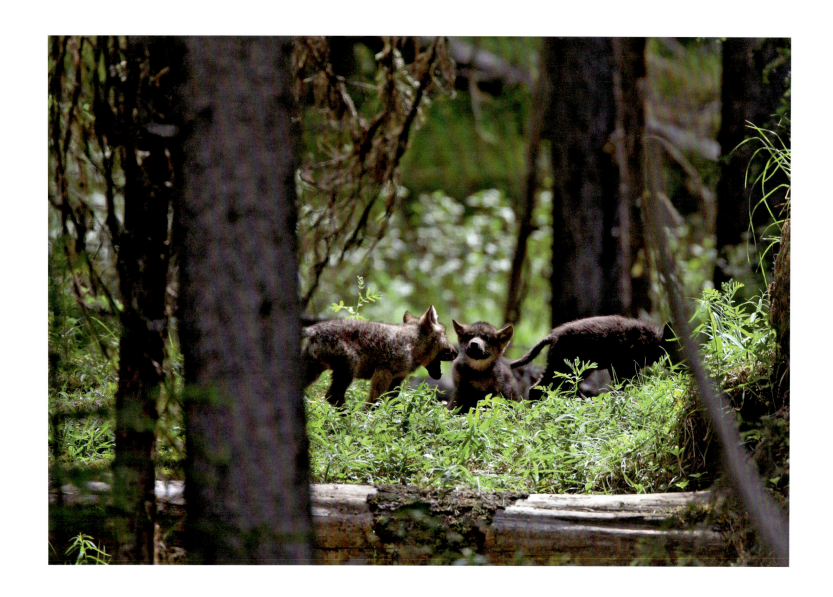

LAST STAND

What is needed in Canada today is an informed public opinion which will voice an indignant protest against any vulgarization of the beauty of our National Parks or any invasion of their sanctity.

—James Bernard Harkin
Commissioner of Canada's Dominion Parks Branch, 1911–1936

In late June 2009 I received several reports of wolves in the Bow Valley. There were sightings of pups near Lake Louise and someone had taken photos of wolves on a carcass, but I did not know these wolves. Reports also filtered in of two wolves competing with a grizzly for a road-killed elk east of Lake Louise. One wolf, with an open wound, was seen limping away not far from that scene. So much activity near Lake Louise, but still no sign whatsoever of Nanuk and company. Nearly every day I wondered what had happened to them all. Were there any pups? If so, who were the parents?

I arrived near Lake Louise at dawn on Saturday, July 4, determined to find out. Soon I found my first sign of new life in a little canine track coming out of the forest toward the pond. The small tracks eventually met a set of much larger tracks, those of a full-grown wolf. The adult wolf had escorted the young one down to the pond for a drink. There may have been more wolves, but it was hard to tell from the tracks alone. At least there was some new lupine life near Lake Louise, but what had happened to the Bows?

I decided to check out an area the Bows had frequented over the past few years. After I parked the car I grabbed my camera equipment, a can of bear spray and ventured out into the woods. At first everything was silent. Every now and again, the air would explode with cracking pines bending in the wind. And occasionally, of course, an annoyed red squirrel would protest my intrusion. I walked to the familiar opening in the forest, checked the surroundings with my binoculars and sat down to wait. And wait and wait.

Finally, a siren broke the silence. Somewhere nearby, a police car sped by, hopefully nabbing one of the NASCAR wannabes who race through the park as if it were Daytona. Then, from a distance, came an unexpected response. The speeder had triggered a siren that triggered howls: the high-pitched voices of young wolves. Then a deeper, more powerful voice joined the concert; the call of the wild replaced the fading call of civilization. I thought perhaps I could recognize Nanuk's voice, but could not tell for sure.

Instead of trying to move closer to the howling wolves, I decided to reposition myself a bit farther away with a nice overview of the area. While this move decreased my chances of getting a close glimpse of the wolves, it increased my chances of remaining undetected, which was all that mattered. Half an hour passed. And then an hour. Perhaps my plan was not that great after all.

A last ray of hope for the Bows, a new litter of five pups was born in April 2009. Once wolf pups are born, they form the social centre of the entire wolf family. The pups live in and around the den for the first eight weeks. During that time, the mother might move them from the birth den to an alternative den, which may help to prevent a parasitic infestation of the natal den.

Suddenly a small piece of fur, decorated with two little ears and a tiny, thin tail popped up behind a fallen tree. The lone explorer disappeared as quickly as he had arrived. Then, an hour later, he reappeared. This time he had company. While he peeked up over the log, another wolf pup appeared and then another and another and another. Five pups in total: three grey and two black. They seemed small and unsteady on their feet, but the fact that they existed at all was a miracle. Perhaps the Bows were not finished after all. On the way out, Fluffy appeared on the road, looked in my direction and then trotted back into the dark woods. There was just enough time for me to take a photograph of her and confirm that she was now a young lactating mother. Perhaps there was hope after all.

I returned from photographing polar bears in the Arctic a few months later. Soon after, in early September 2009, I spotted a devastating headline in the local newspaper: "Fourth wolf killed on highway." The article continued: "For the fourth time in three weeks, a wolf has been struck and killed on a highway in the Rocky Mountain national parks." On August 19 a wolf had been killed in Yoho National Park, and on August 25 another had died near Banff. A young female had been killed on Highway 93 in Banff National Park on August 26, and then another female, this one a pup, was found dead on the 93 in Yoho National Park on September 4.

"It's a lot of bad luck," the spokesperson for the Lake Louise, Kootenay and Yoho field unit said. "We ask people to recognize that there are wolves in our national parks along roadways." The article continued, "Parks Canada is asking motorists to obey the posted speed limits and use extra caution when driving at dusk and dawn."

It has nothing to do with luck. Asking people to obey the law does not work. If it did, we would not need a police force. If we want to reduce the carnage on highways in our national parks, Parks Canada and the RCMP need to work together aggressively to reduce speed limits and eliminate speeding. It is that simple. We do not allow speeding near our schools and playgrounds in the city, because we value the lives of our children. Obviously, the lives and well-being of wild animals do not seem to matter other than to provide fodder for billboards and marketing campaigns.

Yet the lack of accountability is not what bothered me the most. If Fluffy were one of the dead wolves, it could mean the end of the Bow Valley family. My worries grew when I received an email from a friend, Sadie Parr, who works at the wolf centre near Golden, BC. Some visitors had seen some wolf pups near Johnston Canyon, on the Bow Valley Parkway in Banff National Park. The pups were out late in the morning, trotting along the road and ignoring the tourists. Some even seemed intent on getting some food from the peculiar four-wheeled creatures on the road. This strange behaviour reminded me of the situation back in 2005, when Nanuk's mate died and consequently the pups did not make it through the first six months of their young lives. I hoped there was no link between those two messages: the dead wolves near Banff and the pups sighted on the Bow Valley Parkway.

I investigated and received a photo of the wolf killed near Storm Mountain. It was Fluffy. Struck by a passenger vehicle, her back broken and she still managed to pull herself off the road. When a park warden arrived on the scene, he had no choice but to put her out of her misery. Up to her very last breath, she kept her typical confidence: tail straight up combined with a hypnotizing stare.

Sundance, White Fang and Nanuk, the perennial survivor, also disappeared while I was in the Arctic. It seems that after their disappearance, Fluffy tried to recruit a young male from a neighbouring wolf family. For a little while, a young black male wolf apparently accompanied her and together they tried to raise pups. Sadly, both Fluffy and her partner died on the highways that run through Banff National Park, on August 25 and 26 respectively. With their deaths and the disappearance of the other, older family members, the young pups were on their own. The pups' appearance on the Bow Valley Parkway in early September was probably their last desperate attempt to avoid death by starvation. They did not succeed.

One last ray of hope for the continuation of the Bow Valley wolf family emerged when Sundance reappeared on the scene about a month later. Sundance was the first Bow Valley wolf pup I had ever photographed, while Günther and Karin were away in the summer of 2007. As she was one of six pups born to Delinda that summer, her appearance that July had been a harbinger of hope. The birth of Sundance and her siblings had held the potential to be the beginning of a new chapter in the story of the Bow Valley wolves. Now, just over two years later, Sundance was the only chance left for a happy beginning to another new chapter.

Sundance remained in her family's traditional home range along the Bow Valley Parkway until a new family of seven wolves, the Pipestone family, set up shop near Lake Louise. She tried to join them, but the lead female refused to have another potential breeding female in the group. So Sundance tried another strategy. Instead of remaining with the Pipestones, Sundance lured two of the males away to start a new family of her own. Sadly, her efforts to carry on the legacy of her Bow Valley family were dashed when she and her two Pipestone males crossed a cattle guard at Compound Road and wandered onto the Trans-Canada, where Sundance was hit and killed on January 25, 2010.

The 16-year struggle of the Bows to survive in the Banff Bow Valley came to a brutal end. We will probably never know what happened to Nanuk. Perhaps he died on the highway or the railway. Perhaps he was injured by a grizzly or killed by other wolves, as sometimes happens. Did he simply leave the area after having gone through so much? That last possibility is the least likely one, since he had pups waiting for him at home. Yet, I silently hope he is still out there somewhere. Maybe he decided once and for all to leave the Banff Bow Valley – the heart and soul of Canada's premier national park, part of a UNESCO World Heritage Site, a place ostensibly set aside to form a stronghold for wildlife – which is one of the most dangerous places for a wolf to live.

If only Nanuk had heard an interview regarding the lack of safety for wolves living in Banff National Park on the CBC's *Wildrose Forum* radio program in November 2009. Surely he would have stuck around if he had heard Kevin Van Tighem, Banff superintendent, pronounce:

…I am actually extremely proud of Parks Canada's performance over the last 30 years and continuing performance at making this a park that large predators like wolves and grizzly bears can recolonize and live in safely.

With many of his family members' lives extinguished under Parks Canada's watch, Nanuk might not have echoed the superintendent's pride in Parks Canada's performance. In fact, after hearing that interview, Nanuk may have sought out a few more rear-ends to spend a moment with.

According to Parks Canada statistics a sombre 86 wolves have been killed by cars and trains on protected lands in the four mountain national parks (Banff, Kootenay, Yoho, Jasper) between 1999 and 2008. This number showcases only the confirmed deaths. The actual effect on the wolf families has very little to do with numbers, as has been painfully documented in this book. As for the Banff Bow Valley wolves, here is a final tribute to the family members the author had gotten to know since late 2006, presented in chronological order of their final fates.

CHINOOK (below, September 2007)
This shy female was born in April 2006, one of a litter of four. She left the family sometime in early 2008, headed in the direction of Kootenay National Park. Fate unknown.

MICKEY (below, August 2007)
Part of the 2007 litter, Mickey and her five siblings survived their first year in the Bow Valley. In late March and early April 2008 she also participated in the "Battle for Nanuk's Hill." She was last seen in June 2008, when she was about 16 to 17 months old. Fate unknown.

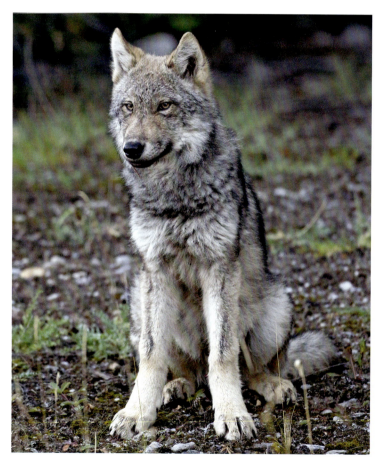

DELINDA (right, December 2007; below, September 2008)
Delinda arrived in the Bow Valley toward the end of 2005 and started a new family with Nanuk in early 2006. The pair were highly successful parents. Of their known 10 pups born in 2006 and 2007, eight made it through their first year. Delinda was killed on a fenced part of the Trans-Canada Highway near Redearth Creek, about 10 km west of Banff on August 25, 2008. She was approximately 5½ years old.

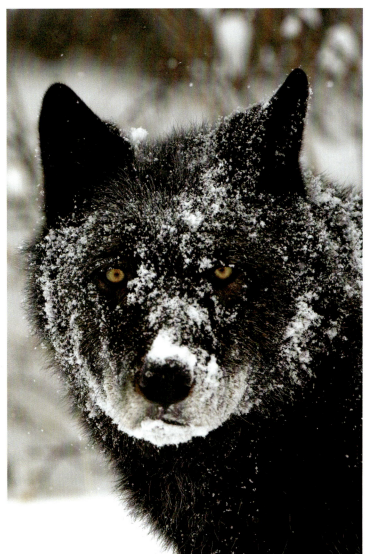

SILVERTIP (above left, March 2008; above, September 2008)
Born in April 2007, this long-legged, black-grizzled male was hit and killed on a fenced part of the Trans-Canada Highway on September 4, 2008, not far from the place where his mother was killed 10 days earlier.

LAKOTA (left, September 2007)
Chinook's brother Lakota was born in April 2006. This very loyal, gregarious and good-tempered male left the family after his mother, Delinda, was killed in August 2008, though he hung around the family's territory for a while until his tracks got lost. Fate unknown.

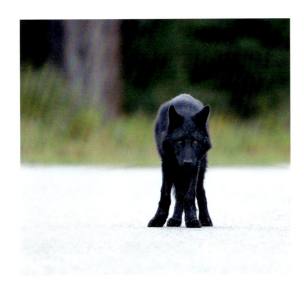

RANGER (above, September 2007; right, February 2009)
This somewhat shy black female was born in April 2007. She was killed February 18, 2009, on an unfenced part of the Trans-Canada 14 km east of Lake Louise. She was in all likelihood checking out the area for some last remains of a moose her family had taken down about 10 days earlier.

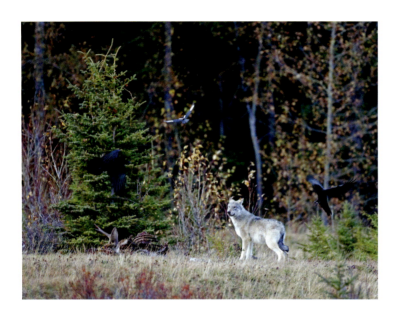

Survivor (October 2008)

Survivor was the only pup to make it through the disastrous summer of 2008. He was a very strong-minded young wolf who, at the tender age of 6 months, even managed to displace his year-older and very dominant sister Fluffy on an ungulate carcass. Yet all his survival skills and strength didn't help him when he was struck by a vehicle on Highway 93 south in Banff National Park on March 19, 2009. He didn't survive his injuries and died shortly before reaching his first birthday.

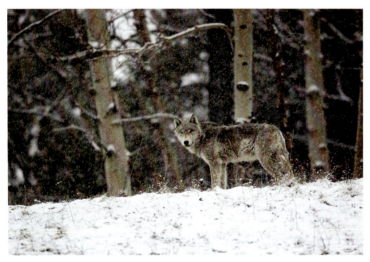

White Fang (April 2008)

Seldom has a wolf made such an impression on the author as White Fang, born to the Bow Valley family in April 2007. His magnificent stature, combined with a very social and calming character, made him an ideal candidate to start a successful family of his own one day. The last photograph of him was taken in March 2009. Soon after that, he disappeared. Fate unknown.

FLUFFY (below, March 2008; right, January 2010)
Part of the 2007 litter, Fluffy was a very strong-minded and dominant female. After the death of her mother, Delinda, she mated with Nanuk sometime in February 2009. When she was hit by a car August 26, 2009, on Highway 93 south near Storm Mountain in Banff National Park, the impact didn't kill her right away, but it broke her back. A Parks Canada warden euthanized her when he found her suffering next to the highway. She left behind five pups, all of which starved to death. In the photo at right, of carcasses preserved in a Parks Canada freezer, Fluffy is the rearmost one, leaning against the wall with face obscured. The photo was taken in January 2010 when the author was called to identify the remains of Sundance, upside-down in the foreground here (see also p. 139). The centre carcass was an unidentified wolf that had been trapped outside the park and was not a member of the Bow Valley family.

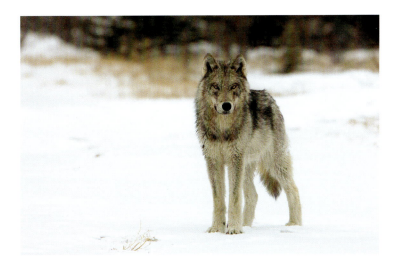

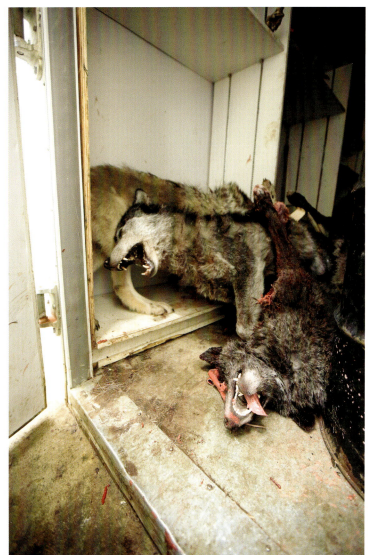

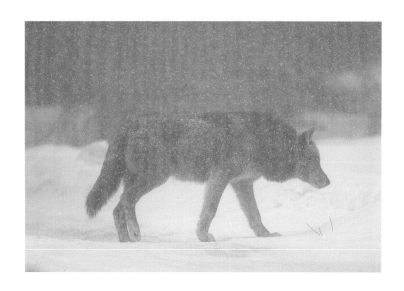

Nanuk (March 2008)

Nanuk was born in the Bow Valley in April 2002 and was the only pup that survived out of a litter of six. His father, Storm, and brother Yukon were killed by a trapper just outside Kootenay National Park in 2002, which ultimately led his mother, Hope, to leave him behind alone in the Bow Valley in 2003 at the age of 16 months. After finding a partner, April, in 2004, Nanuk lost her to a hunting accident a year later, resulting in the starvation of their six pups. Ever the survivor, Nanuk found Delinda by the end of 2005. They had a total of 10 pups. They lost two to traffic on the Bow Valley Parkway but the rest survived until late August 2008 when Delinda was killed on the Trans-Canada. In the following year, Nanuk's family fell apart as more members either disappeared or were killed by the traffic cutting through his territory. After a long and hard fight for survival in the Bow Valley, Nanuk disappeared sometime during the early summer of 2009. He was 7¼ years old.

No name

An unnamed young wolf showed up in early August 2009 at the side of Fluffy, the last remaining adult wolf in the Banff Bow Valley. He was in all likelihood born into a neighbouring pack a year or two earlier. It was clearly not an easy task for him to fill the tracks of Nanuk. He was killed on a fenced part of the Trans-Canada near the Banff townsite on August 25, 2009.

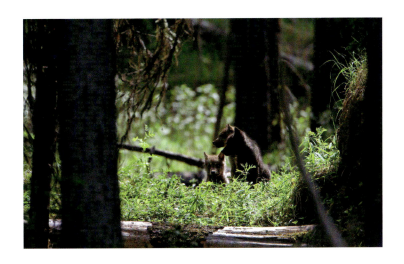

THE FIVE PUPS OF THE 2010 LITTER (left, July 2009)
As a direct consequence of Delinda's death on the highway in August 2008, it came to inbreeding between Nanuk and Fluffy, resulting in five pups. Although inbreeding has been observed in the wild before, incest is not common in wolves where they can choose mates other than close relatives, according to research reported in Mech and Boitani. The impact of inbreeding on wild wolf populations is not well understood.

SUNDANCE (below left, July 2007; below, January 2010)
Sundance was born in April 2007. By the time her sister Fluffy bore her first litter, Sundance was only sporadically seen in the core territory of the Bow Valley wolves and she later left the area. She returned, however, in the fall of 2009 after yet another disaster had struck the formerly 10-strong family. Sundance was the last of the Bows when she teamed up with two wolves from the neighbouring Pipestone pack. The reign of the Bows came to an end when Sundance was killed on January 25, 2010, on a fenced part of the Trans-Canada just off the exit to Banff's industrial park. The driver didn't bother to report the incident.

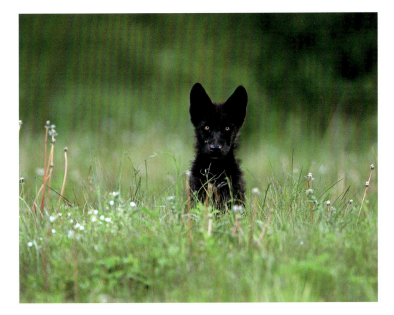

REGAINING PARADISE

In the end, we will conserve only what we love. We will love only what we understand. We will understand only what we are taught.

—Senegalese environmentalist Baba Dioum in a 1968 speech to the International Union for Conservation of Nature

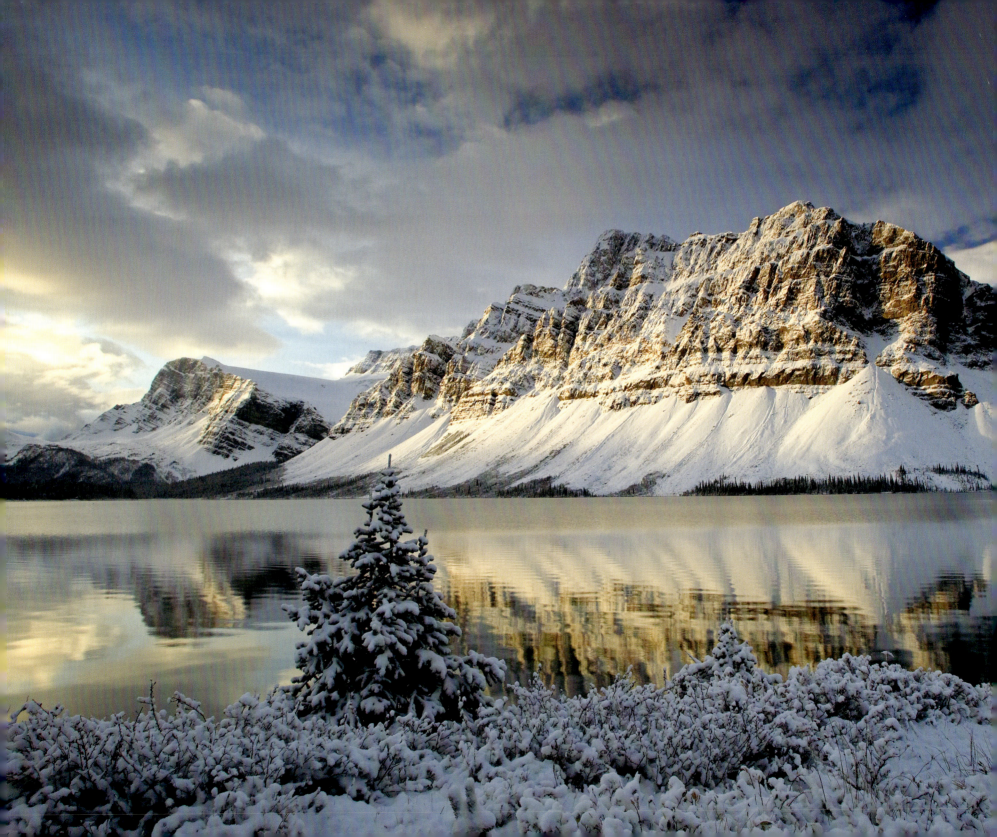

Once the fate of the Bow Valley wolves had sunk in, along with the tragic death of the Brave One, I abandoned everything else on my overflowing plate and began to read. This may seem like an odd reaction for an angry man to have regarding the needless deaths of his subject-companions. Indeed, I felt more like driving to Ottawa and laying siege to the Parliament Buildings than I did sitting in an easy chair thumbing through a box of books. Nevertheless, I needed to understand how Banff National Park had arrived at this untenable crossroads before I could do much of anything else.

I scoured history books, analyzed 50 years worth of scientific literature and began combing contemporary media coverage for issues that I learned have been controversial for decades. During my research I came across an April 9, 2009, article in the *Rocky Mountain Outlook* that stated: "Parks Canada may be opening the door to more commercial activities and new recreational opportunities in Banff National Park." That door was *opening* as part of the regular five-year review of Banff's management plan. Right on cue, the tourism and business community supported the move, saying it was "necessary for Canada's national parks to become more relevant to Canadians and offer a broader range of activities to help the region stay competitive, particularly in these turbulent economic times."

I could not believe it. The bodies of Fluffy and the Brave One were hardly even cold, the last Banff mountain caribou hardly excavated from their snowy graves, and yet Parks Canada was considering increasing the very thing that had killed them: unsustainable levels of human activity. I dug out the Canada National Parks Act, which regulates such things, for clarification. Nowhere did it suggest that the role of Canada's national parks was to "offer a broader range of activities" so that the regions in which they were located "stayed competitive" on the international tourist map. Instead, when I went to Parks Canada's website searching for a definition of what a national park was, I found the following statement:

Protected and preserved for all Canadians and for the world, each [national park] is a sanctuary in which nature is allowed to evolve in its own way, as it has done since the dawn of time. Each provides a haven, not only for plants and animals, but also for the human spirit.

Sanctuary? Haven? Nature allowed to evolve in its own way? This may be part of a glorified Parks Canada slogan, but it sure as hell was not playing out that way on the ground in Banff National Park.

It was clear to me that in order to understand the role of Parks Canada and the national parks in the 21st century, I would need to see it from a different perspective. It was time, I decided, to stop swimming upstream and become a tourist once again.

Mountain aspen leaves resembling a broken heart. In 1994 the federal government inaugurated a two-year, $2-million study to assess the state of the park independently of Parks Canada. The task force in charge of the study concluded that if business as usual were allowed to continue, "the ecological integrity of the Banff Bow Valley cannot be sustained." The study offered over 500 specific recommendations. While some minor improvements have been achieved since, such as removing the bison paddock in favour of wildlife corridors and capping the Banff townsite population, Banff National Park and all the other mountain national parks' ecosystems continue to suffer greatly from overdevelopment with no end in sight unless a great paradigm shift takes place.

THE GREAT DECEPTION

Banff, Glacier, Jasper, Kootenay, Mount Revelstoke, Waterton Lakes and Yoho national parks – seven treasured places dedicated by Canada's early visionaries to future generations – are renowned examples of the very best in the conservation of mountain ecosystems and the presentation of mountain history.

Welcome letter from Parks Canada (2009/2010) in
The Mountain Parks: Visitors' Guide to Alberta & British Columbia

On a warm fall afternoon in 2009 I wandered up Banff Avenue and perused the hundreds of shop windows. Just as in a shopping mall in any big North American city, there are stores to buy jewellery, clothing, candy, even get a tattoo. Brand-name boutiques like Jacques Cartier, Roots and Gap share the streets with dozens of cafes, restaurants and bars. A Starbucks competes with a Second Cup, and now even an Indigo Books has driven one of the finest independent bookstores in Canada out of town. You can have a massage and get your nails done, then book a helicopter-skiing trip or an ATV adventure (neither of which are permitted in the park, at least for the time being). Why not buy a diamond necklace and wear it with your new fur coat while you order everything from junk food to frog legs or even shark fondues! Really, only the stunning peaks rising above the shopping arcades reminded me that I just might be in a national park.

Motivated by my desire to put more pieces of this national parks puzzle together, my aim was to go back to my roots of being a tourist in this park. Of course, I could never forget what the years had taught me, but I knew if I started to go through the motions, something

would resonate. My determination must have been visible on my face, for as I entered a souvenir shop the man behind the counter looked at me and said: "You look like you're on a mission."

I just smiled back at him and thought, "Damn right I am." I looked around a bit, pondering the role that businesses have in a national park. After some quick decision-making, I handed the clerk a bottle of maple syrup in the shape of a maple leaf and a bear-paw-adorned T-shirt, in honour of the Brave One and his kind.

"That'll be $39.99."

Moving on, I decided to partake in a trip to the Cave and Basin National Historic Site, an experience I had always avoided. The Cave and Basin, one of the nine sulphurous hot springs found on the northeast flank of Sulphur Mountain, is the venerable shrine to the creation of Banff National Park. I always thought of the site as a contrived effort by Parks Canada's PR hacks to rationalize away the inconsistencies inherent in the Banff tourist experience. As it turns out, there is more to it than that. My pleasant visit actually taught me a lot about the real spirit of Banff National Park.

I walked through the cave and felt the warm, bubbling waters of the thermal springs that, in 1885, had spawned the idea for a park. In 1886 a tunnel was blasted into the rock in an effort to boost visitation. I passed the replica bathhouse and entered a small cinema to see how Parks Canada conceives its own creation myth. The main characters were Frank McCabe, William McCardell and his brother Tom; these CPR crew workers decided to try their luck at trapping and prospecting in the Bow Valley, rather than head home for the winter. Instead of ore and pelts, they discovered this cave and spent the winter bathing in the warm, mineral-rich waters. At one point, apparently, Tom McCardell shouted to his brother, "Billie, we're gonna be rich!"

The rest, as they say, is history. In 1885, the federal government created the 26-square-kilometre Hot Springs Reserve. Several years later they expanded it into the 405-square-kilometre Rocky Mountains Park of Canada: a "public park and pleasure ground for the benefit, advantage and enjoyment of the people of Canada." While the historical details are interesting, they are rather less important than the old attitudes that accompanied the new discovery. Neither the McCardell brothers nor the CPR were permitted to claim the hot springs, but that clearly did not stop them from being developed. Both the Government of Canada and the CPR were aware of the potential for tourist traffic and profit.

"Since we can't export the scenery," said Sir William Cornelius Van Horne, an American railroader renowned for his drive and determination who was the CPR's vice-president at the time, "we shall have to import the tourists."

Those tourists, added Sir Sandford Fleming, the CPR's chief engineer, "would become a source of general profit."

Thus the stage was set to change the Canadian Rocky Mountains into a tourism mecca from day one, with Banff National Park as its most shining example. Today Banff National Park is the heart of a multi-billion-dollar economy that, like Disneyland and Niagara Falls, attracts people from all over the world. As a typical holiday destination of the 21st century, holidaymakers come to dine, shop and see the sights.

The 2008 Banff National Park "State of the Park Report" lists park visitors' top ten activities. Though the document makes passing mention of a "Patterns of Visitor Use Survey" taken in 2003 for all four mountain parks, it doesn't state the currency of the data or the

methodology employed. The bibliography cites only Parks Canada itself as author of a "2003 survey of visitors to Banff, Jasper, Kootenay and Yoho National Parks of Canada . . . sponsored by Parks Canada and the Mountain Parks Visitor Survey Partnership with a contribution by Alberta Economic Development." Nevertheless, those issues do not matter for our purposes. For the sake of simplicity, let us say that each activity itself is out of 100 per cent and that even if the data is from a few years ago, it still illustrates important trends. With that, the top ten activities for visitors to Banff National Park are:

1) Driving and sightseeing 46%
2) Eating in a restaurant 42%
3) Shopping 35%
4) Sightseeing and landmarks 29%
5) Hiking 24%
6) Relaxing 17%
7) Walking 17%
8) Riding the gondola 13%
9) Eating outside a restaurant 12%
10) Skiing/snowboarding 12%

In the executive summary of the report, it states: "Visitor satisfaction remains high and visitors participate in a wide range of activities, with driving and townsite-related activities (shopping, restaurants) the most popular." Nowhere, it seems, is there room for the celebration of Banff as a model of restraint and an oasis of ecological health. Economy, even in a national park, has displaced ecology as the lingua franca of a nation. It was and still is, first and foremost, a park for *the benefit* of people. Nothing will change in Canada's Rocky Mountain national parks until the day commercial interests come second to preservation of nature.

My next excursion took me up the gondola at the Lake Louise Ski Area. It was a sunny, yet somewhat windy, September day when I entered the massive parking lot at the bottom of the ski hill. I realized that despite months of traipsing around in the Bow Valley in search of the Bows, I had rarely taken the time to get a bird's eye view of their home. The gondola to the top of Mount Whitehorn was just the ticket.

Before we could board, the Lake Louise gondola staff forced us all to watch a video on bear safety. Beside the screen was the requisite sign, ALL BEARS ARE DANGEROUS. Also present was a big painting of a fearsome-looking grizzly with his mouth open to show off his massive teeth. I could nearly hear his Hollywood growl. "Must be a hell of a dangerous hike up there," I thought to myself.

At the top, I was pleased to learn they had closed the trail up to the Mount Whitehorn summit due to bear activity. A grizzly with cubs had been seen in the morning, so the closure was to allow them to feed in peace. "Let 'em have some privacy, then," I thought as I walked down to the wildlife information centre instead. At the centre I found a host of interesting and useful information about the bears, mountain goats, bighorn sheep and wolves that use the area.

The information centre also provided some more serious facts and figures about the plight of wildlife in the national parks. Talking with one of the interpreters, I found out what happened to Jolie's mother, Blondie. As it turns out, a passenger vehicle on the Trans-Canada Highway killed Blondie not far from the Lake O'Hara turnoff at 11 p.m. on June 2, 2004. The next morning, Parks Canada staff found her and her two now orphaned 2-year-old cubs about 60 metres back in the bush, where she had managed to drag herself after being hit. Reluctant to leave her, the cubs lay beside her still body, one cub's front

paw draped over her protectively. Lake Louise interpreters now use Blondie's pelt as part of their educational display.

Blondie died the same day I first photographed mating grizzly bears. Earlier that same day, the off-duty park warden had pointed me away from the road bear and toward the remote location of Blondie and her cubs. The same day, somewhat ironically, the warden used Blondie as an example of the success of the aversive conditioning program. Blondie's death, to me, was the final proof that aversive conditioning simply does not work in the long run.

After learning of Blondie's fate, I decided to walk around to the other side of the mountain. The trail was not well marked and the little map I received at the information centre was useless. The trail turned out to be an ugly ski maintenance road, gouged into the hillside for the sake of "getting people connected to the park." Disappointment rose in my heart. What in God's name does a ski hill have to do with the vision of a national park anyway? How can Canadians explain to the world that in one of the most sensitive parts of their flagship national park there are three ski hills, a golf course, a commercial dam, a major highway, lots of secondary roads, a railway, a gondola, two towns, ski races, dragon boat races, bike races and God knows what else. Compared to Swiss National Park, Banff National Park looks more like an amusement park than an area set aside to protect nature. Then, remembering my visit to the Cave and Basin, it struck me again that this is a park for people, especially those looking to make a buck.

It is not as if nobody warned us. The dangers of overdevelopment were readily apparent right from the very beginning. James Harkin, who became the first commissioner of national parks in 1911, wrestled with the "use without abuse" paradox. Too much development, he worried, and "the parks may lose the very thing that distinguishes them from the outside world." As unbelievable as it seems today, Harkin believed that the "building of motor roads should be restricted as much as possible," because, "it is only from the trails that one can get into real intimacy with the peaks." James Harkin had good reason to be worried. Nevertheless, Harkin's concerns were mostly ignored as the automobile and tourism industries rose to prominence.

As described earlier, the establishment of railways and roads went hand in hand with the creation of Canada's Rocky Mountain national parks. When British Columbia joined Confederation, in 1871, it was on the condition that the federal government would build a railway to link the province to the rest of the country. In order to ease the financial pressure of this massive undertaking, the federal government and the Canadian Pacific Railway co-operated to promote the Banff area as an international resort and spa.

In 1907 a second cross-country railway, built through Jasper and the Athabasca Valley, created what would, in 1930, become Jasper National Park. Then, in 1909, the first road reached the east gate of Banff park. Later, after another agreement with BC, the Canadian government built Highway 93 in exchange for a strip of land eight kilometres long on both sides of the route. With the highway completed in 1922, the land on either side was declared a national park and thus Kootenay National Park was established. The expansion of roadways in these areas ushered in a new age of motorized tourism, which boosted the number of tourists from 100,000 per year in 1925 to over four million, for example, in the early 1990s.

While hotels multiplied like cancer cells and the Banff townsite swelled like a diseased liver, Canadians strengthened, if not clarified,

Parks Canada's mandate. In 1930 the Canada National Parks Act stipulated that although national parks were "dedicated to the people of Canada for their benefit, education and enjoyment," they were to be "maintained and made use of so as to leave them unimpaired." In 1998, as evidence of our environmental troubles mounted and conservation issues became more salient, the Minister of Canadian Heritage appointed a panel of scientists to assess the strengths and weaknesses in Parks Canada's management of the national parks. The panel subsequently made many recommendations, such as those found in their "Ecological Integrity Panel Report," which called for legislative amendments to ensure that ecological integrity would be the overriding consideration in managing the national parks. In 2001 Parliament responded by making "maintenance or restoration of ecological integrity, through the protection of natural resources and natural processes" the "first priority of the Minister when considering all aspects of the management of parks." Those who care about such things cheered, hopeful perhaps that things might change.

But words on paper are one thing. The most important aspect of those words on paper is what people, especially judges, make of them. No one who has studied even rudimentary ecology can claim that the Canada National Parks Act has ever been interpreted in a manner that leaves our national parks unimpaired. When Parks Canada proposes or allows increased human activity or further augments their highly intrusive wildlife management practices in our national parks, someone often challenges their interpretation of ecological integrity. Many independent experts – University of Calgary law professor Shawn Fluker among them – contend that Parks Canada has done nothing to enforce the primacy of ecological integrity in our national parks, which the law says are places where nature is to take precedence over people. Despite these findings and Parks's own research, the courts usually defer to Parks Canada's "expertise." Why?

Now, as then, Canada (and the world, for that matter) is governed by the Cornelius Van Hornes among us rather than the James Harkins. Tourism in Banff and the other Rocky Mountain national parks has grown into a multi-billion dollar business, thanks in large part to the roads that Harkin so feared. The difference today is that we are being deceived. In the late 19th century there was no pretence that Banff should be anything but an engine of commerce and profit. Today, despite the science-informed guidance provided by the Canada National Parks Act, hucksters, lobbyists and politicians have created a veil of self-congratulatory "do goodism" behind which they continue to erode the ecological integrity of many of Canada's national parks.

No need to only take my word on the *actual* state of the parks. Just ask the people who work there. More than one Parks Canada employee, even those who feel they have to chase wolves and bears away from the road, has told me with a sigh and slumping shoulders that morale has never been so low. They see from the inside what should be so evident from the outside: inaction, kowtowing and deception. To hear them talk about it, you would think they were living in a Franz Kafka novel.

As use increases, investment in the research necessary to manage, mitigate and repair the damage that human activity causes has plummeted. Calls for more development and more activity are never accompanied by support for more mitigation. Despite creating billions of dollars in economic activity and millions of dollars in tax revenue, the town of Banff is penniless. We have all heard this story before. Neither the business community that profits nor the federal

government in charge of management is prepared to internalize the environmental costs of doing business. Instead, the wolves and the bears, the bull trout, the harlequin ducks and the caribou must pay our debt with their lives.

By trying to understand and meet the "needs of the Canadian people," Parks Canada has become a slave to the tourism and transportation industries. In the end, the noble idea they actively sell to the world – "ecological integrity as the first priority" – looks increasingly like a jeweller showboating a string of phony pearls.

In fact, the fall of 2009 offered a new opportunity for the public to inspect those pearls when Parks Canada released draft management plans that propose to allow more activities that are "non-traditional" in the Rocky Mountain national parks. Their goal is to increase the number of visitors to the parks. Business groups, such as the Association for Mountain Parks Protection & Enjoyment, want Parks to heed the warnings of tourism decreases and pave the road for new business projects. Particularly, calls have been made for more ski lifts, a new gondola in Banff, zip-lining, dogsled rides, treetop-level walkways in forests, a teepee campground in Waterton, and hammering metal rungs and safety lines into mountain faces to make them easier to climb. Also in the news has been discussion about opening the Maligne River for commercial rafting again after environmental concerns led to the activity being banned a decade ago.

Environmentally concerned responses to the management plans have pointed to the fact that Parks is moving further away from ecological integrity and toward turning the national parks into amusement parks, accusations which business groups have helped to sustain by saying Banff National Park needs to up the amusement ante because it is in direct competition with Disney World for tourists. Wilderness groups wonder how the increase in visitors and non-traditional activities can occur without further risking wildlife survival and habitat. Ecological integrity made it to first official priority in Parliament in 1988 and again in 2001. At least in part, our Parliament at the time must have understood some essence of what our first national parks commissioner, James Harkin, pointed out: that "the parks may lose the very thing that distinguishes them from the outside world."

When reacting in an interview to responses critical of the draft management plans, the CEO of Parks Canada, Alan Latourelle, told reporter John Cotter: "It is not about tourism, it is about connecting Canadians." Latourelle continued: "There is a select group of individuals who have the perspective that the mandate of Parks Canada is simply ecological integrity, which is incorrect. Our job at Parks Canada is to protect our national parks for Canadians, not from Canadians." Latourelle assured Cotter, to assure Canadians, that the "right direction for the agency" is to ensure ecological integrity *and* an increase in opportunities for visitor experiences – together. Latourelle said he can "reassure Canadians that [Parks Canada is] taking [their] conservation objectives seriously." But given what we already know, how seriously can we take his reassurance?

Banff, once a postcard signifier of Canada's natural beauty and Canadians' mythical environmental ethic, has become a mockery, another symbol of the greed and deception that Canada's political representatives also displayed at the climate change negotiations in Copenhagen in December 2009. Banff has come to represent our inability to change our ways and our compulsion to rationalize unsustainable levels of commercialization and economic development, even in Canada's most protected of protected areas: our national parks. In

some ways, the Rocky Mountain national parks are even worse than the Alberta tar sands: the parks are a carefully crafted untruth that deceives us into thinking that protection of our natural heritage can live hand in hand with big business. We are all fiddling as Rome burns.

Construction of the 230-kilometre (143-mile) Icefields Parkway was started in 1933 and the road was officially opened in 1940, connecting Lake Louise with the town of Jasper. Unlike funding for wildlife monitoring or maintaining adequate staff, there never seems to be any shortage of money for widening, repairing or upgrading the roads in the mountain national parks, particularly when stimulus for a struggling economy is needed. As Robert W. Sandford points out in his book *Ecology and Wonder*, large parts of the current infrastructure in the mountain parks are a legacy of government efforts to counteract the Great Depression of the 1930s. Current twinning of the Trans-Canada Highway near Lake Louise is yet another example of using "stimulus money" for the sake of helping a struggling economy.

Large infrastructure improvements will benefit industrial transportation and negatively impact sensitive ecosystems, despite all the efforts to "mitigate" the direct effects of habitat fragmentation and road and railway kills. And not all such industrial infrastructure upgrades in Canada's Rocky Mountain World Heritage Site are above ground. In 2008 an existing oil pipeline running through Jasper National Park and Mount Robson Provincial Park was enlarged to prepare for moving increased production from the Alberta oil sands toward world markets via the west coast.

Above: According to Parks Canada statistics, 2,456 animals the size of a coyote or larger have been killed on the roads of Banff, Kootenay, Yoho and Jasper national parks between 1999 and 2008. This is just the confirmed death toll. The real number may double if not triple (see pages 186, 187 for detailed information).
Right: Railway tracks cut through three of the four national parks located within the Canadian Rocky Mountain Parks UNESCO World Heritage Site. The image shows a Canadian Pacific Railway train in the Banff Bow Valley bound for the coast.

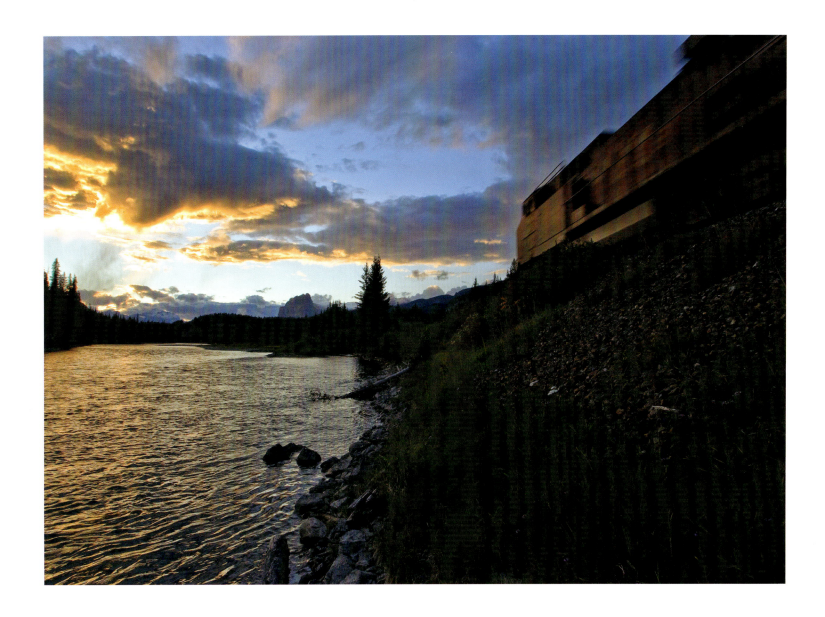

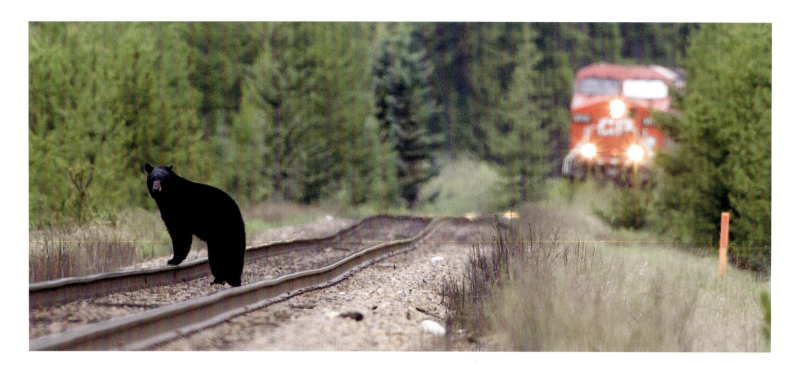

ABOVE: Countless animals such as this black bear are drawn to the tracks not only by the grain spilled from trains but also by the lush vegetation found alongside the right-of-way. A variety of animals also use the vegetation-free tracks as a corridor to travel faster through the rugged landscape and at the same time scavenge railway-killed carcasses.

RIGHT: According to CP, the company has about 20,000 hopper cars in its fleet and moved a total of 470,000 carloads of grain across its network in 2009 (a fully loaded car holds about 100 tonnes of grain). Of this 20,000-car fleet, only the 6,300 government-owned units are the focus of the five-year repair program that is supposed to be completed in 2011. Despite this nearly finished $20-million program and the purchase of a $500,000 vacuum truck in 1998 for the Banff/Yoho region, animals continue to die in record numbers (see page 185). In the meantime CP and CN together reportedly earned $19.015-billion in net income (on $106.9-billion total revenue) between 1999 and 2008.

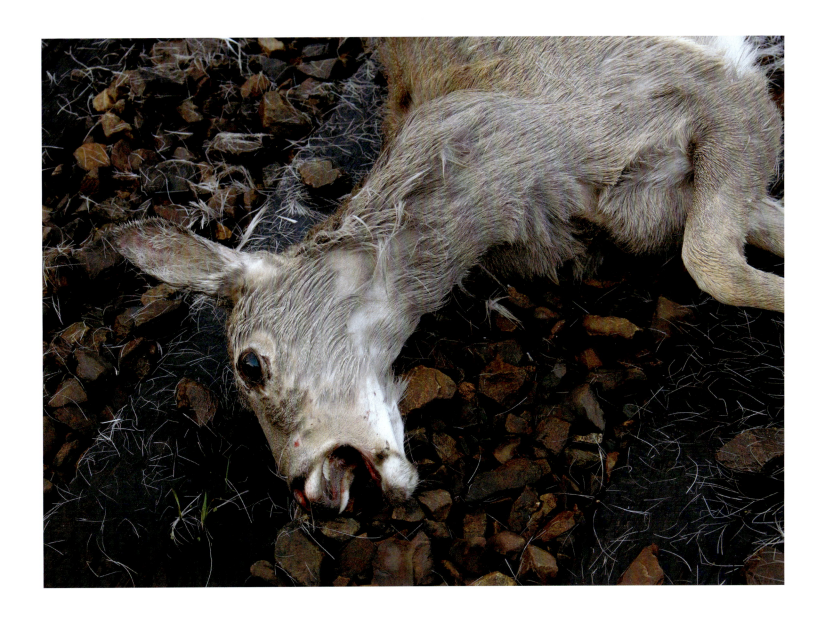

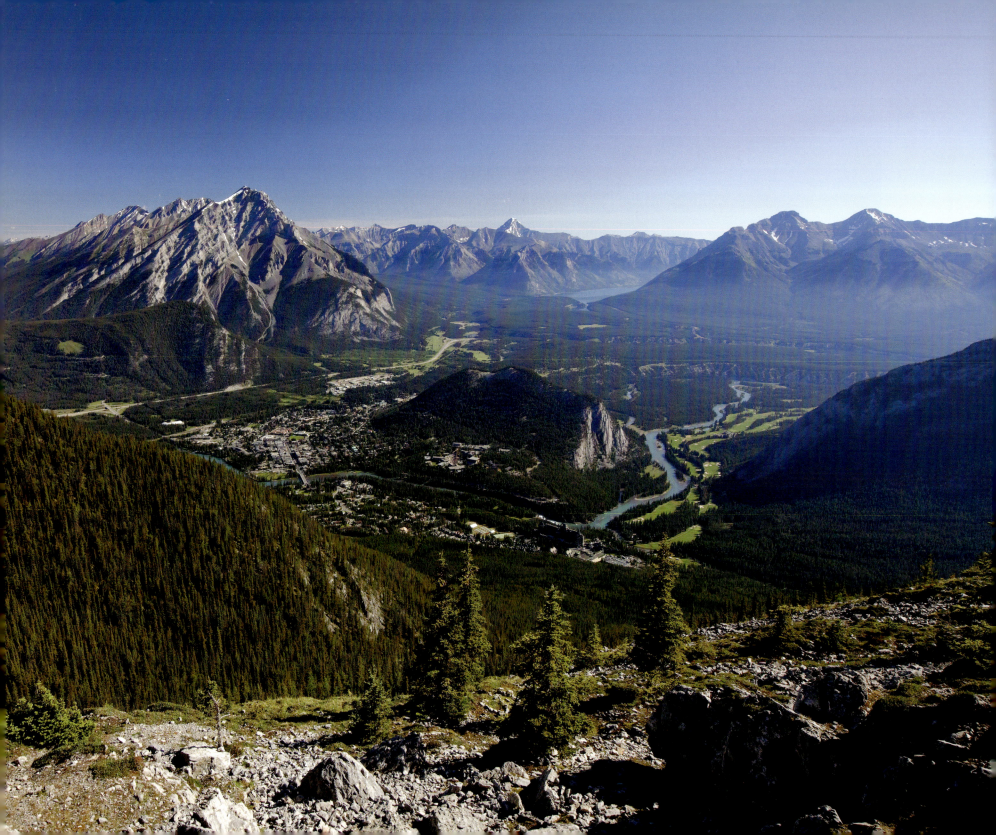

Left: The town of Banff and part of the Bow Valley as seen from Sanson Peak. Approximately eight million people enter Banff National Park each year, of whom 4.7 million are passing through to destinations beyond the park. Despite the negative impact on the park's flora and fauna caused by the development of a mass tourism industry, Parks Canada's 2010 management plan targets a whopping 10 per cent increase in visitation over the plan's first five years, or 2 per cent annually.

Right top: The Banff Bow Valley Summary Report predicted in 1996 that "declining public funding will force Parks Canada to look for alternatives… The combined effect of these pressures will deflect Parks Canada from its core mandate, shift its organizational culture and values, and limit the ability of the government to govern.… And so we have arrived at the crossroads. Which fork should we take? Based on a careful and thoughtful examination of the evidence, the Task Force believes that unless we take a new path, Banff cannot remain a national park. Is this what Canadians want?" This question remains as relevant today as it was in 1996, or for that matter in 1885.

Right bottom: Canoeists floating down the Bow River east of Lake Louise in early June through what is known to be some of the most important harlequin duck breeding and nesting habitat in the Canadian Rockies. Due to the vulnerability of harlequins to human disturbance, Jasper, for its part, closed an 18-kilometre stretch of the Maligne River to human activity in 1999. The closure continues to be under heavy pressure from business lobby groups such as the Association for Mountain Parks Protection & Enjoyment which want to resume whitewater rafting.

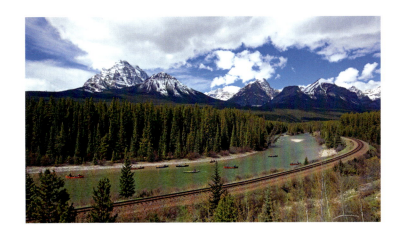

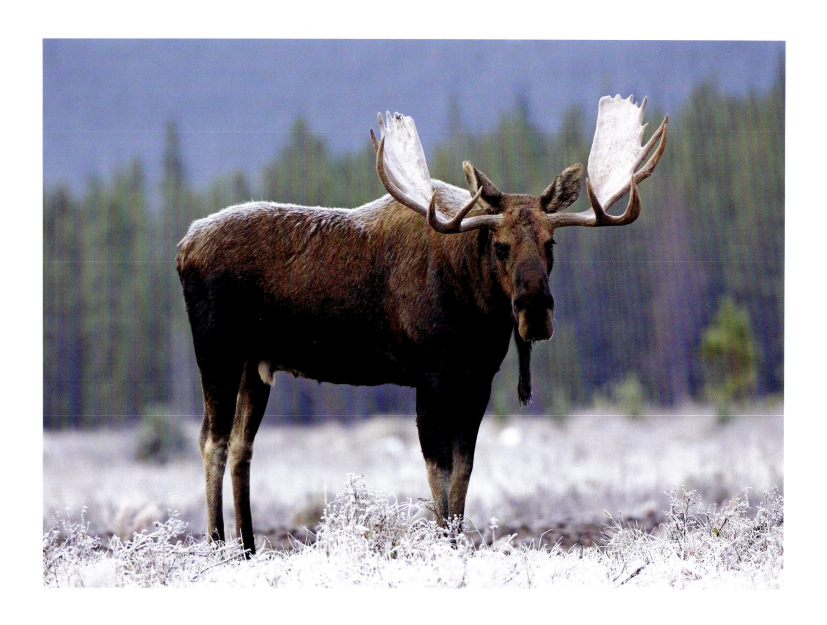

QUO VADIS?

...nature's object in making animals and plants might possibly be first of all the happiness of each one of them, not the creation of all for the happiness of one. Why should man value himself as more than an infinitely small composing unit of the one great unit of creation? ... The universe would be incomplete without man; but it would also be incomplete without the smallest transmicroscopic creature that dwells beyond our conceitful eyes and knowledge.

—John Muir, *A Thousand-Mile Walk to the Gulf* (1916)

December 6, 2009, marked the end of my photographic journey for this particular book. Since I did not possess any decent images of Banff springs snails or the thermal springs themselves, I returned with the intention of taking some. The bitter cold of minus-20-something Celsius slowly filtered through my many layers. When I entered the

Banff Park's moose population depends on migration of individuals from outside the park to sustain it. In addition to the threats facing animal populations within the park, animals continue to be hunted and trapped and to be disturbed by large-scale industrial, commercial and recreational activities outside park boundaries as well, such as "heli-yoga." The parks are simply too small to effectively protect wide-roaming animals such as grizzlies, wolves and caribou. Restoring the parks to their pre-1911 size or creating buffer zones around the current park boundaries will have to be considered again in order to create long-lasting and stable animal populations.

tunnel, walking toward the springs, the smell of sulphur filled the air. The heat increased with each step I took into the cave, forcing me to take off two of my treasured layers.

Arriving at the hot pool, I was pleasantly surprised to see only three other people, who were just about to leave. Strangely enough, on a Sunday too, I found solitude in the centre of Banff. It even lasted for over an hour and a half. I felt privileged. While admiring the beautifully lit cave, I felt a strange and deep connection with the heart and soul of Canada's national park system. I lingered on. Finally, I continued my Sunday afternoon journey to one of the outer pools, where I searched for the famous Banff springs snails. Snow and frost covered the ground around the hot pool, while the water was steaming in the arctic air. Finally I found what I was looking for: the tiny snails.

Zooming in on a single snail that was holding on to a leaf floating on the hot waters, I again felt that feeling of humbleness, connectedness and joy. Maybe it was the realization that I was looking at a creature that exists nowhere else on earth but right here in the Banff thermal springs, amongst all the human activities.

Eventually I bundled back up into my layers and left this unique environment. As I drove down Banff Avenue at dusk, the street was glowing like a gigantic jewel set in the mountain scenery. The town of Banff looked its best. Christmas lights shone to the left and right, with the last sun rays hitting the top of Cascade Mountain and rising sharply at the far end. Charming. Banff exuded the impression that everything was just fine and harmonious.

While the glamorous town of Banff disappeared into my rear-view mirror, doubts started to rise in my heart. What am I doing? Should I really proceed with writing and publishing this book? After all, I just

felt, once again, how deeply I love Banff. I left my family, my country and my roots to come to this area and settle down. Banff, Jasper, Kootenay, Yoho, Mount Assiniboine and Mount Robson have given me so much. They have filled me with an incredible feeling of love, connection, strength, personal growth and understanding. And now, am I doing this place justice to so heavily criticize what has become of these mountains? Am I betraying my new home, my new country?

As I turned onto the highway, my thoughts drifted away and I imagined how things must have been here, long before the white man moved west. I would love to see this place, with the knowledge of today, before the European settlers brought along their "old-world mentality." It would be extraordinary to ride along the Bow River on a horse rather than in an automobile, and see an unpaved Bow Valley,

RIGHT: The endangered Banff spring snail in one of the hot springs at the Cave and Basin National Historic Site. Banff is Canada's oldest national park and the third oldest in the world after Yellowstone in the US (established in 1872) and Royal National Park in Australia (1879).
LEFT: Native fish such as west slope cutthroat and bull trout were once abundant throughout the upper Bow River watershed. The primary causes of their decline include artificial barriers to movement such as railway, highway and hydroelectric infrastructure, water withdrawals by golf courses for sprinklers and by ski resorts for snowmaking, pollution from road-de-icing chemicals, and the introduction of non-native fish such as the rainbow trout shown here. A study commissioned by the Yellowstone to Yukon Conservation Initiative revealed that in Banff National Park, 41.5 per cent of running waters in the Bow watershed are now regulated, obstructed or altered by humans.

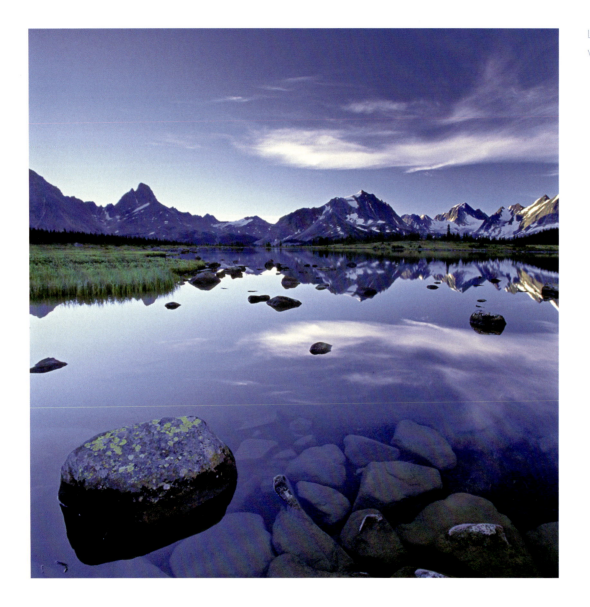

Lower Amethyst Lake, Tonquin Valley, in Jasper National Park

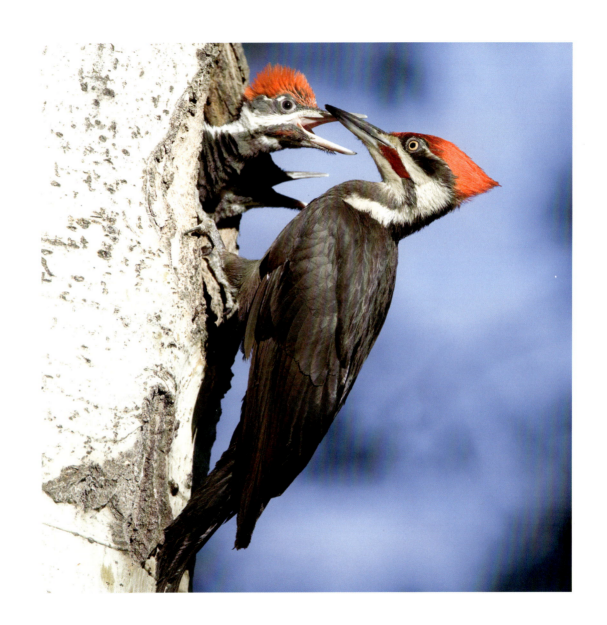

Pileated woodpecker family,
Banff National Park

encountering herds of bison, bighorn sheep, moose and even mountain caribou. No white-tailed deer, just some mule deer mixing up the ungulate armada.

High up in the mountains, I would spot some white mountain goats. Even higher, golden and bald eagles would circle above the rocky peaks. Maybe, so I imagine, I would spot a wolf or a bear in the distance, walking by some ancient structures standing where the Fairmont Banff Springs golf course is today. Just about then, I realized I had to write this book. I had to go on and finish what I had started.

Canada is a great, peaceful, democratic and wealthy nation, but it is not even able to keep its promises in relatively small, yet mostly glorified "protected" areas. What hope is there, then, for the bigger issues such as climate change, vanishing wilderness and the human-ignited wave of mass extinction? The reality is that if we cannot even get it correct here, then there is no hope.

Yet, there is one great truth. Nothing is or remains stable. Wildlife populations fluctuate, ocean levels rise and fall, climates change, faraway stars are born and die along with human ideas, visions and beliefs. A massive change in society comes when either a better way of life is offered through human ingenuity, or when things get so unbearable that the majority of people either demand it, force it or simply have no other choice in order to survive.

Believing in the goodness of people, and with the understanding that change is inevitable, I find hope. The stories of Nanuk and company are not isolated cases. Rather, they represent the standard our society has created. Maybe by narrating their life stories, which take place inside national park boundaries, I can help us to reach a tipping point. Maybe their stories will evoke the wish and aim to do the right thing.

"A thing is right," as Aldo Leopold expressed it, "when it tends to preserve the integrity, stability and beauty of the biotic community. It is wrong when it tends otherwise." Taking Leopold's words into account, one could argue that the management practices found in the Canadian Rocky Mountain national parks in their 125 years of existence is monumentally wrong, since we have neither achieved nor preserved the integrity or the stability of the biotic community. That said, we could start to do things right by asking ourselves only one set of questions and, importantly, act accordingly:

Are we willing to create a place that is set aside first and foremost NOT for our needs?

Are we willing to set aside a place where humans are NOT the rulers, the masters, but rather students of nature?

Do we have the courage, the commitment and the WILL to do so?

While a long exposure shows the trails of the stars and moon over Mount Rundle in Banff National Park opposite, the composite image above shows the stages of the total lunar eclipse on February 20, 2008.

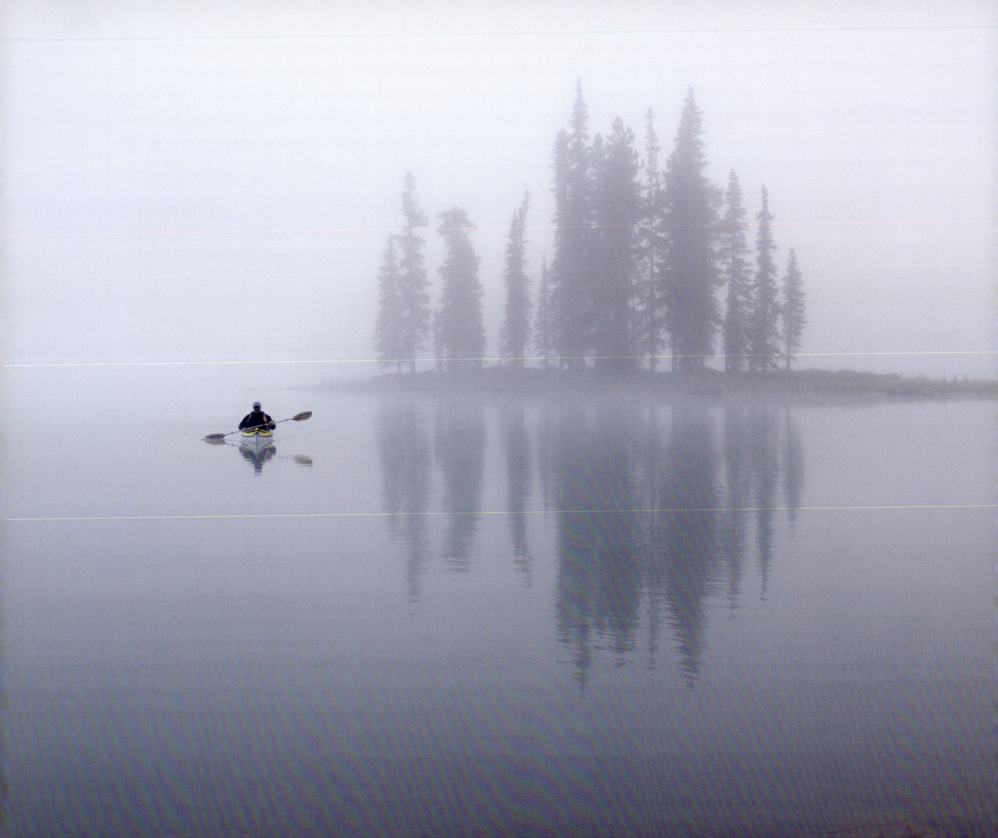

Left: Lone kayaker in front of Spirit Island, Jasper National Park.
Above: Cow and bull moose in what used to be part of Banff National Park, Kananaskis Country. While national parks remain exempt from industrial uses like commercial logging, such activities can still be found in other "protected areas," such as in the oldest provincial park in Canada: Ontario's Algonquin. As the Canadian Parks & Wilderness Society points out in the 2009 edition of their Parks Day Report, if one were to lay all the forestry roads in Algonquin Park end to end, they would reach from the park down to Florida and back.

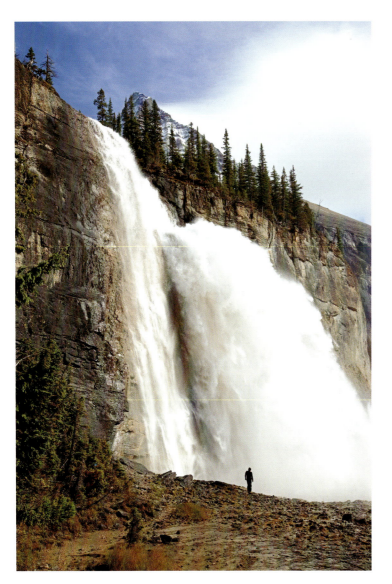

Left: Emperor Falls in Mount Robson Provincial Park. In times of unprecedented human-caused biodiversity loss and climate change, large wilderness areas protected from any kind of human interference are more important than ever. Currently (2009) Canada has set aside only about 3 per cent of its total land mass as national parks, as calculated from data assembled from Parks Canada's list of the 42 parks. Overall, Canada has set aside less than 9 per cent of its land for protection. Compare this with Costa Rica, for example, which has set aside four times as much of its land as national parks (12.23 per cent), according to costarica-nationalparks.com.

Right: Heart-shaped scar on a tree in Banff National Park. Disturbingly, even the last and grandest enclaves of protected wilderness around the world are under threat in order to nourish an insatiable global economy, from industrial logging in Ontario's Algonquin Provincial Park to ski hill proposals in one of Europe's last wildernesses, Tatra National Park in Slovakia. From rezoning the borders of a World Heritage Site to accommodate the needs of the 2014 Olympic Games in Sochi, Russia, to a recently approved commercial highway that will cut through one of the most famous protected areas, the Serengeti in Tanzania. Sadly, the Canadian Rocky Mountain parks can be cited worldwide as a model of what happens when economic thinking trumps protection of the natural world even in the most protected of protected areas.

If the answers to these questions are yes, we could start immediately by adding a relatively few words to the Canada National Parks Act which would have validity for all of Canada's national parks. After reading about how other nations define their national parks, I have created the following draft of such a revision. My goal is to come up with a clear mandate that cannot be challenged every few years, by anyone. It is a matter of setting priorities and showing the will to follow through. Consider the following:

The national parks of Canada are hereby dedicated first and foremost for the protection of the natural environment. Inside national park boundaries, the entire flora and fauna and the natural landscape are protected by law from any human interference and left to their natural development. The Canadian government provides the framework for achieving this goal by preventing or eliminating, as soon as possible, exploitation or occupation in the whole. The sole purpose of Canada's national parks shall be based on these three main pillars:

I. Nature conservation

No tree shall be felled, no animal hunted, no meadow mown, no human intervention of any kind. Nature shall be able to evolve as it has since the dawn of time. If one or several ecosystems are already materially altered by human occupation, exploitation or infrastructure (such as dams, roads or towns), and where plant and animal species populations suffer as a consequence, the Canadian government and Parks Canada are legally obliged to take all necessary steps to prevent or eliminate such human-caused conditions as soon as possible. In places where human infrastructure and industrial transportation is excessive, such as in the Canadian Rocky Mountain national parks, the Canadian government, along with the provinces and the private sector, commit themselves to eliminate the negative impact of human activities with long-term strategies. If the highest authorities involved are not able to find a satisfying solution to eliminate the unacceptably high road/railway mortality soon, highways and railways shall be moved or, if necessary, buried in such a way that the east/west industrial transportation link will become an ultramodern, highly efficient traffic carrier offering increased transportation capacities and shorter journey times, such as has been done in Switzerland (the NEAT). Such an undertaking would guarantee not only sustainability but also environmentally friendly management of mobility for ever-increasing volumes of traffic. Absolutely no more roads shall be built inside national park boundaries.

II. Non-intrusive research

Scientific research shall be placed at the centre of Parks Canada's mandate and will help to document and understand the changes taking place in our national parks. Of particular interest and importance are non-intrusive research projects conducted over prolonged periods.

III. Make the natural (non-human-created) world relevant to our modern society

Alongside protection of the natural environment, including biodiversity and intact wilderness areas, national parks shall play an increasingly important role in passing along knowledge, gained through research, to the public. This activity shall form the heart and soul of making our national parks relevant for all Canadians and the world. Rather than manage wildlife, as practised in the past, people shall be managed in a way that encourages a formidable experience for both humans and wildlife. Sports venues, racetracks and related facilities shall be banned from national parks. Law shall

demand long-term sustainability and ecological accountability in order to run any kind of business operation inside national park boundaries. No more chain stores or franchises shall be found inside national park boundaries. Local products, local ingenuity and locally owned stores, restaurants and accommodation facilities shall be promoted and fostered, without ever compromising the health of the biotic community. Additionally, neighbouring farming areas or communities shall provide fair trade, predator-friendly, organically grown food and environmentally friendly goods and services to the existing towns inside national park boundaries.

<div align="center">✱✱✱</div>

The Canadian government shall lay down detailed and clear regulations covering the aims of protection, paths, prohibitions etc., in accordance with the guidance of an independent expert panel. This independent expert panel shall also be responsible for monitoring and publishing, on a regular basis, the success or failure of national park management practices and of human activity inside our national parks. This would provide an open and transparent way to ensure that these national treasures are not overused, exploited or destroyed (economy over ecology).

It is evident that there is a need for change. According to the United Nations Environment Programme (UNEP), climate change, the rate of extinction of species and the challenge of feeding a growing population are among the major threats to the planet. Failure to address these persistent problems may undo all achievements on the simpler issues. In concluding remarks to Section A of their "Global Environmental Outlook 4" report, the UNEP authors state: "The objective is not to present a dark and gloomy scenario, but an urgent call for action." Ultimately, our inaction may threaten humanity's survival.

Change does not come easy. Considering the history of the parks, we cannot rely on our government or any other authority of the country to stop the ongoing exploitation of this unfortunate wilderness. One sign of progress is the steady increase in protected areas. But those areas must be effectively managed and properly enforced. As cultural anthropologist Margaret Mead expressed it: "Never depend upon institutions or government to solve any problem. All social movements are founded by, guided by, motivated and seen through by the passion of individuals."

EPILOGUE: THE WILL OF THE LAND

...the love of wilderness is more than a hunger for what is always beyond reach; it is also an expression of loyalty to the earth, the earth which bore us and sustains us, the only home we shall ever know, the only paradise we ever need – if only we had the eyes to see. Original sin, the true original sin, is the blind destruction for the sake of greed of this natural paradise which lies all around us – if only we were worthy of it.

—Edward Abbey, *Desert Solitaire* (1968)

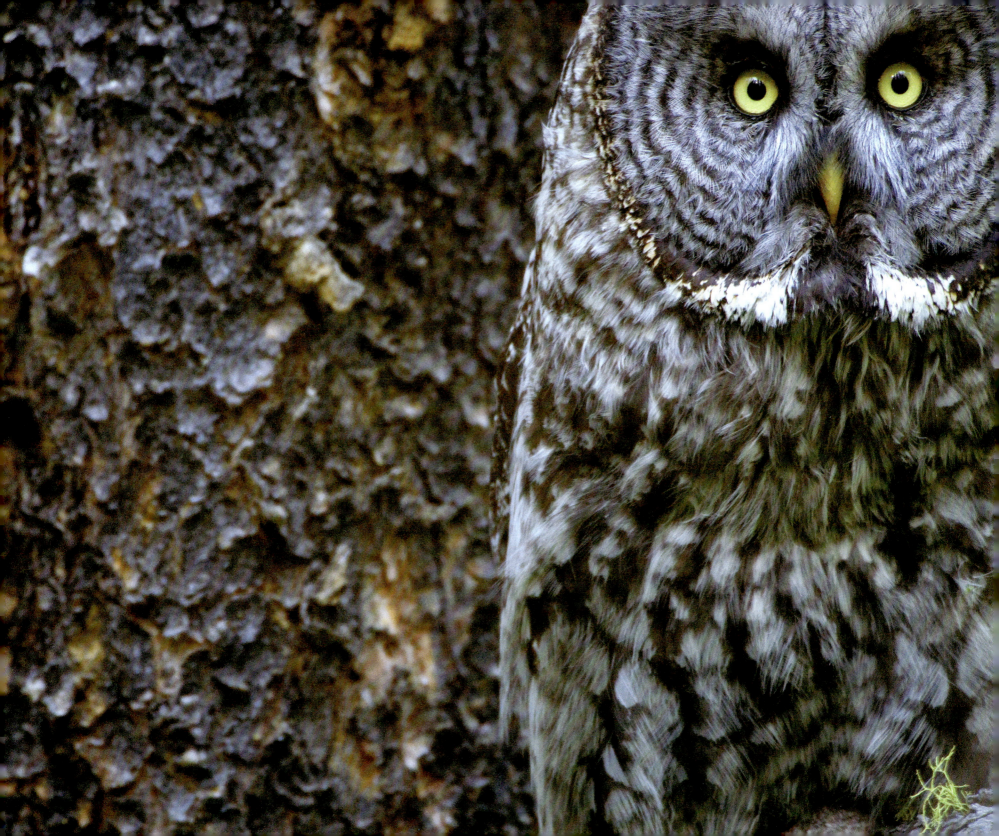

In 1983, at the third World Wilderness Congress, in Scotland, Jay Hansford C. Vest presented a paper that concluded with the idea that wil-der-ness means "will-of-the-land":

This "willed" conception is itself in opposition to the controlled and ordered environment which is characteristic of the notion of civilization. While control, order, domination and management are true of civilization and domestication, they are not essentials of primal culture. The primal peoples of northern Europe were not bent upon dominating and controlling all environments. Thus, their "will-of-the-land" conception – wilderness – demonstrates a recognition of land in and for itself.

Vest further says that the Baltic–Slavic peoples maintained an early animistic notion centred upon forces called siela. These sylvan spirits guarded the forest and would not allow people to so much as whistle or shout there. They also protected animals, particularly the bear.

Some Native American tribes, such as the Niitsítapi (Blackfoot), also have this type of respect for the natural world in their belief systems. The Blackfoot refer to the mountains as sacred places where profound earth spirits dispatch important lessons to human and faunal citizens.

With this context in mind, as it is in mine, I would like to end this book with one of the most profound personal experiences I have had to date with a wild-living bear. It begins in July 2009, when I received an impromptu call from some Swiss friends who were in Banff and wanted me to show them around. We agreed to meet a couple of days later at 4:30 a.m. to go bear watching. The past year and a half had been long and frustrating, so I was looking forward to the companionship of old friends.

The day before I met my Swiss friends, I phoned around to get an update on recent bear activity. Near Lake Louise someone had spotted a grizzly sow with two tiny cubs, news I had been waiting to hear for weeks. We all met early the next day and started out toward Lake Louise. Once there, for quite some time, we saw very little activity. There were a few elk and deer, but no bears, so I guided them to a few of the more scenic spots. It was late in the morning by then and I had mostly given up hope of seeing the grizzly sow and her cubs.

Often, the moment you abandon hope, truth and beauty are revealed. On the way home we found what we were looking for: a beautiful blonde grizzly bear and her two cubs. They were close to the road and did not mind our presence. For the next two hours, we got up close and personal. We watched her eat dandelions and spring beauties while the cubs tumbled after each other like overgrown puppies. When the sow turned her head just so, I saw the orange tag in her ear, "9301." It was Jolie.

My friends were delighted with their good fortune and grateful for the experience. They later drove on to Jasper while I spent the next few days observing Jolie and her cubs. One evening, when I could not find her, I remembered an area where bears sometimes hang out. I would have to leave the safety of my car and walk in, but I had grown to know and trust Jolie. I felt comfortable with her. It was time to confront my bear-attack-book complex.

A slight wind blew at my back, which meant that if she were where I hoped she would be, she would catch my scent and know ahead of time that I was coming. To be on the safe side, I spoke loudly and calmly while walking through the forest. Just before I got to the opening in the trees, I stopped again: "Hey Jolie, here I come. It's just me." I stepped out into the open. The bears were where I expected them to be.

I continued to talk while I knelt down behind my tripod and camera. I could clearly see the two cubs, but Jolie was partially hidden by a little rise and I could only see her rippling shoulder hump. To my relief, she finally took a few steps forward into view. Instantly she lifted her head and stuck her nose into the wind. I looked down and dug some little stones from the ground. Jolie watched for a few seconds and then went back to grazing on the new-growth grass, perhaps recognizing who I was.

She seemed to be comfortable with my presence, but I had a hard time forgetting all the horror stories about how dangerous bear mothers could be. Jolie gave me no reason to feel nervous, but the images in my head made me feel uncomfortable so I moved back a few metres. I sat down again and dug up more stones and dirt while Jolie kept on grazing away. One, two, three, four stones in my hand. What beautiful stones! I was finally able to relax.

One of her cubs had taken an interest in a rusty old chain hanging from a wooden gate. I watched it climb up to get a closer look, when suddenly it lost its footing. A quick swipe of its front paw and it was swinging from the rail like the pendulum on a Swiss clock. While the cub struggled to regain its balance, I couldn't help think of the future

Grizzly bears are fascinating creatures in many ways. After mating season is over, males and females part ways. The female is able to delay implantation of the embryo until the fall. If she is well fed, the cycle continues and the embryo implants in the uterine wall and begins to grow. If not, the embryo is reabsorbed by her body and she will not give birth to any cubs. Jolie obviously had found enough food the previous summer and fall and re-emerged the following spring with these two tiny cubs, Bow and Peyto.

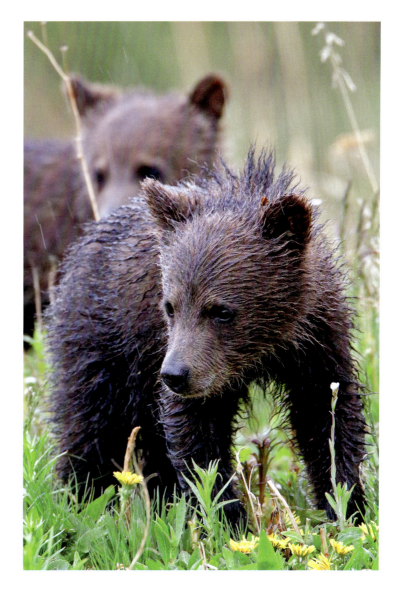

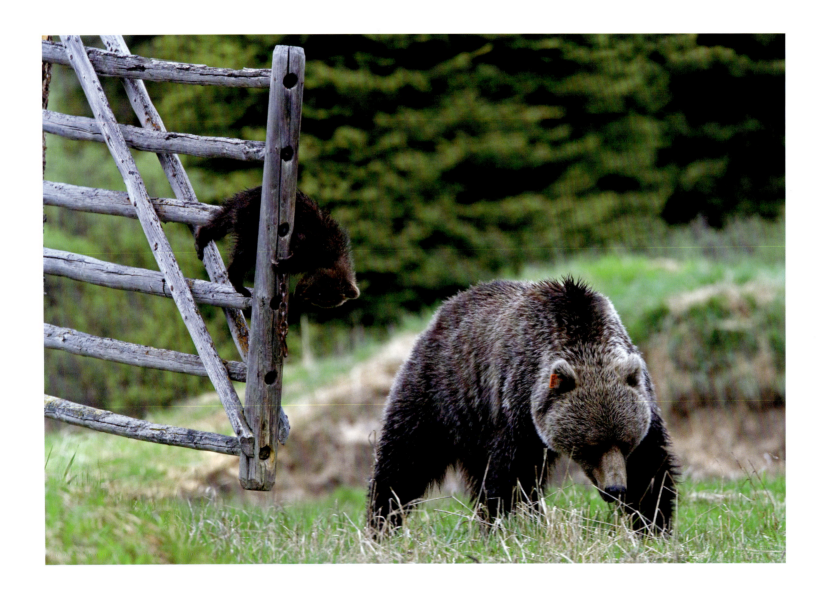

While mum grazes away, Peyto decides to take a closer look at a rusty chain hanging from an old gate. After Jolie mated with both Arnie and Casanova the year before, and because of delayed implantation, each of her cubs could have a different father. In fact, DNA analyses on northern grizzlies by Lance Craighead revealed that in as many as one-third of litters the cubs had different fathers.

of their kin. Jolie and her cubs are three of only about 800 grizzlies left in what little wilderness remains in all of Alberta. The Alberta Endangered Species Conservation Committee recommended almost a decade ago that grizzlies be listed as a threatened species, but it was not until June 2010 that the Alberta government finally did so (though see the image caption on p. 177). The federal government still has not done so. Given the small population and the amount of industrial and recreational development in what remains of bear habitat, it is hard to understand why. Or perhaps it isn't.

In the meantime, Jolie stepped forward and stopped just metres away from me. She turned sideways and lowered her head to get a few sips of water from a small pond, all the while eyeing me intently. I figured it was time to leave the bears alone. Slowly I turned my whole body sideways, chin close to my chest, and stood up. In a soft voice I thanked Jolie and her cubs for their trust and tolerance. Then, more humble than I have ever felt in my life, I walked back to civilization with a mixture of joy, worry and shame. And hope.

That hope stuck with me. Then, while I was writing the last few phrases for this project, it was nourished in receiving some good news for once. That good news came in four areas:

1. Habituation, aversive conditioning, roadside animals

A Parks Canada representative informed me that there is a good chance that the Canadian Rocky Mountain national parks will adopt the Yellowstone model and tolerate roadside animals such as bears and wolves, starting later in 2010.

2. Caribou and bison reintroduction

The 2009 Banff National Park Management Plan stated a goal of reintroducing a breeding herd of bison to the east slopes of Banff National Park. In December 2009 it was announced that a caribou reintroduction program in Banff is also underway.

3. Highway twinning and fencing

More highways will be twinned and fenced in and around Lake Louise. In addition, the federal government announced, in November 2009, an "Action on the Ground Funding" of $5.15-million for Highway 93 south, in Kootenay National Park, to reduce animal/vehicle collisions and improve both wildlife connectivity and public safety.

4. Parks Canada and CP meet for talks

On December 25, 2009, I read that wildlife and railway experts will be "thinking outside the boxcar" to come up with solutions to reduce the grizzly bear mortality rate on the railway tracks in Banff and Yoho National Parks.

Although these rays of hope are encouraging, we must bathe in them with hesitation. Similar statements have been made throughout the last 125 years of "managing" the Rocky Mountain national parks of Canada. As the saying goes, one swallow does not make a summer.

1. Habituation, aversive conditioning, roadside animals

The shift in philosophy is a ray of hope – hope for an enhanced and more respectful way for people to share protected land with wild animals. To what extent and how exactly it will turn out is left to be seen. The fact remains that wolves have already been punished for using the Bow Valley Parkway, even after I received the "good news" that Parks Canada would be more tolerant toward roadside animals. The speeding problem also still needs to be solved. Until it is, the Canadian Rocky Mountain World Heritage Site remains a deadly place for animals.

2. Caribou and bison reintroduction

The bison and caribou reintroductions will help to bring back two missing native large-mammal species found in these valleys before the Europeans took over. While caribou reintroduction may not stir up too much opposition, the bison reintroduction will. Dave Ealey, spokesperson for Alberta Sustainable Resource Development, expressed the province's concern that outside national park boundaries, migrating bison "would create fairly significant management issues for us." He added, in the November 5, 2009, *Rocky Mountain Outlook* article, that the reintroduction of bison into Banff would have impacts on the province's elk population, raise concerns for public safety and affect outdoor recreation.

It will take a concerted effort and require great leadership, determination and commitment to go ahead with these long overdue reintroduction programs – not to mention eliminating the false myths about the impacts of reintroducing bison into their former range. Similarly strong leadership is needed to save the declining mountain caribou. It is time the highest authorities start concentrating on the negative impact that human encroachment has on mountain caribou habitat, rather than blame their decline on wolves. After all, wolves and caribou evolved with each other and the balance was only disrupted when *Homo sapiens manipulus* started playing God without understanding the rules.

3. Highway twinning and fencing

As good as road improvement projects sound, the twinning and fencing of highways are not so much because of concern for wildlife. These projects are largely intended to enhance safety for people and allow an increase in traffic volume. Wildlife crossing structures will accompany the twinning, but as evidence suggests, wildlife crossing structures are far from perfect.

Crossing structures are not a cure for encroachment and wildlife habitat fragmentation. Highways, with or without crossing structures, do fragment habitat for wildlife. Many unrecorded animals will continue to die every year, from bluebirds to coyotes, wolves and bears. In addition, crossing structures do influence migration patterns. Also, Jasper, Yoho and large parts of Kootenay National Park remain unfenced while traffic volume continues to increase.

4. Parks Canada and CP meets for talks

Talks and statements have gone on for decades. The result? No substantial change for wildlife. Unless there is great commitment, there will be no significant change for the better, and wild animals will keep on dying by the hundreds each year throughout the Rockies.

My pessimistic thinking about the future of our national parks does remain. Mostly, this pessimism comes from the continually reaffirmed belief held by decision-makers that national parks are first and foremost for the benefit and enjoyment of people. Until the day that

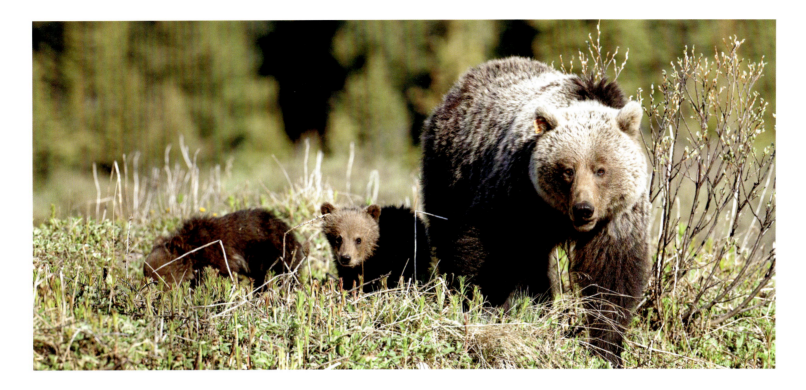

human interests come second, or until we even realize what is *truly* in our greatest interest – at the very least in those small pockets of "protected" lands we call national parks – the "protection and maintenance of ecological integrity" will continue to falter under the rampant economic desires of people. Therein lies our greatest failure.

If you, dear reader, believe as I do that it is time for a change, then let's *demand it*. Remember, though, that ultimately the amount of land we set aside as national parks or protected areas is not what

On June 3, 2010, after years of delay, the Alberta government listed the grizzly bears as "threatened" under Alberta's Wildlife Act. However, protection on paper is one thing, action on the ground another. Only five days after listing the grizzlies as "threatened," Alberta's Energy Resources Conservation Board approved a large industrial development in core grizzly habitat. Petro-Canada will be allowed to drill 11 sour gas wells, construct a battery and build two pipelines in the eastern slopes region of southwestern Alberta (Sullivan Creek).

particularly counts. The fate of humanity will play out regardless of national park boundaries. Nevertheless, it is here in our national parks, I believe, that we could find our way back home the soonest, if we are willing. Home to nature. Home to the only place we are so utterly dependent upon. Once again we can become part of the bigger picture. No greater, no lesser and certainly no better, but simply part of it – in full understanding, acceptance and humility.

Until one is committed, there is hesitancy, the chance to draw back, always ineffectiveness. Concerning all acts of initiative (and creation), there is one elementary truth the ignorance of which kills countless ideas and splendid plans: that the moment one definitely commits oneself, then providence moves too. A whole stream of events issues from the decision, raising in one's favour all manner of unforeseen incidents, meetings and material assistance which no man could have dreamt would have come his way. I learned a deep respect for one of Goethe's couplets:

Whatever you can do or dream you can, begin it.
Boldness has genius, power and magic in it!

—W.H. Murray, *The Scottish Himalayan Expedition* (1951)
[Goethe's couplet from a "very free translation" of *Faust* in 1835]

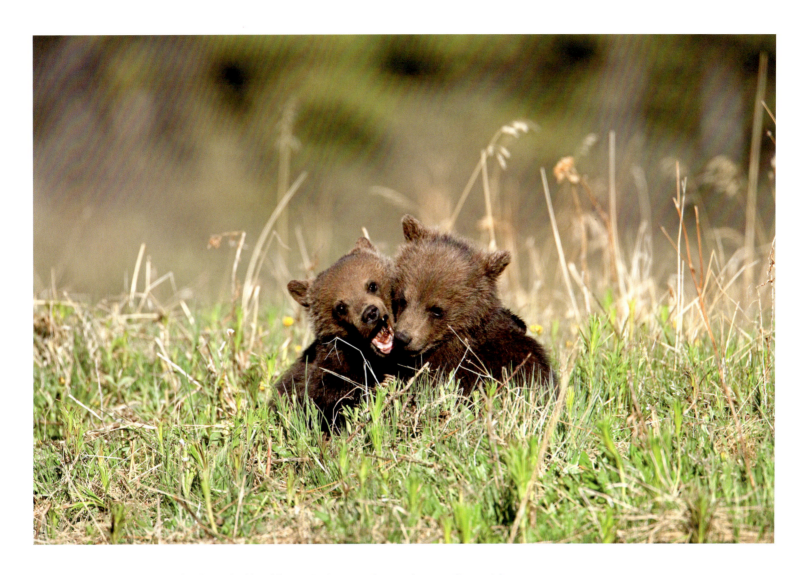

Bow and Peyto as approximately 20-week-old toddlers, enjoying an early-morning wrestling match.

CANADIAN ROCKY MOUNTAIN PARKS WORLD HERITAGE SITE

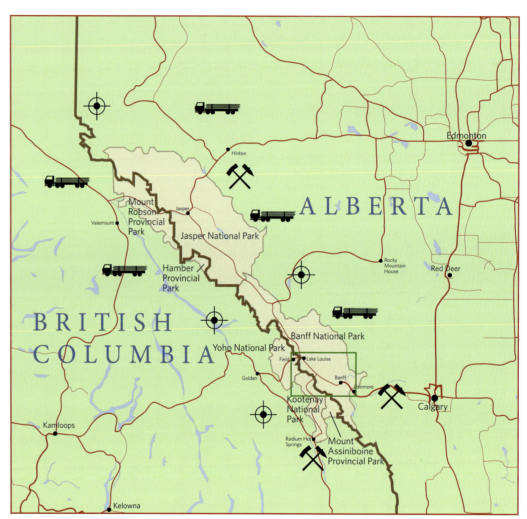

Banff National Park has changed size several times. Between 1902 and 1911 it encompassed the Kananaskis, Red Deer, Bow and Spray rivers, totalling 11,400 km² (4,402 mi²). In 1911 farming and logging interests successfully lobbied to reduce the area to 4,663 km² (1,800 mi²), eliminating much of the foothills. In 1930 the park encompassed 6,697 km² (2,586 mi²). After additional minor changes in 1949, the area changed to its current (2010) size of 6,641 km² (2,564 mi²).

Much of the Banff Bow Valley infrastructure we see today was created as part of economic stimulus projects. The Bow Valley Parkway and the expansion of the Banff Springs golf course were built by internees of the First World War. A variety of other projects were triggered by the Great Depression, such as the Norquay ski road, a Banff airstrip and a single-lane, gravel Banff–Jasper road. The various phases of twinning the Trans-Canada Highway came regularly after economic recessions. Phases 1, 2 and 3 were all built during or shortly after downturns in the early 1980s and 1990s and in late 2008 (see map on page 181).

THE BOW VALLEY

The Canadian Rocky Mountain Parks World Heritage Site is under heavy pressure from within (mass tourism, industrial transportation routes etc.) and without (industrial mining, logging, hunting, trapping etc.). The Banff Bow Valley is the ecological heart of Banff National Park and lies within the Montane ecoregion. Only 3 per cent of Banff National Park lies within this ecologically sensitive and highly important ecoregion. About eight million people pass through the Banff Bow Valley each year. The source for the elk population zones is the Banff Bow Valley Study, Ecological Outlook, June 1996.

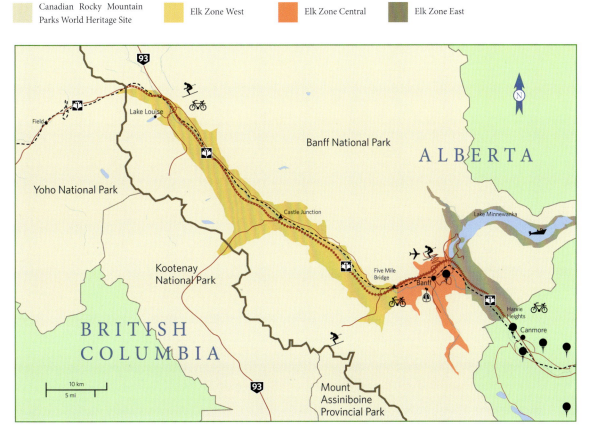
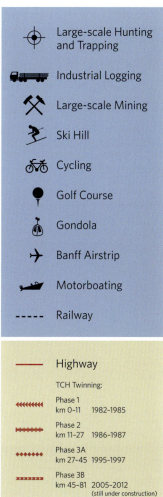

KINSHIP TIMELINES

Jolie's Family

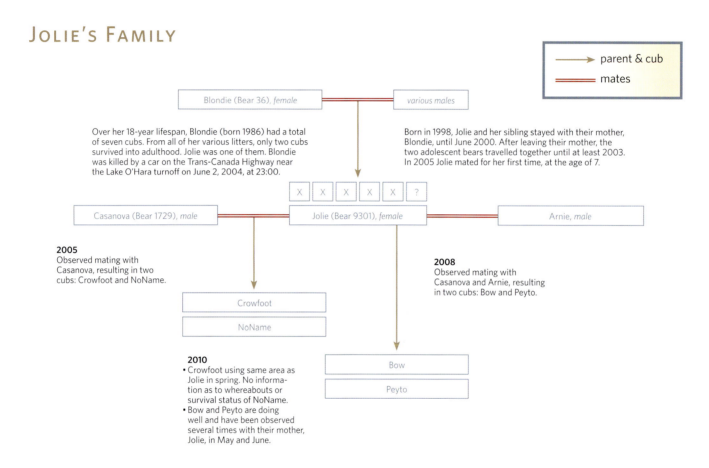

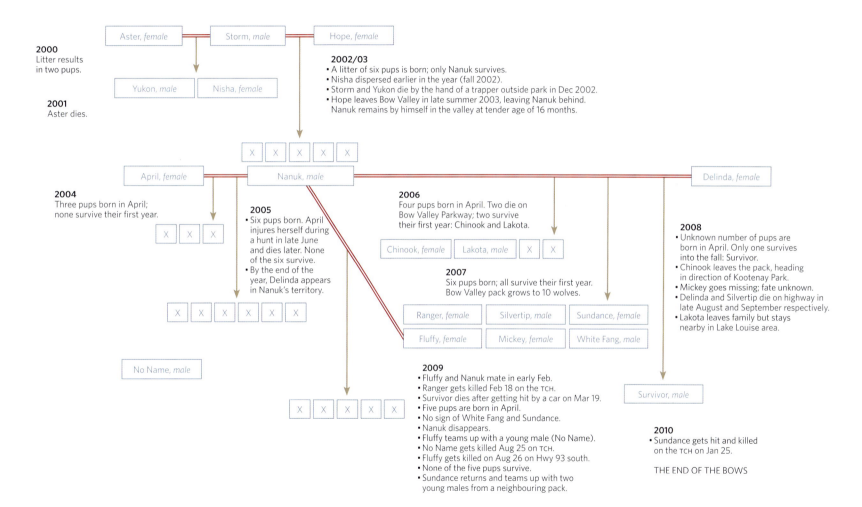

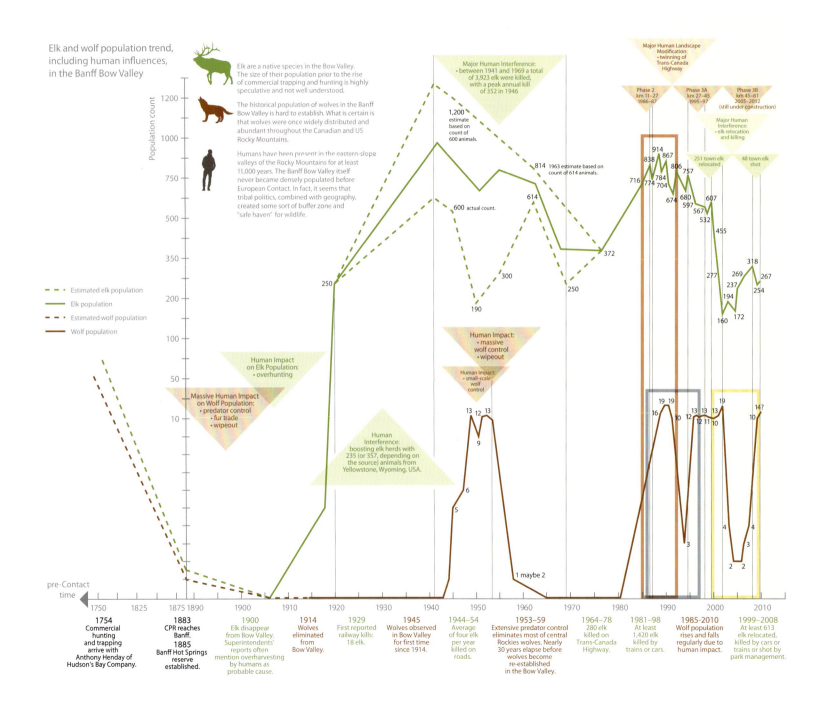

MORTALITY STATISTICS

Mortality in the Banff Bow Valley Elk Population, Banff National Park 1985–1992
number of fatalities by cause and as percentage of zone totals and global total

	Highway (%)	Rail (%)	Wolf (%)	Other (%)	Totals
West Zone	239 (45%)	140 (26%)	111 (21%)	41 (8%)	531
Central Zone	89 (37%)	34 (14%)	44 (18%)	74 (31%)	241
East Zone	98 (40%)	71 (29%)	30 (12%)	44 (18%)	243
	426 (42%)	245 (24%)	185 (18%)	159 (16%)	1,015

Aggregate causes of mortality as documented for entire Banff Bow Valley elk herd for the period:
Human 66% Wolf 18% Other 16%

Source: Banff Bow Valley study, Ecological Outlook, Final Report 1996, section 7-30

Mortality in the Bow River Valley Wolf Population, Banff National Park 1986–1995
number of fatalities by cause and as percentage of total

Highway (%)	Rail (%)	Shot (%) outside park	Unknown (%)	Total
15 (56%)	6 (22%)	3 (11%)	3 (11%)	27

Aggregate causes of mortality as documented for Bow River Valley wolf population for the period:
Human 89% Unknown 11%

Source: Banff Bow Valley study, Ecological Outlook, Final Report 1996, section 7-26

Mortality in the Bow Valley Wolf Family, Banff National Park – Nanuk's Era (2002 to early 2010)
number of fatalities by cause and as percentage of total

Highway (%)	Trapping (%) outside park	Natural (%)	Unknown (%)	Total
8 (67%)	2 (17%)	1 (8%)	1 (8%)	12

Aggregate causes of mortality as documented for Bow Valley family for the period (wolves aged ≥6 months):
Human 84% Natural 8% Unknown 8%

Source: Günther & Karin Bloch and Peter A. Dettling

Since 1980 (excluding a few years of missing data for certain species) the roads and railways have killed at least 9,802 animals in Yoho, Kootenay, Banff and Jasper national parks. The list contains only the reported and confirmed hits; the actual number of animals killed may be two to three times higher. The British Columbia Ministry of Transportation, for example, estimates that only 25 per cent to 35 per cent of total animal fatalities may be represented in the confirmed-killed statistics for BC roads. As for the railways, a published study by Pat Wells, John G. Woods, Hal Morrison and Grete Bridgewater called "Wildlife Mortalities on Railways: Monitoring, Methods and Mitigation Strategies," conducted between 1993 and 1998, reported that an experienced observer claimed twice as many individual railway kills than were reported. As to elk, for example, the experienced observer reported a total of 55 killed on a stretch of 125.6 miles versus 25 kills tabulated by the routine monthly reporting system of CP (several observers).

Excluded from the numbers are all mammal species smaller than a wolverine and all of the bird species. Also not included are the numbers of animals that die indirectly due, for example, to loss of a relative, especially young animals that are dependent on their mother. Not to be forgotten is the fact that a single killed animal may trigger collapse of an entire family structure, such as documented in the case of the Bow Valley wolf Delinda. Two further omissions from these statistics are: all animals killed or relocated for safety or management reasons; and those that died from other human causes besides roads or railways.

Conclusion: Between 1980 and 2008 the roads and railways combined slaughtered some 20,000 to 30,000 (1,000 to 1,500 annually) animals the size of a wolverine or larger in the four Rocky Mountain national parks (Yoho, Kootenay, Banff and Jasper), all part of a UNESCO World Heritage Site. For a detailed summary of the past decade (1999–2008), please see the following two pages.

ANIMAL MORTALITY FROM VEHICLE IMPACT

Banff National Park (1999–2008)

Species	Confirmed highway-caused fatalities	Unconfirmed highway-caused fatalities*	Confirmed railway-caused fatalities	Unconfirmed railway-caused fatalities*	Total confirmed and unconfirmed fatalities
BIGHORN SHEEP	11	0	5	0	16
MOUNTAIN GOAT	1	0	0	0	1
BEAR (SPECIES UNKNOWN)	0	1	0	0	1
BLACK BEAR	27	28	10	20	85
GRIZZLY BEAR	5	0	7	0	12
BOBCAT	1	0	1	0	2
COUGAR	3	0	1	0	4
LYNX	4	0	0	0	4
DEER (SPECIES UNKNOWN)	26	5	15	0	46
MULE DEER	98	2	49	1	150
WHITE-TAILED DEER	107	7	58	4	176
ELK	86	5	228	17	336
MOOSE	17	1	8	1	27
RED FOX	5	0	0	0	5
COYOTE	94	1	4	1	100
WOLF	10	1	4	0	15
ALL SPECIES	495	51	390	44	980

Kootenay National Park (1999–2008)

Species	Confirmed highway-caused fatalities	Unconfirmed highway-caused fatalities*	Total confirmed and unconfirmed fatalities
BIGHORN SHEEP	17	7	24
MOUNTAIN GOAT	2	0	2
BLACK BEAR	15	10	25
GRIZZLY BEAR	3	1	4
BOBCAT	1	0	1
LYNX	1	0	1
DEER (SPECIES UNKNOWN)	17	10	27
MULE DEER	31	1	32
WHITE-TAILED DEER	257	9	266
ELK	19	3	22
MOOSE	55	7	62
RED FOX	1	0	1
COYOTE	13	0	13
WOLF	4	2	6
ALL SPECIES	436	50	486

Yoho National Park (1999–2008)

Species	Confirmed highway-caused fatalities	Unconfirmed highway-caused fatalities*	Confirmed railway-caused fatalities	Unconfirmed railway-caused fatalities*	Total confirmed and unconfirmed fatalities
BIGHORN SHEEP	1	0	0	0	1
MOUNTAIN GOAT	5	1	0	0	6
BEAR (SPECIES UNKNOWN)	1	0	0	0	1
BLACK BEAR	19	10	11	16	56
GRIZZLY BEAR	1	0	0	0	1
COUGAR	1	0	0	0	1
LYNX	4	0	0	0	4
DEER (SPECIES UNKNOWN)	10	3	0	0	13
MULE DEER	38	2	1	0	41
WHITE-TAILED DEER	52	5	0	0	57
ELK	47	7	11	8	73
MOOSE	31	3	2	1	37
COYOTE	20	1	0	0	21
WOLF	16	0	5	0	21
AMERICAN BADGER	1	0	0	0	1
ALL SPECIES	247	32	30	25	334

Jasper National Park (1999–2008)

Species	Confirmed highway-caused fatalities	Confirmed railway-caused fatalities	Total confirmed fatalities, both causes
BIGHORN SHEEP	147	145	292
MOUNTAIN GOAT	2	0	2
BLACK BEAR	43	37	80
GRIZZLY BEAR	1	0	1
DEER (SPECIES UNKNOWN)	9	1	10
MULE DEER	205	36	241
WHITE-TAILED DEER	342	32	374
ELK	356	204	560
MOOSE	80	25	105
CARIBOU	7	0	7
COYOTE	59	2	61
WOLF	34	13	47
ALL SPECIES	1,285	495	1,780

*UNCONFIRMED FATALITIES (STRIKES): A "strike" is considered an unconfirmed fatality and occurs when an animal is reported to have been hit on either a road or a railway but upon investigation by Parks Canada staff no carcass or evidence was found. Reasons for such reports include that the animal may have survived the strike altogether or at least long enough to have travelled away from the road or railway but perished out of sight, or that the location report was inaccurate (Parks Canada staff will search an extensive section of road or railway during an investigation, but some location descriptions are very poor or vague).

REFERENCES AND RELATED READING

BOOKS

Abbey, Edward. *Desert Solitaire: A Season in the Wilderness*. New York: McGraw-Hill, 1968. Reprinted New York: Simon & Schuster, 1990.

Abram, David. *The Spell of the Sensuous: Perception and Language in a More-than-Human World*. New York: Pantheon Books, 1996.

Beston, Henry. *The Outermost House: A Year of Life on the Great Beach of Cape Cod*. New York: Henry Holt, 2003. First published in 1928 by Doubleday, Doran & Co.

Bloch, Günther, and Peter A. Dettling. *Auge in Auge mit dem Wolf: 20 Jahre unterwegs mit frei lebenden Wölfen*. Stuttgart: Kosmos, 2009.

Boitani, Luigi, Paul C. Paquet, and Marco Musiani. *A New Era for Wolves and People: Wolf Recovery, Human Attitudes and Policy*. Calgary: University of Calgary Press, 2009.

———. *The World of Wolves: New Perspectives on Ecology, Behaviour and Management*. Calgary: University of Calgary Press, 2010.

Botkin, Daniel B. *Discordant Harmonies: A New Ecology for the Twenty-first Century*. New York: Oxford University Press, 1990.

Brenders, Carl. *Wildlife: The Nature Paintings of Carl Brenders*. New York: Harry N. Abrams, 1994.

Bright, William. *Native American Placenames of the United States*. Norman: University of Oklahoma Press, 2004.

Busch, Robert. *The Wolf Almanac*. New York: Lyons & Burford, 1995.

Chadwick, Douglas H., and Raymond Gehman. *Yellowstone to Yukon*. National Geographic Destinations Series. Washington, D.C.: National Geographic Society, 2000.

Dutcher, James, and Jamie Dutcher. *Living with Wolves*. Seattle: Mountaineers Books, 2004.

Gadd, Ben. *Handbook of the Canadian Rockies*. 2nd ed., updated. Jasper, Alta.: Corax Press, 1995 [2009].

Halfpenny, James C. *Yellowstone Wolves in the Wild*. Helena, Mont.: Riverbend, 2003.

Halfpenny, James C., and Michael H. Francis. *Yellowstone Bears in the Wild*. Helena, Mont.: Riverbend, 2007.

Harrington, Fred H., and Paul C. Paquet. *Wolves of the World: Perspectives of Behavior, Ecology, and Conservation*. Noyes Series in Animal Behavior, Ecology, Conservation and Management. Park Ridge, N.J.: Noyes Publications, 1982.

Hart, E.J. *The Place of Bows: Exploring the Heritage of the Banff Bow Valley*. Part I, to 1930. Banff, Alta.: EJH Literary Enterprises, 1999.

Jones, Karen R. *Wolf Mountains: A History of Wolves Along the Great Divide*. Calgary: University of Calgary Press, 2002.

Kipling, Rudyard. The Law for the Wolves, in A Victorian Anthology, 1837–1895, edited by Edmund Clarence Stedman. www.bartleby.com/246/1131.html (accessed August 25, 2010).

Kyber, Manfred. *Das Manfred-Kyber-Buch: Tiergeschichten u. Märchen*. Reinbek: Rowohlt, 1984.

Leopold, Aldo. *A Sand County Almanac, and Sketches Here and There*. Illustrated by Charles W. Schwartz. New York: Oxford University Press, 1987. First published in 1949 by Oxford University Press.

Lopez, Barry Holstun. *Of Wolves and Men*. New York: Scribner Classics, 2004. First published in 1978 by Scribner.

Lynch, Wayne. *Bears: Monarchs of the Northern Wilderness*. Seattle: Mountaineers Books, 1993.

Mech, L. David., and Luigi Boitani. *Wolves: Behavior, Ecology and Conservation*. Chicago: University of Chicago Press, 2003.

Mowat, Farley. *Never Cry Wolf*. Toronto: McClelland & Stewart, 1963.

Muir, John, and William Frederic Badè. *A Thousand-Mile Walk to the Gulf*. Boston: Houghton, Mifflin Co., 1916.

Murray, W.H. *The Scottish Himalayan Expedition*. London: J.M. Dent & Sons, 1951.

Russell, Charles, Maureen Enns and Fred Stenson. *Grizzly Heart: Living without Fear among the Brown Bears of Kamchatka*. Toronto: Random House Canada, 2002.

Sandford, Robert W. *Ecology & Wonder in the Canadian Rocky Mountain Parks World Heritage Site*. Edmonton: AU Press, 2010.

Wilson, Edward O. *Biophilia*. Cambridge, Mass.: Harvard University Press, 1984.

REPORTS, ARTICLES ETC.

Attenborough, David, et al. *Wolf: The Legendary Outlaw*. BBC Wildlife Specials. London: BBC Television, 1998.

Banff Bow Valley Study. Banff Bow Valley at the Crossroads. Summary Report of the Banff Bow Valley Task Force to the Minister of Canadian Heritage. Ottawa: Department of Canadian Heritage, 1996. www.whyte.org/time/riveroflife/bveng.pdf (accessed August 14, 2010).

Bertch, Barbara, and Mike Gibeau. Black Bear Mortalities in Mountain National Parks 1990–2009: 20-Year Summary Report. Ottawa: Parks Canada, 2010. www.bearsmart.com/report/371 (accessed August 14, 2010).

Blank, Matt, and Tony Clevenger. Improving the Ecological Function of the Upper Bow River: Bow Lake to Kananaskis Dam. Technical Report #7, April 2009. Canmore, Alta.: Yellowstone to Yukon Conservation Initiative. PDF linked from http://is.gd/eL0bp (accessed August 27, 2010).

Callaghan, Carolyn J. The Ecology of Grey Wolf (*Canis lupus*) Habitat Use, Survival & Persistence in the Central Rockies. Ottawa: National Library of Canada, 2003.

Canada National Parks Act, S.C. 2000, c. C-32. http://is.gd/egUE9 (accessed August 14, 2010).

Canadian Parks & Wilderness Society. CPAWS 2009 Parks Day Report. Ottawa: CPAWS, 2009. http://cpaws.org/files/report-parks-2009-FINAL-web.pdf (accessed August 14, 2010).

Chilson, Peter. "Right of Way." *Audubon* magazine, June 2003. www.ecopassage.org/cuttingedge0306.html (accessed August 11, 2010).

Clevenger, A.P., and N. Waltho. Factors Influencing the Effectiveness of Wildlife Underpasses in Banff National Park, Alberta, Canada. *Conservation Biology*, vol. 14, no. 1 (2000): 47–56.

Cotter, John. "Conservationists worried about Parks Canada's plan to attract more visitors." *Whitehorse Star*, January 6, 2010.

———. "Parks Canada tries to reassure people about plans to attract more visitors." *Whitehorse Star*, January 25, 2010.

Dickmeyer, Laurie. The Banff Bow Valley: Environmental Conflict, Wildlife Management and Movement. Masters thesis to UBC, 2009. http://circle.ubc.ca/handle/2429/12659 (accessed August 10, 2010).

Dorsey, Benjamin. Bear & Ungulate Mortality Relative to Abundance along the CPR. Parks Canada Research Updates Speaker Series at Whyte Museum, Banff, May 27, 2010. MP3 audio at Banff Park Radio, http://is.gd/eKNhN (accessed August 26, 2010).

Fluker, Shaun. Ecological Integrity in Canada's National Parks: The False Promise of Law. ABlawg: University of Calgary Faculty of Law Blog, http://is.gd/eFSFf (accessed August 24, 2010).

Green, Jeffrey, et al., eds. Ecological Outlooks Project: A Cumulative Effects Assessment and Futures Outlook of the Banff Bow Valley, Final Report. Ottawa: Department of Canadian Heritage, 1996.

Hildebrandt, Walter. Historical Analysis of Parks Canada and Banff National Park, 1968–1995. Banff Bow Valley Study. Ottawa: Department of Canadian Heritage, 1995.

Humane Society of US. Wildlife Crossings: Wild Animals and Roads. Washington, D.C.: The Humane Society of the United States, 2009. http://is.gd/eDKa7 (accessed August 11, 2010).

Murie, O.J. Progress Report on the Yellowstone Bear Study. National Park Service 13:13 (1944). Wildlife & Ecology Studies Worldwide.

Panel on the Ecological Integrity of Canada's National Parks. Report on the Ecological Integrity of Canada's National Parks: Unimpaired for Future Generations? Conserving Ecological Integrity within Canada's National Parks. [Ottawa]: Panel on the Ecological Integrity of Canada's National Parks, 2000.

Parks Canada Agency. Banff National Park State of the Park Report 2008. www.pc.gc.ca/pn-np/ab/banff/plan.aspx (accessed August 24, 2010).

Parks Canada. Banff National Park Trans-Canada Highway Twinning, Highway Fencing and Wildlife Crossings. www.pc.gc.ca/eng/pn-np/ab/banff/docs/routes/sec3.aspx (accessed August 11, 2010).

Prevost, Ruffin. "Researcher: Yellowstone wolves distinct." *Billings (Mont.) Gazette*, October 2, 2009, sec. Wyoming News. http://is.gd/eDGUF (accessed August 9, 2010).

United Nations Environment Programme. Global Environment Outlook 4: Environment for Development. Nairobi, Kenya: United Nations Environment Programme, 2007. www.unep.org/geo/geo4/media (accessed August 11, 2010).

Vest, Jay Hansford C. 1985. Will-of-the-Land: Wilderness among Primal Indo-Europeans. *Environmental Review,* vol. 9, no. 4 (Winter 1985): 323–29.

Wildlife Act, R.S.A. 2000, c. W-10. http://is.gd/eFRxK (accessed August 11, 2010).

Woods, John G. Effectiveness of Fences and Underpasses on the Trans-Canada Highway and Their Impact on Ungulate Populations Project. Ottawa: Environment Canada, Parks Service, 1990.

Woods, J.G., et al. "Elk and other ungulates." Chapter 8 in J. Green et al., eds. Ecological Outlooks Project: A Cumulative Effects Assessment and Futures Outlook of the Banff Bow Valley, Final Report. Ottawa: Department of Canadian Heritage, 1996.

Yellowstone to Yukon Bow River study. *See* Blank, Matt, and Tony Clevenger.

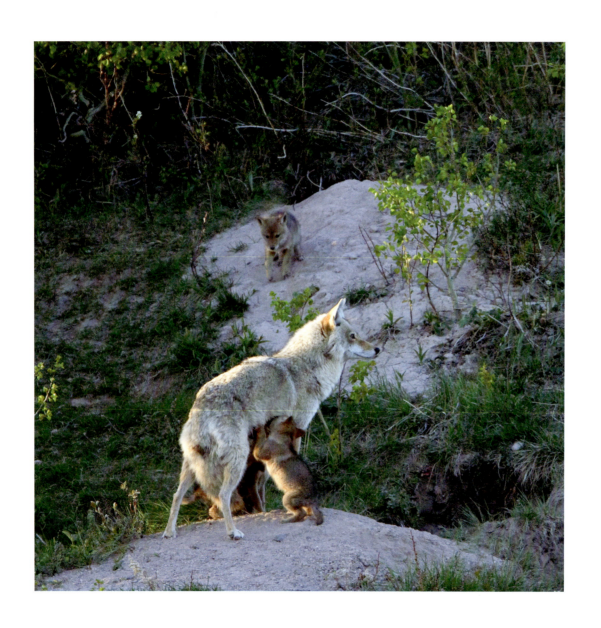

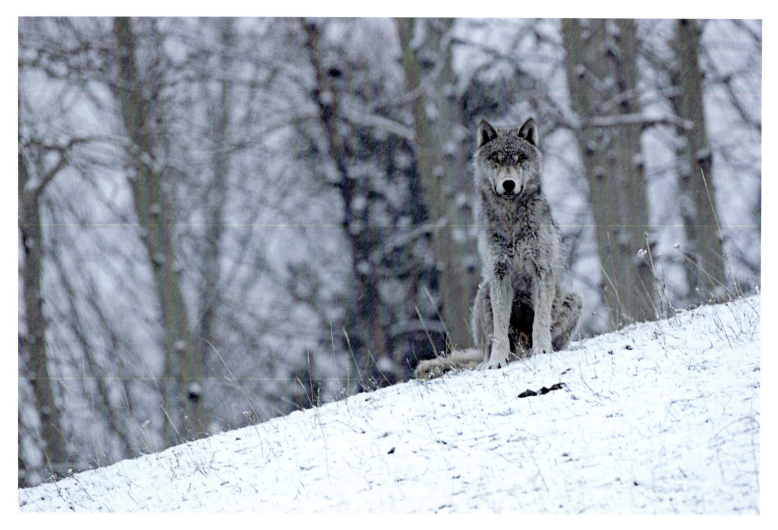

You may choose to look the other way but you can never say again that you did not know.

— William Wilberforce (1759–1833) British politician